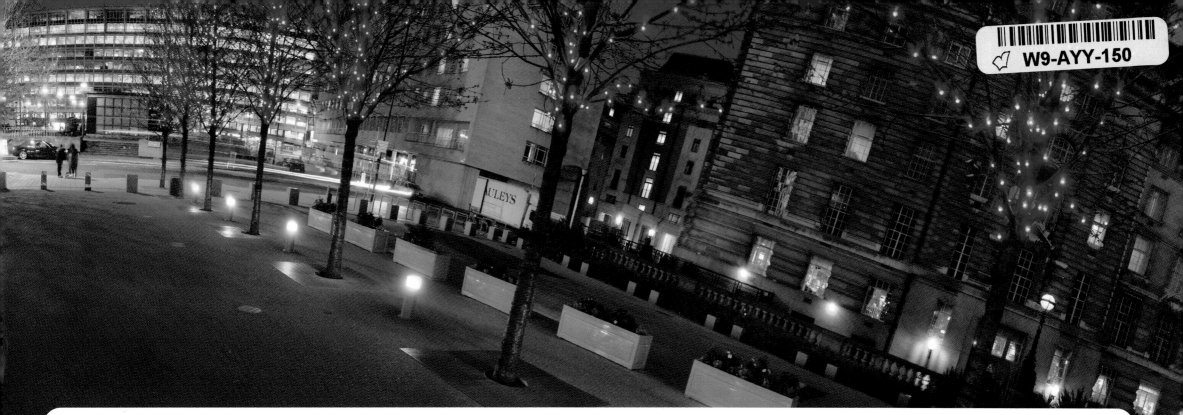

FROM THE GREENWICH MERIDIAN TO KEW GARDENS, AND FROM THE BANK OF ENGLAND TO BRIXTON MARKET, **360° LONDON** FOLLOWS THE TWISTS AND TURNS OF THE THAMES, WITH SOME DETOURS ALONG THE WAY, TO BRING YOU THE GREAT SIGHTS OF THE CITY. IN EACH OF THE **360° PANORAMAS** YOU ARE PLACED RIGHT AT THE HEART OF THE SCENE SO THAT YOU EXPERIENCE THE ATMOSPHERE OF LONDON MORE COMPLETELY THAN EVER BEFORE ON THE PRINTED PAGE. AMONG THE MANY WONDERFUL LOCATIONS HERE ARE LANDMARKS SUCH AS THE TOWER OF LONDON, THE LONDON EYE, TATE MODERN, AND PICCADILLY CIRCUS, WHILE MORE UNUSUAL SPOTS INCLUDE A BRICK LANE BAGEL BAKERY AND THE BATTERSEA DOGS HOME.

°PHOTOGRAPHER **NICK WOOD** HAS HAD A CAMERA IN HIS HAND FOR MORE THAN 20 YEARS, AND HAS LIVED IN LONDON FOR EVEN LONGER THAN THAT. BASED IN A STUDIO AT CLAPHAM COMMON IN SOUTH LONDON, HE SHOOTS WITH BOTH DIGITAL AND FILM CAMERAS. MOST OF HIS COMMISSIONED WORK INVOLVES PHOTOGRAPHING LARGE FORMAT LANDSCAPES, THE BUILT ENVIRONMENT, AND PORTRAITS OF PEOPLE IN THEIR WORKPLACES. HE IS ALSO THE PHOTOGRAPHER OF 360° NEW YORK.

NICK WOOD

360° LONDON

360° LONDON IS ...

experiencing a variety of locations shot in a complete circle. From the gleaming City of London, to the green spaces of St. James's Park and the quirky streets of Soho, discover London, one of the world's most exciting cities, in **360°**.

The photographs in this book were shot on a Nikon digital camera mounted vertically on a special tripod. By turning the camera and shooting every 22.5°, sixteen individual images are created. These shots are then "stitched" together using a Mac computer to produce the entire **360°** image.

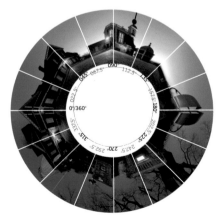

INTRODUCTION LONDON IS ...

7.2 million people speaking over **300** different languages

8,452 miles of roads

2,318 miles of bus routes and **127** miles of dedicated bus lanes

240 miles of Underground and DLR train lines, covering **292** stations

33 boroughs, **74** parliamentary constituencies and **10** European constituencies

a **£116,444 million** annual economy—**17%** of the UK's GDP

a **£425 billion** daily turnover on the London Stock Exchange

28.4 million tourists per year—**40%** from overseas

... and a great place to see in 360°

Ever since starting my career as a photographer, I've been fascinated by 360° images. I'm frequently commissioned to photograph landscapes, urban environments and the way people interact with them, and have often been frustrated by having to "crop" the location or situation where they are shot.

360° images are a very honest medium: that's how we experience life, so why not shoot it like that?

Through all my adventures around the globe, London has been my home for over 20 years. Every time I come back to London, it feels like a city that is at the center of the world, psychologically and spiritually. I wanted to capture the richness, diversity and history of my home city via 360° images—and I took as my theme and motif the River Thames.

London has evolved into a major hub of the international economy and the global community, and is a center of the world's financial markets, with a vibrant population that represents virtually all of the world's religions and cultures. This infinite variety is all clustered in about 100 square miles bisected by the loops and twists of the Thames.

The Thames has always shaped London and its millions of inhabitants. The Romans constructed Londinium at the lowest crossing point of the river, and even today it still dominates the center of the capital. Its spectacular array of bridges provide ever-altering views of the city. These constant changes, the combination of light, architecture and water, and the diversity of people have for two decades made London an irresistible subject for me to photograph.

From London's established industries, to my favorite locations, the city's myriad individual creative talents and its bold architectural icons, both old and new, I have looked to capture the sensations and images of London at the start of the twenty-first century. From Greenwich in the east to Kew Gardens in the west, here is a pictorial record of my home city.

NICK WOOD

CONTENTS

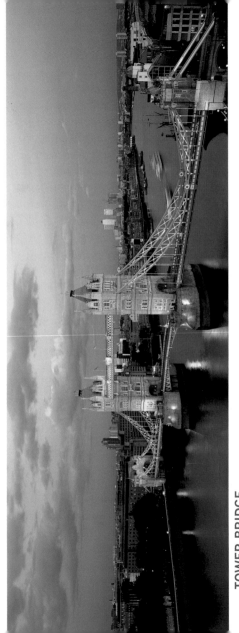

TOWER BRIDGE

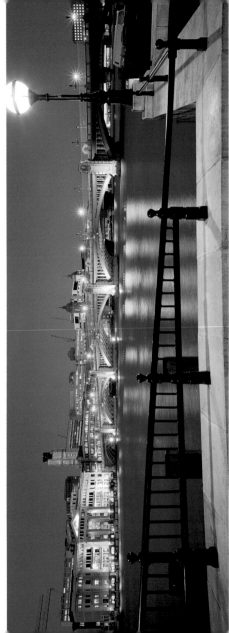

SOUTHWARK BRIDGE

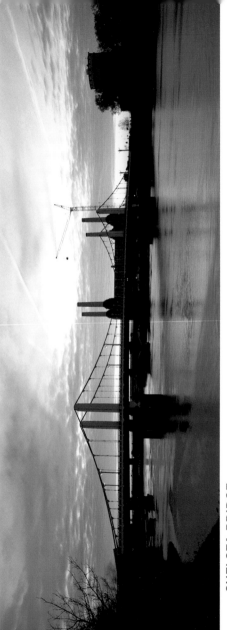

CHELSEA BRIDGE

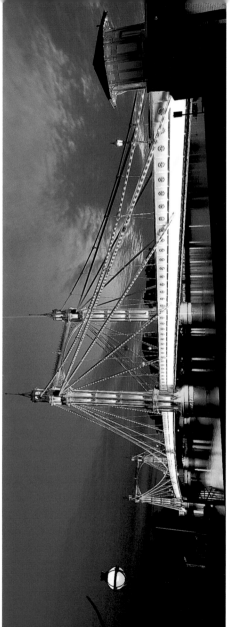

ALBERT BRIDGE

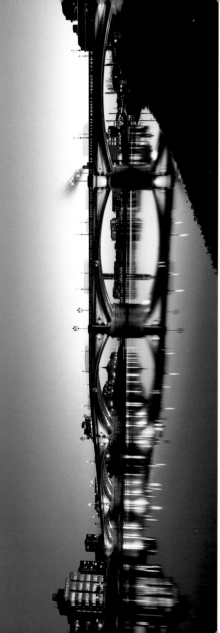

BATTERSEA BRIDGE

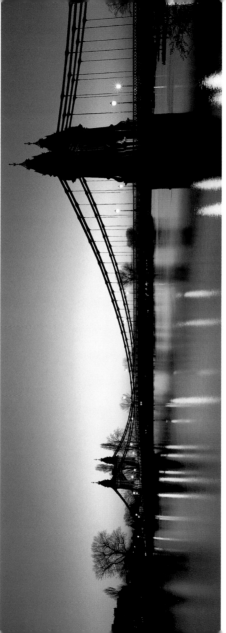

HAMMERSMITH BRIDGE

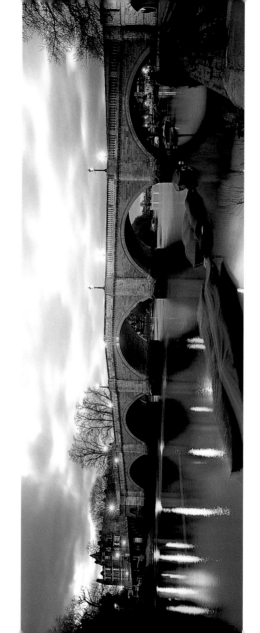

RICHMOND BRIDGE

Library of Congress Cataloging-in-Publication Data

Wood, Nick (Nicholas John)
 360 London / Nick Wood.
 p. cm.
ISBN 0-8109-4623-8
1. Photography, Panoramic—England—London. 2. Travel photography—England—London. 3. London (England)—Pictorial works. 4. Wood, Nick (Nicholas John)—Travel—England—London. I. Title: Three hundred sixty degree London. II. Title.

TR661.W6597 2003
779'.4421—dc22

 2003014838

Photographs and Movies
 © Nick Wood 2003
Text and design
 © Carlton Books Limited 2003
Photography and Movies conceived
 and shot by Nick Wood

Published in 2003 by Harry N. Abrams, Incorporated, New York. All rights reserved. No part of the contents of this book may be reproduced without written permission of the publisher.

Printed and bound in Malaysia

10 9 8 7 6 5 4 3 2 1

THE THAMES IS …

the longest river in England

measures **214** miles from its source to the sea

is **869** feet wide at London Bridge, and **1,469** feet wide at Woolwich

is home to over **55** sailing, rowing and canoeing clubs

was given to the City of London in **1197** by Richard I for **1,500** marks

51° 28' 36" **N**

00° 00' 00" **E/W**

GREENWICH OBSERVATORY

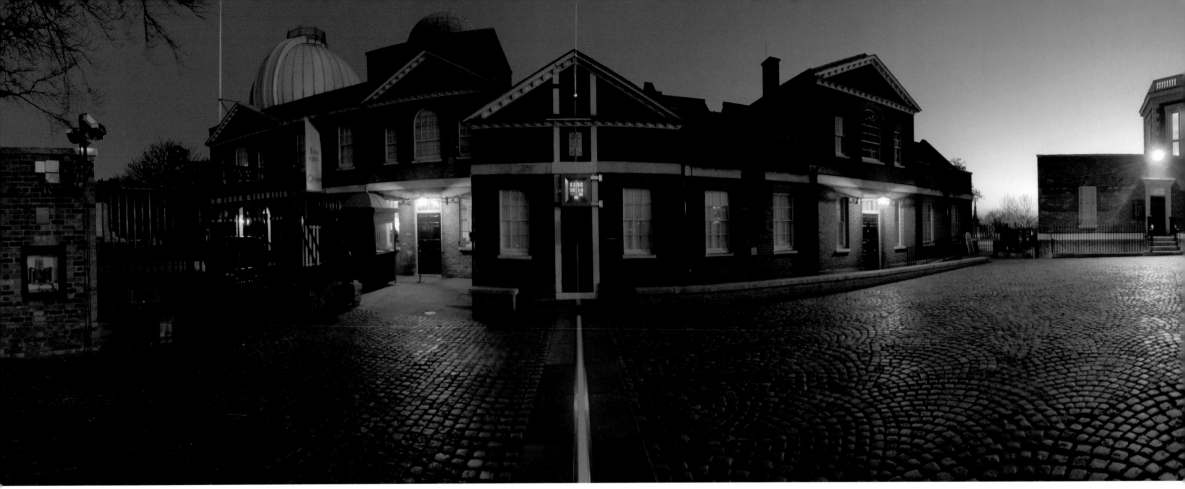

GREENWICH OBSERVATORY Greenwich was designated the center of world time at the International Meridian Conference in Washington D.C. in 1884. The dome surrounding its telescope was originally made of papier maché. It was destroyed by a flying bomb during World War II and replaced by a replica dome made from fiberglass. In 1894, the Observatory was subject to an anarchist bomb attack, an event immortalized in Joseph Conrad's novel *The Secret Agent*.

00° 00' 00"

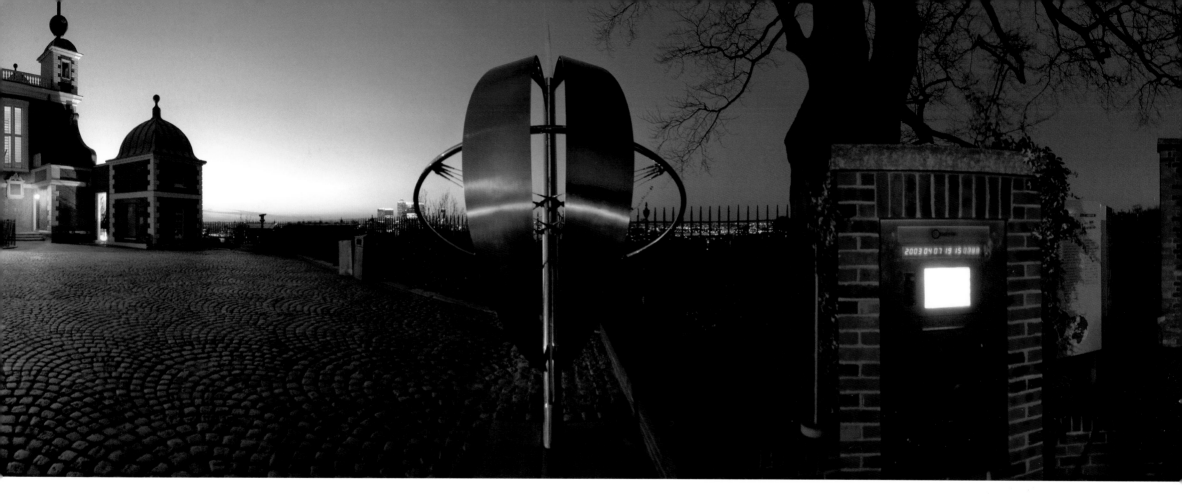

00 00 00 00"

CUTTY SARK (overleaf) The figurehead on the "last of the tea clippers", the Cutty Sark, is Nannie, a wicked witch from the Robert Burns poem, "Tam O'Shanter".

Till first ae caper, syne anither,
Tam tint his reason a'thegither,
And roars out, "Weel done, Cutty-Sark!"
And in an instant all was dark

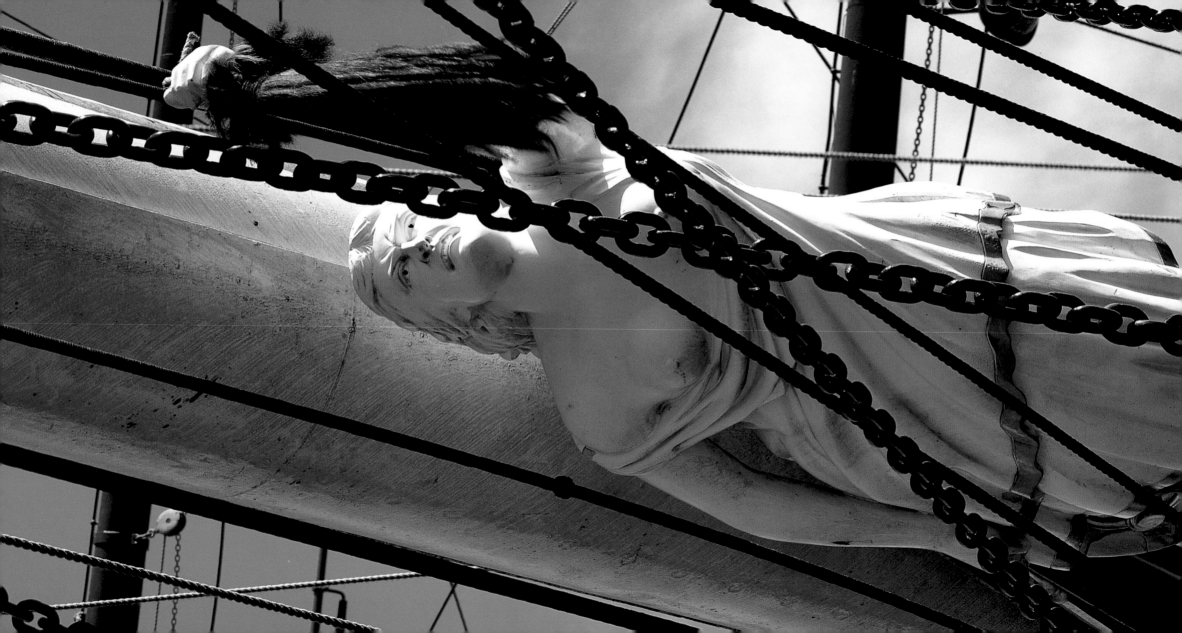

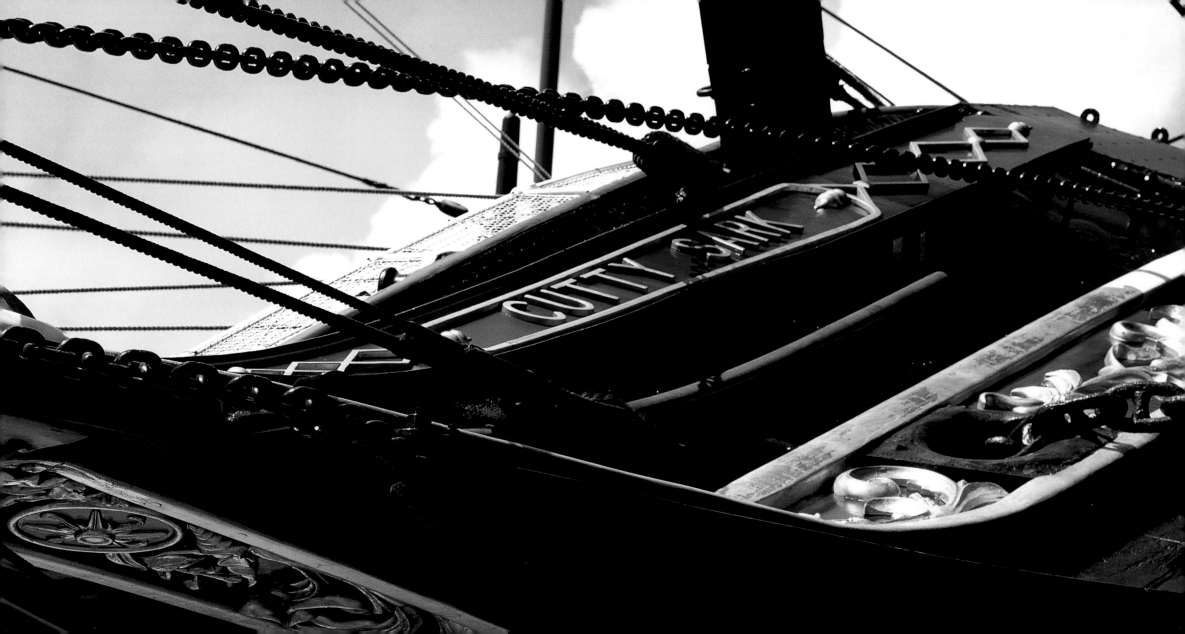

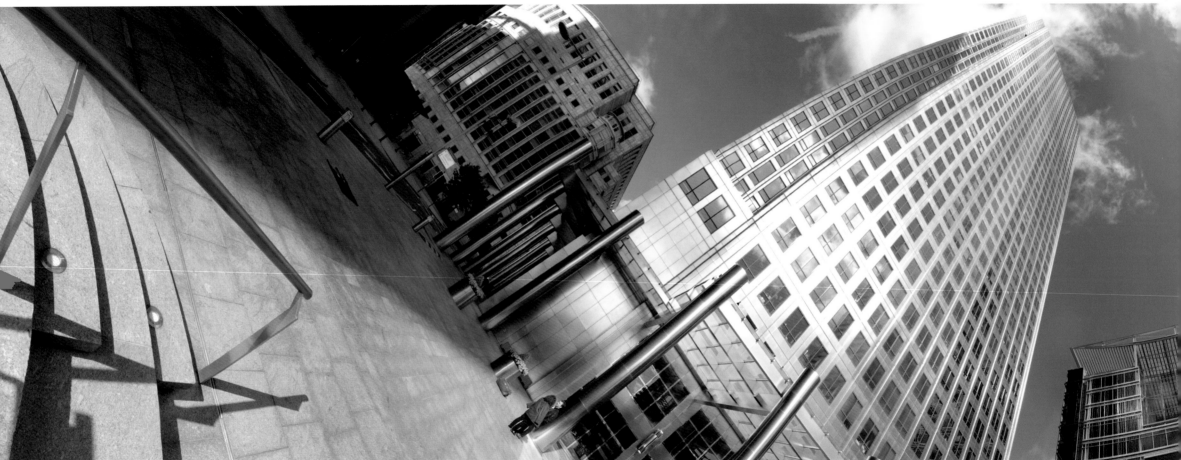

THE "NEW CITY OF LONDON" was built in 1987 in the East End Docklands, where many imports used to arrive from the Canary Islands. It covers 86 acres, and 55,000 people work there each day.
The 800-foot-high One Canada Square has 4,388 steps, 3,960 windows, and is the tallest building in Britain. Lifts travel from the lobby to the 50th floor in just 40 seconds.

CANARY WHARF DOCKLANDS

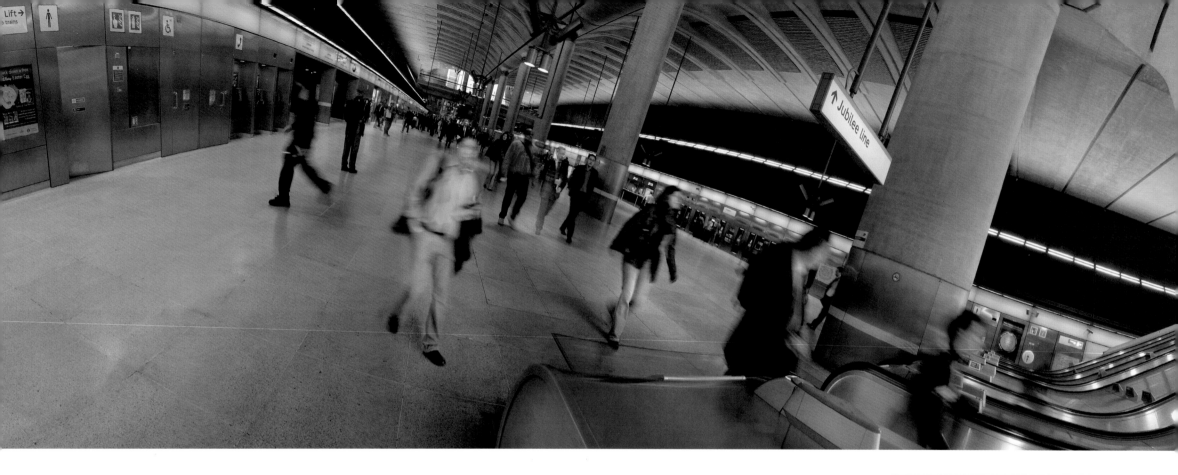

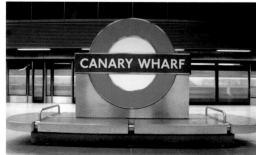

IN 1999 THE JUBILEE LINE Extension opened up Docklands to tube travelers for the first time. Each station was the work of a different architect: Canary Wharf station was designed by Foster and Partners (see page 136). Use of the line doubled when the extension opened, and 140 million people now travel on the Jubilee Line each year.

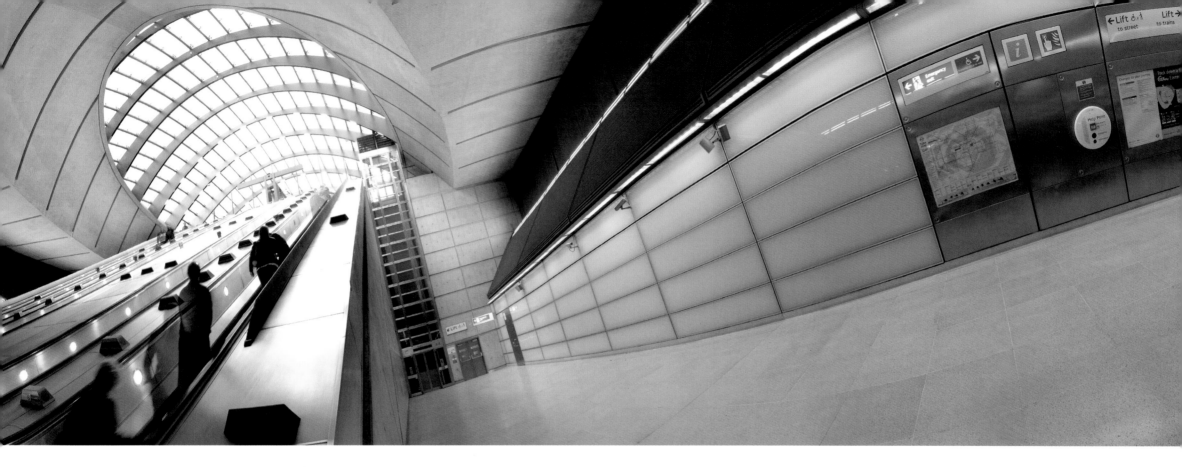

JUBILEE LINE DOCKLANDS

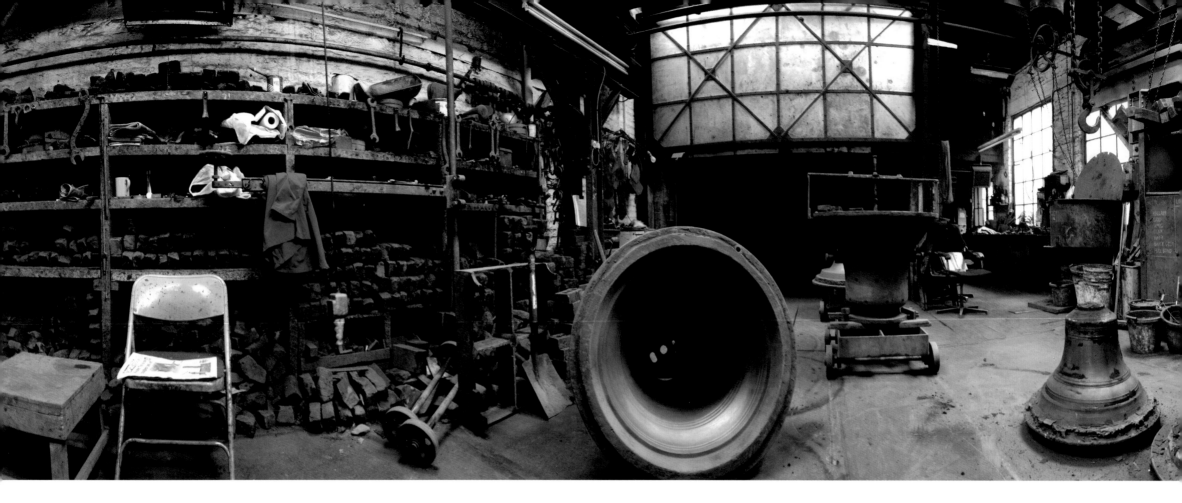

BRITAIN'S OLDEST MANUFACTURING COMPANY and the world's most famous bell foundry was established in 1570 during the reign of Queen Elizabeth I. They cast the original Liberty Bell (1752), the Great Bell of Montreal and, in 1858, Big Ben for the Palace of Westminster. Big Ben is the largest bell ever made at Whitechapel, weighing in at 13½ tons, and a cross-section of the bell surrounds the foundry entrance door.

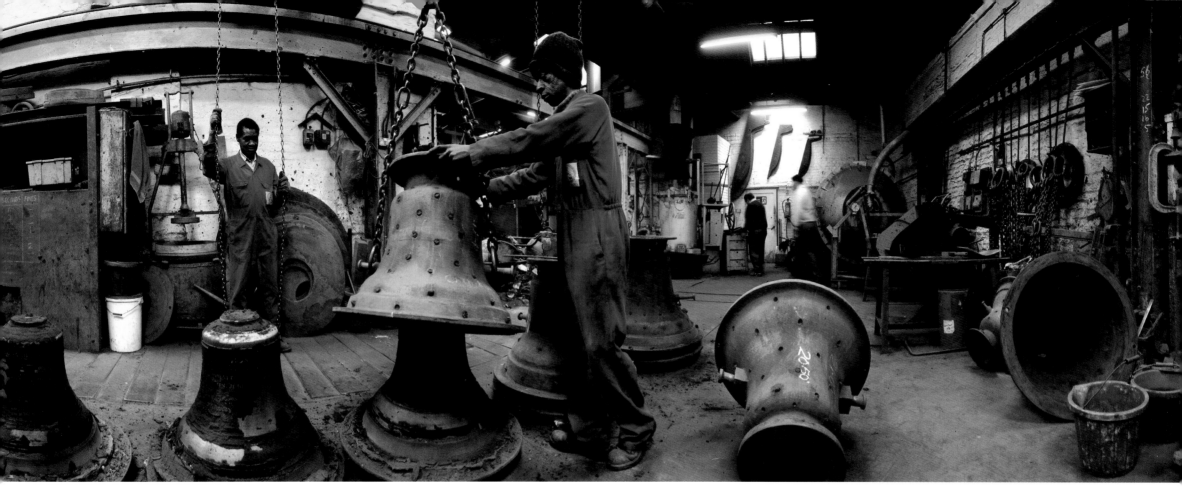

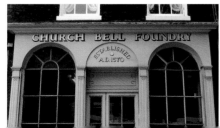

WHITECHAPEL BELL FOUNDRY EAST END

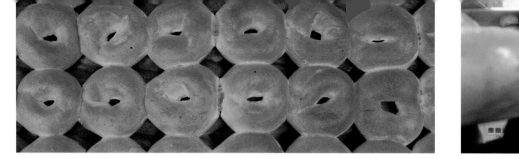
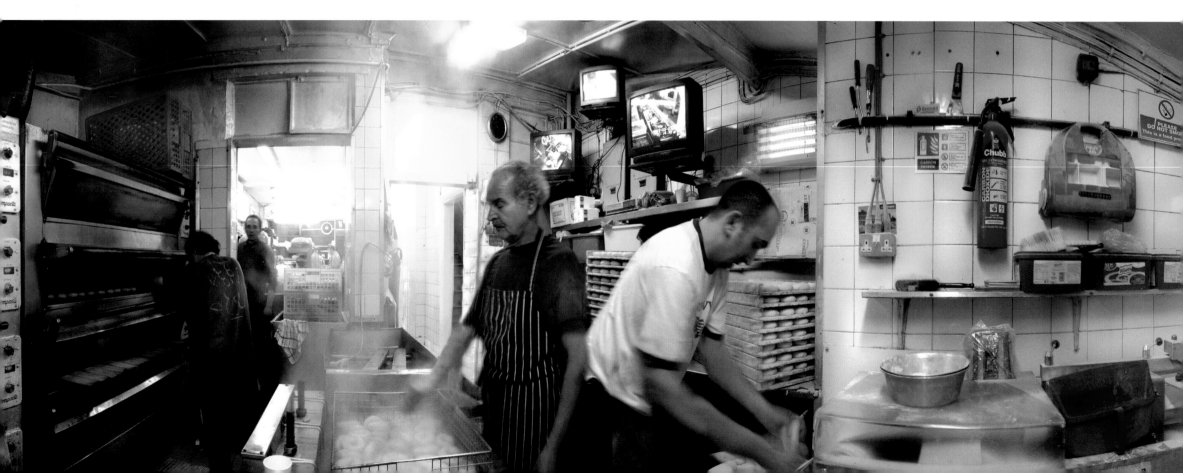

BRICK LANE BAKERY EAST END

OPEN 24 HOURS A DAY, this family business has been making 600 bagels per day since 1963, to an original recipe from Poland. An East End institution, it caters for everybody from city office workers to late night clubbers. To make eight bagels, you need: 3¾ cups strong plain flour, 1 cup warm milk, ¼ ounce easy blend yeast, 1 teaspoon of salt and 2 tablespoons of superfine sugar.

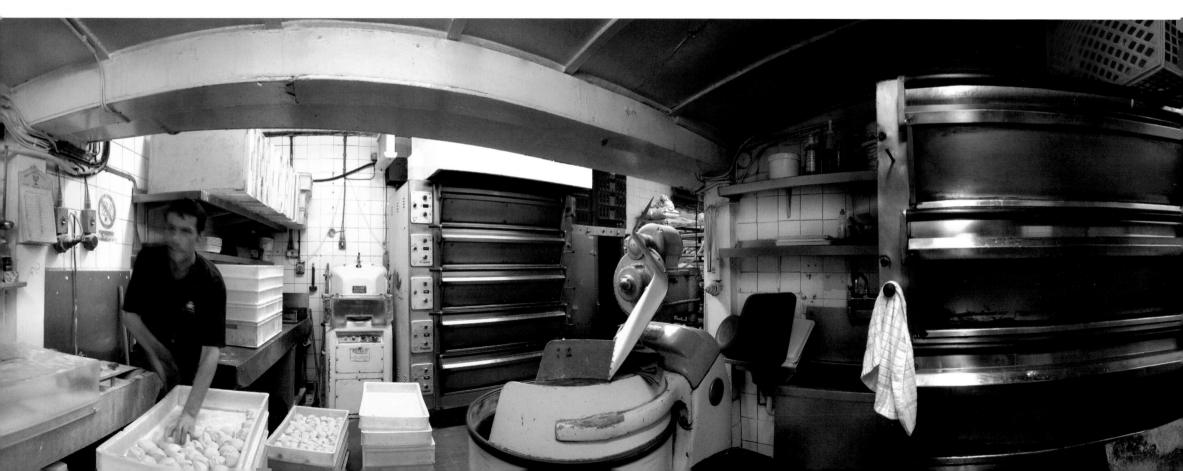

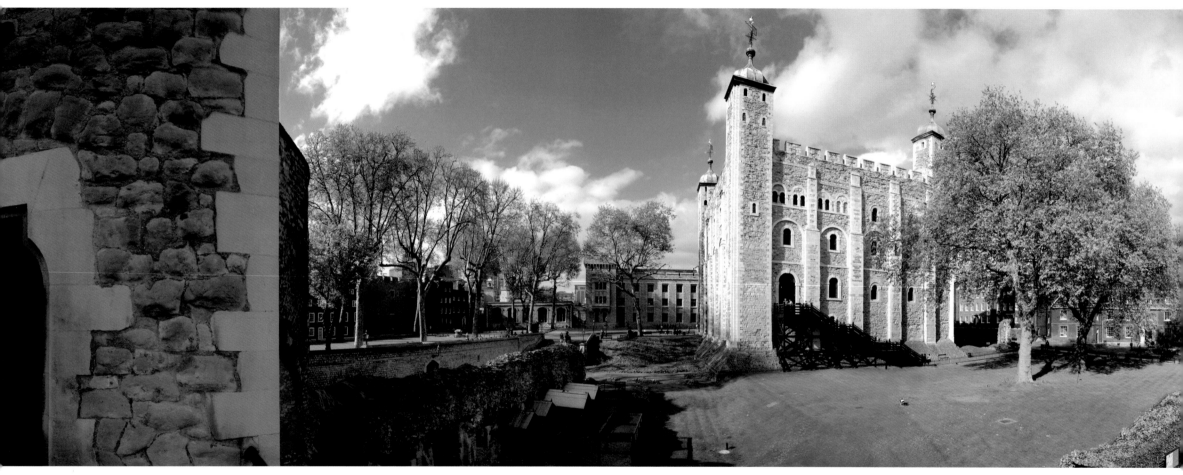

THE MOST PERFECT MEDIEVAL FORTRESS in Britain, the Tower was begun by William I in 1066. It has been the seat of British government, the home of kings and queens and a fearful prison. The Tower has housed leopards, lions and the famous ravens, as well as a polar bear—a gift from the King of Norway in 1252. The bear used to fish in the Thames while tethered by a chain.

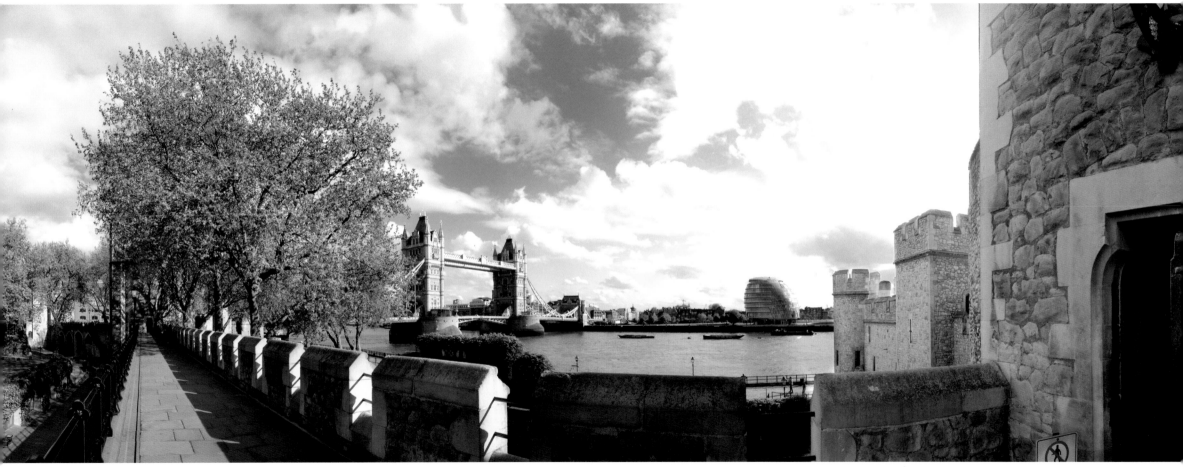

TOWER OF LONDON **POOL OF LONDON**

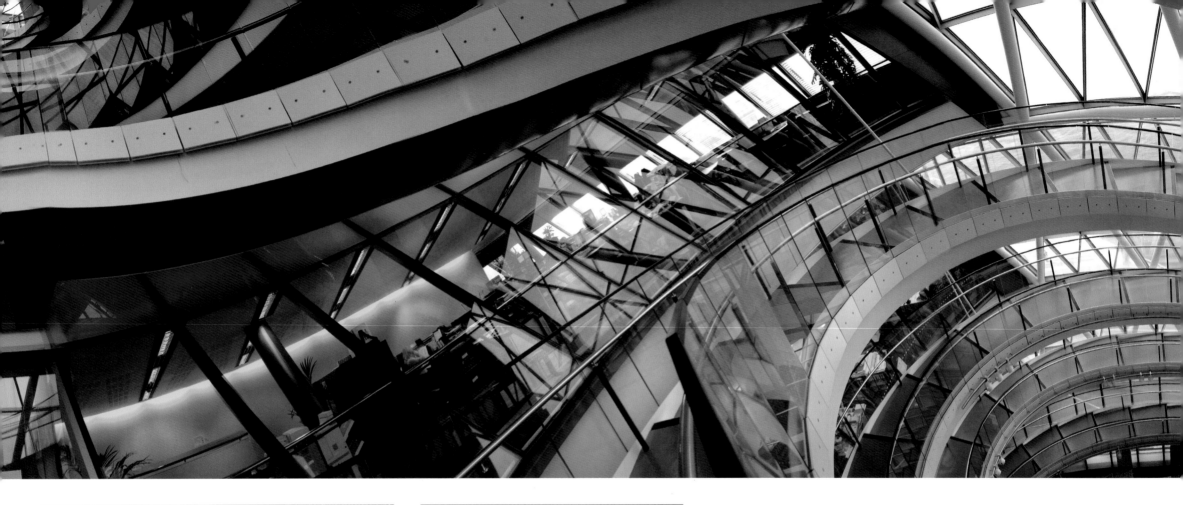

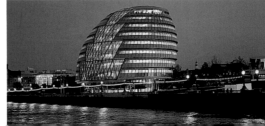

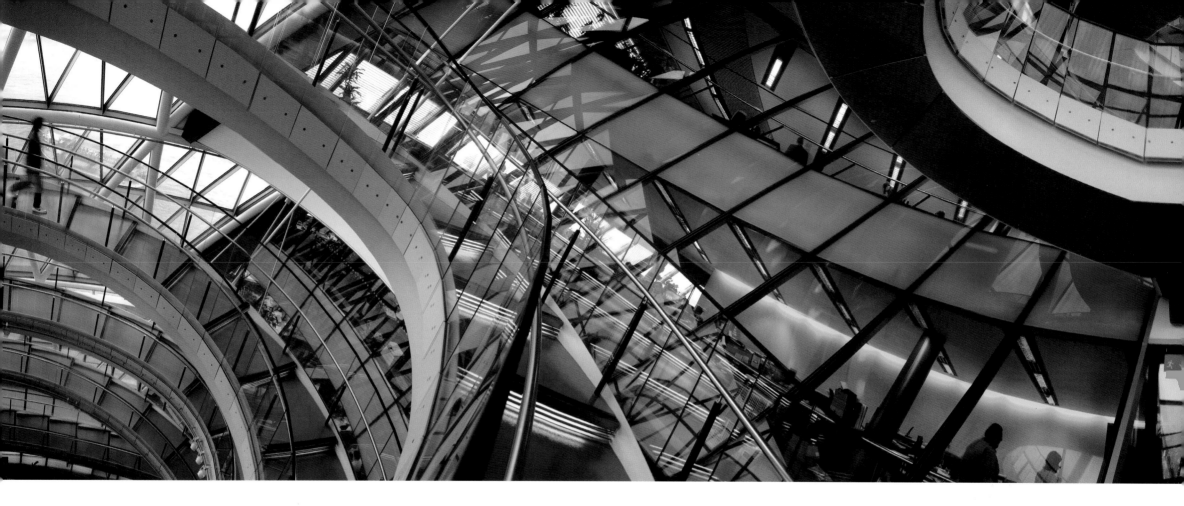

GREATER LONDON AUTHORITY POOL OF LONDON

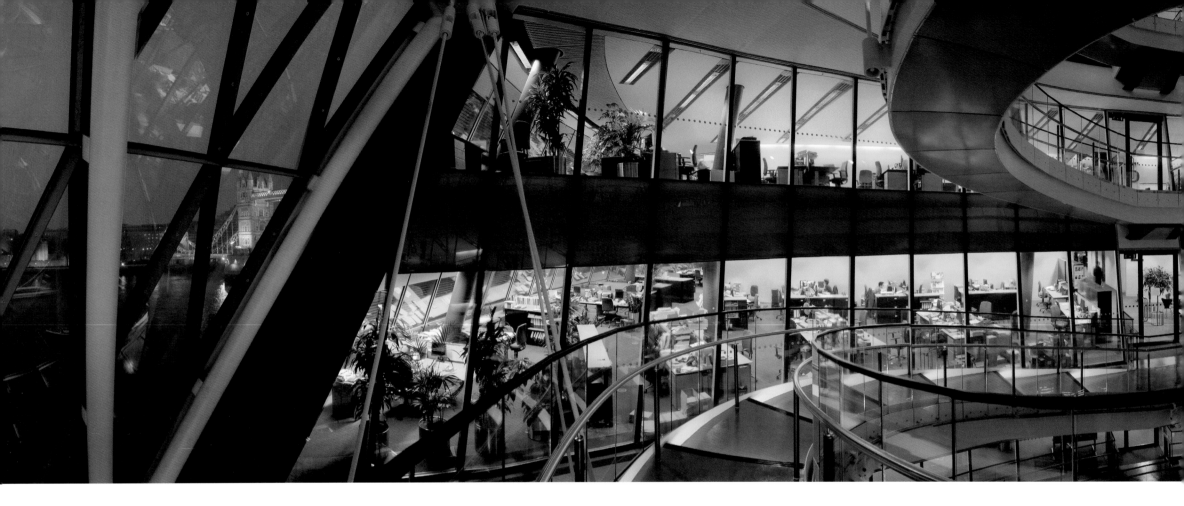

DESIGNED BY FOSTER AND PARTNERS, this striking concrete and glass structure, housing the locally-elected Greater London Authority, resembles an eyeball. The building leans back towards the south, where floor plates are stepped inwards from top to bottom, providing shading from the most intense direct sunlight. Water, extracted through two bore holes from the water table beneath London, is used to cool the building and for flushing the toilets.

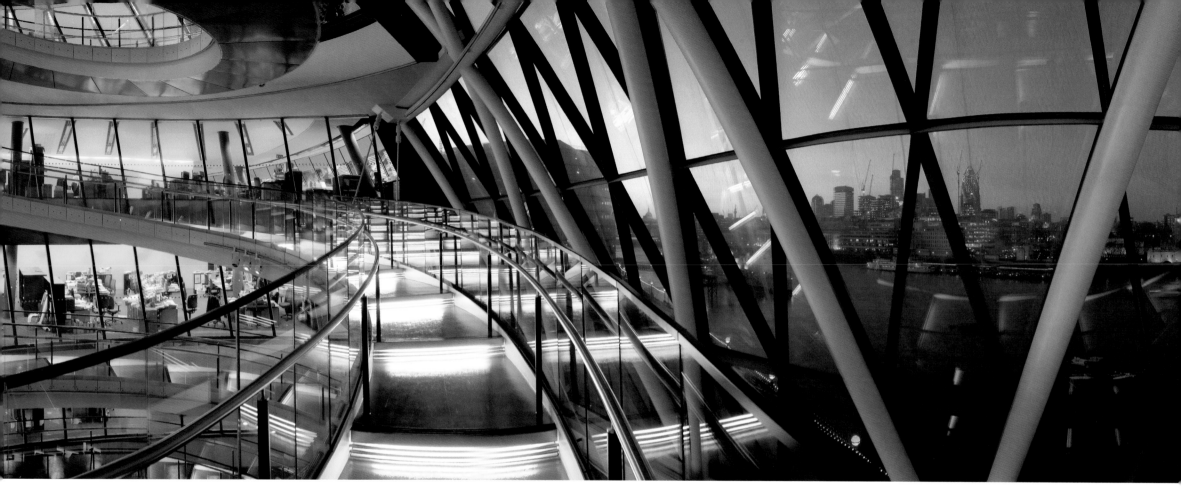

OPENED BY HM QUEEN ELIZABETH ON JULY 15, 2002

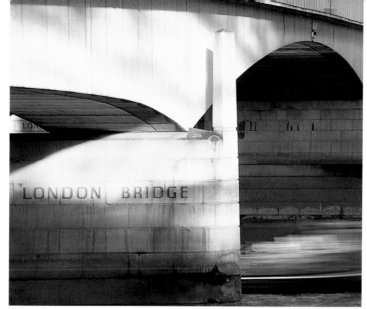

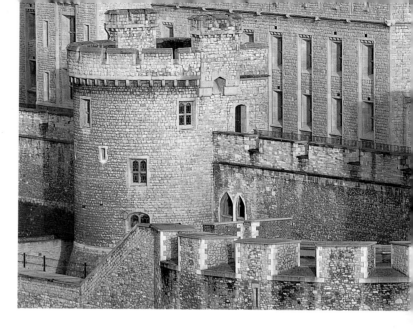

POOL OF LONDON An extraordinary array of textures and architectural styles marks the historic Pool of London, the reach of the River Thames crossed or bordered by London Bridge, Custom House, St Katharine's Dock and the Tower of London. It was here that the Romans founded Londinium around 33AD, seeing the obvious trade potential of the huge river.

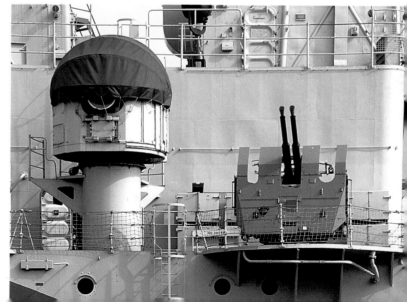

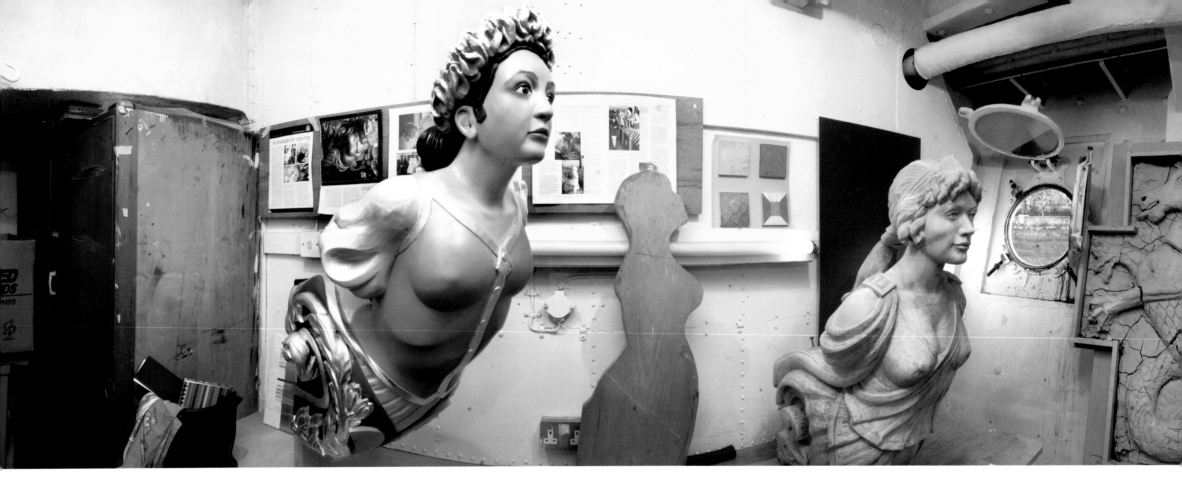

ABIGAIL WRIGHT is the artist in residence on HMS *Belfast*, the former Royal Navy flagship now permanently moored in the Pool of London. She carves figureheads for shipping companies and private clients, and represents artists in the workspaces of London. HMS *Belfast* saw service in World War II and Korea before being opened to the public in 1971.

HMS BELFAST WAS LAUNCHED IN 1938

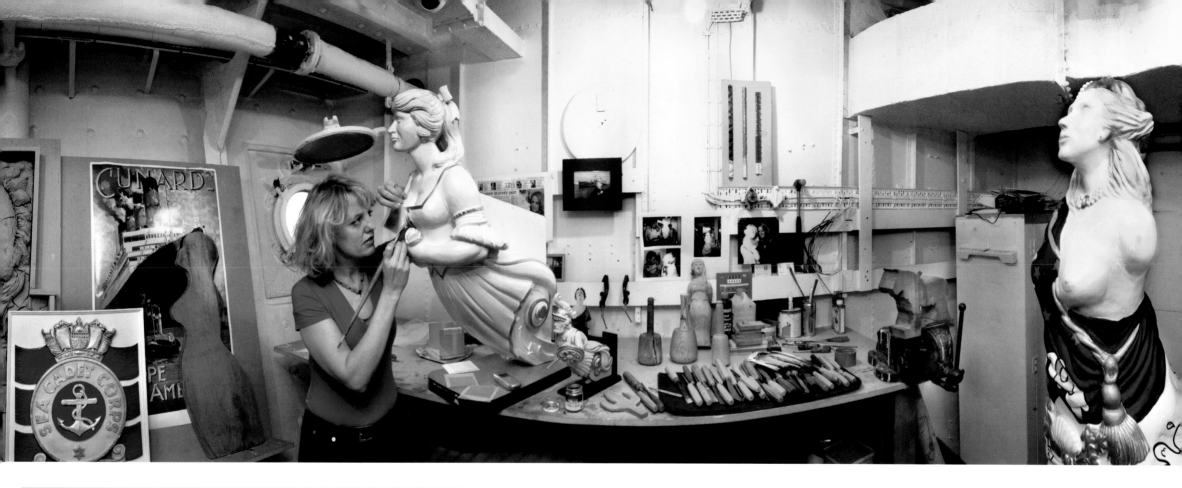

HMS BELFAST
POOL OF LONDON

DESIGNED BY SIR RICHARD ROGERS and built between 1979 and 1984, the headquarters of this unique insurance market is a fantastical, sci-fi construction. The working mechanics of the building—elevators, heating ducts, stairs, air conditioning —are on the outside of the structure, to free up interior floor space for the underwriters, who work on four floors covering a total of 113,990 square feet.

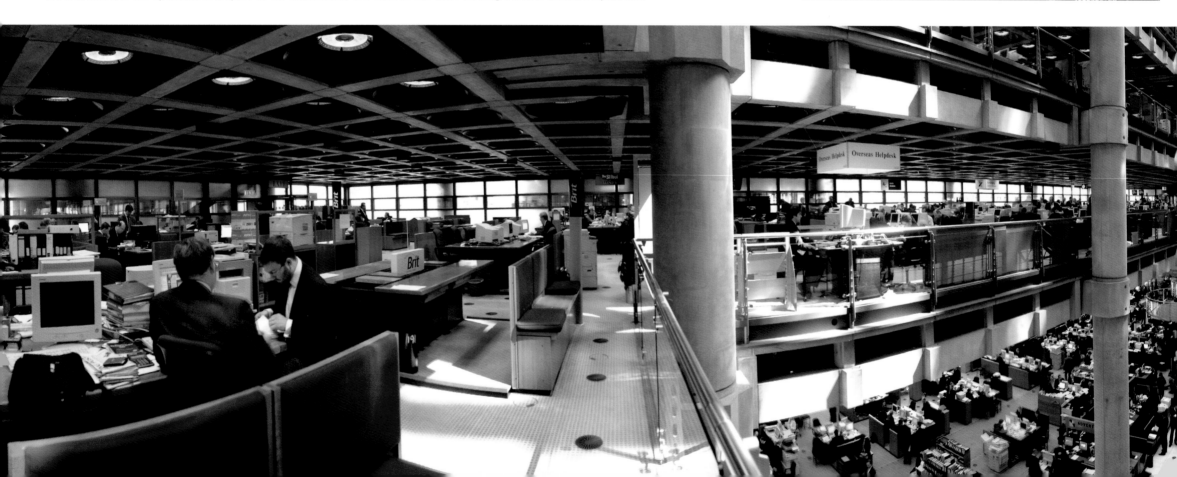

LLOYDS BUILDING

CITY OF LONDON

LLOYDS NO LONGER RINGS A BELL FOR EVERY LOSS AT SEA

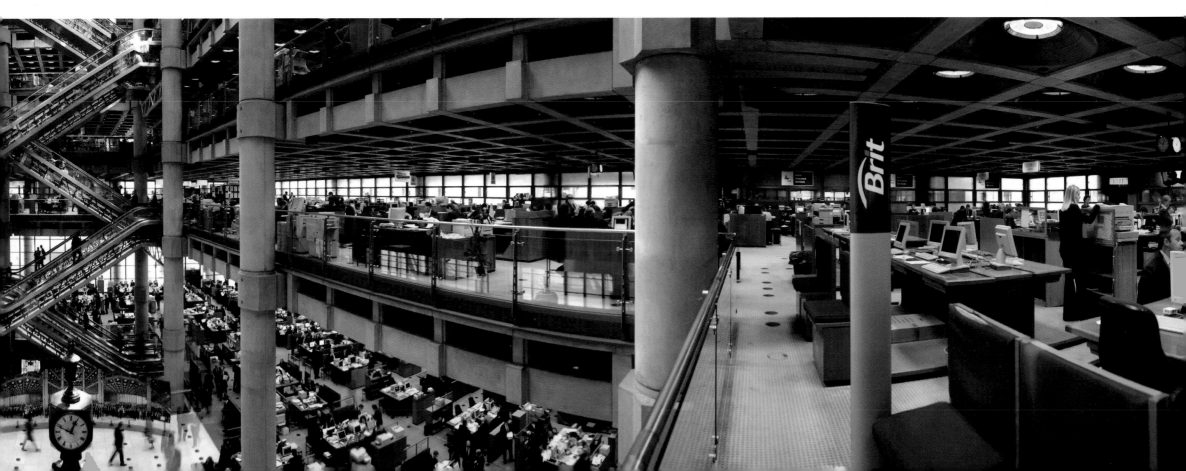

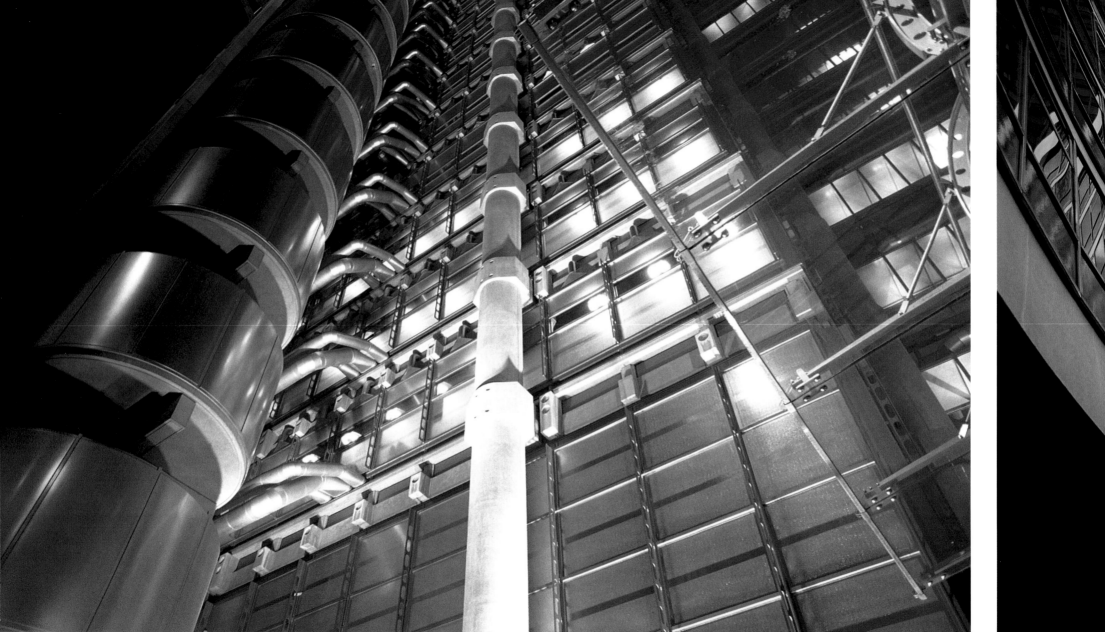

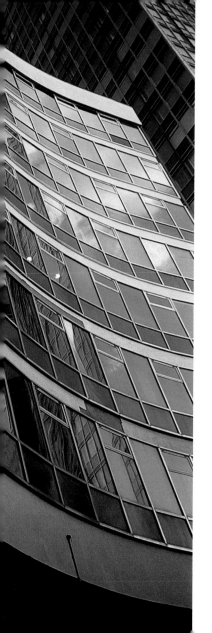

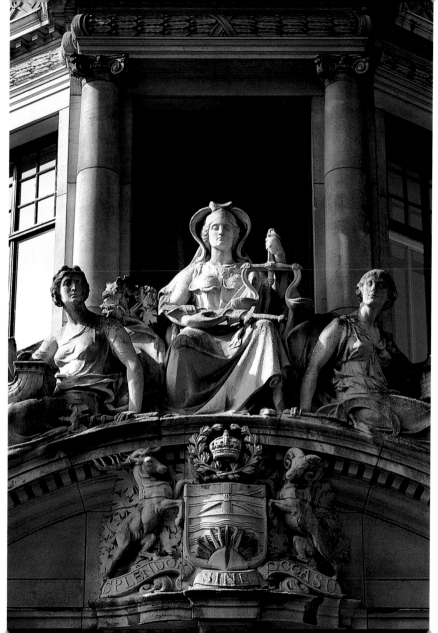

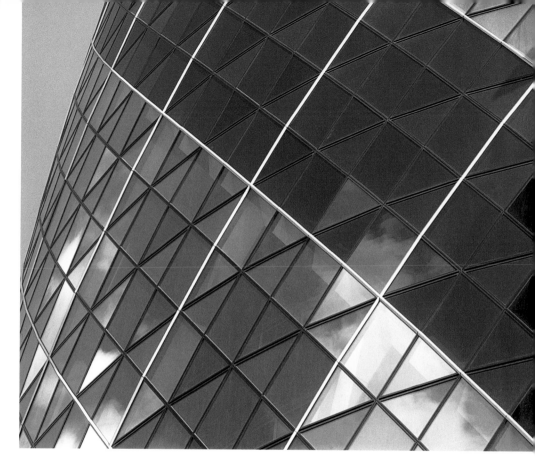

THE LLOYDS BUILDING comprises twelve 52-foot-wide concentric galleries above a central atrium, the main structure supported by six towers. Workers sit in large open plan offices with acres of glass allowing superb views across the city, and internally to fellow workers.

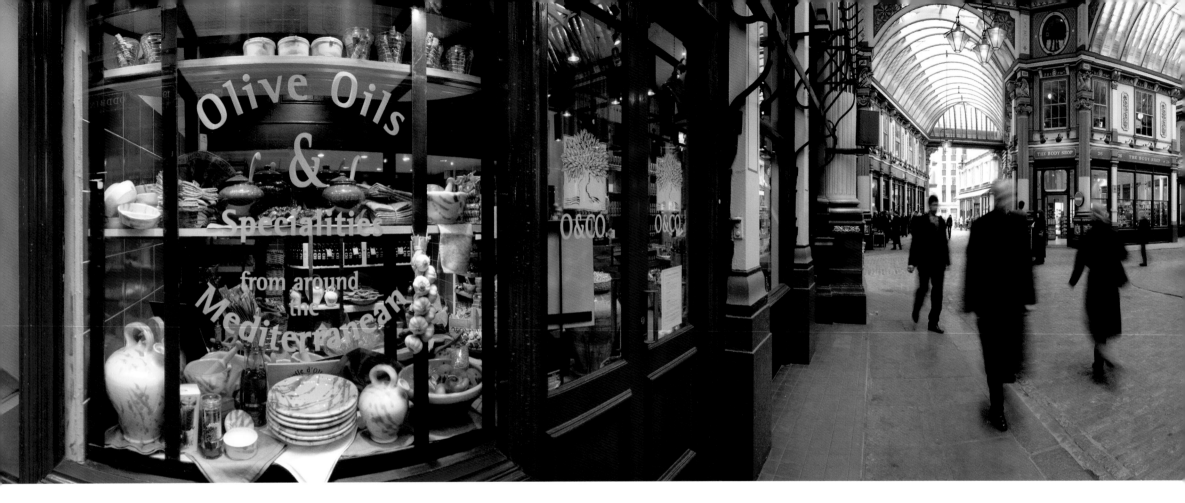

ESTABLISHED IN THE FOURTEENTH CENTURY around a manor house with a lead roof, the Leadenhall was London's best meat, game, fish and poultry market until it was destroyed in the Great Fire of London in 1666. Now it provides an oasis of calm for City workers escaping their desks at lunchtime. It's a far cry from the busy days of the eighteenth century, when a gander named Old Tom escaped slaughter at the poultry market and became a local celebrity. He died, aged 38, in 1835 and was buried in the market.

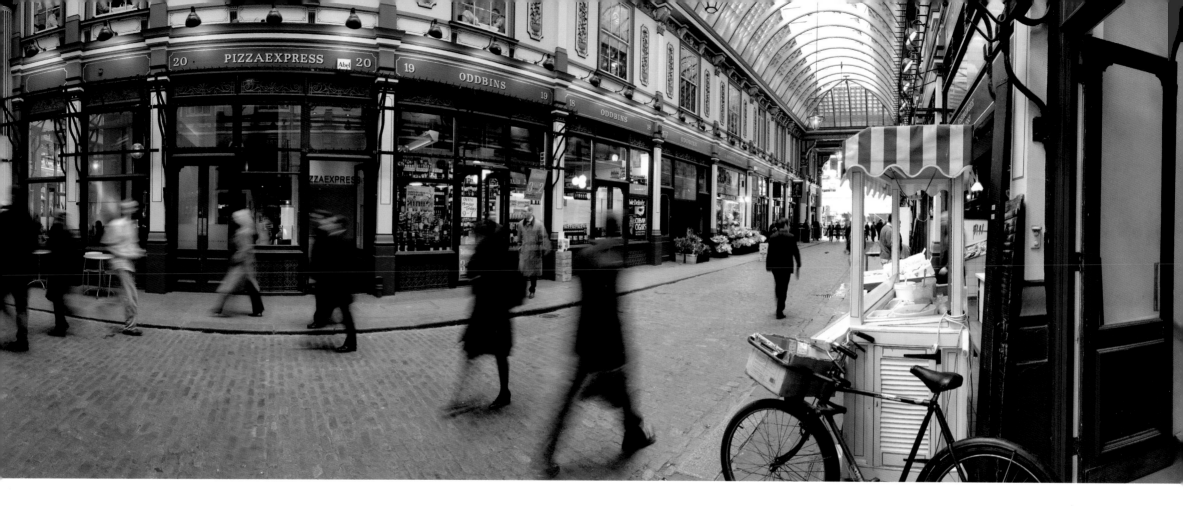

LEADENHALL

CITY OF LONDON

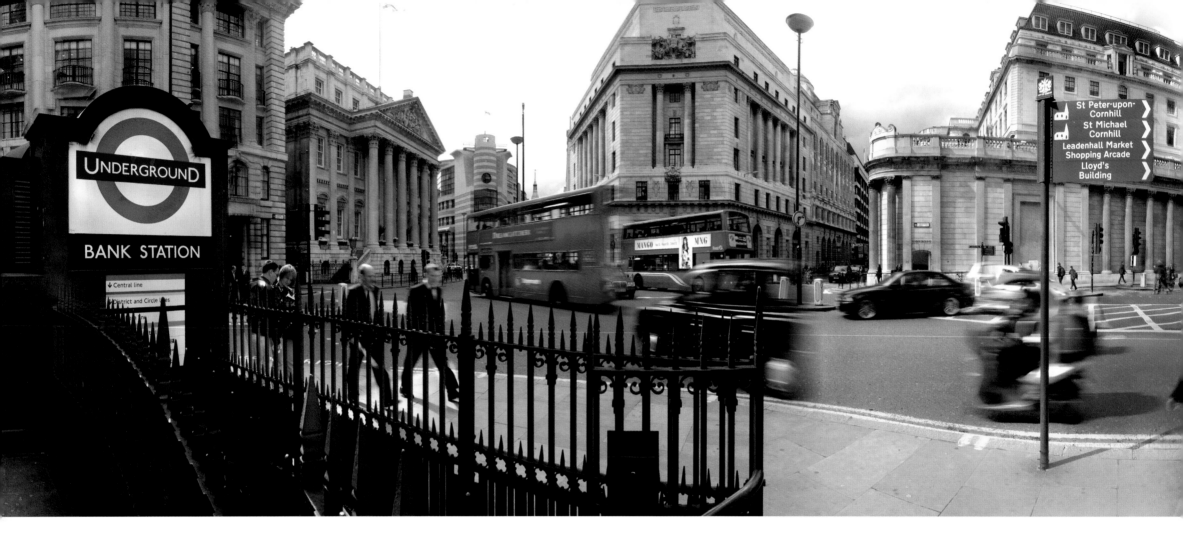

THE BANK OF ENGLAND WAS SET UP IN 1694 TO FINANCE THE WAR AGAINST FRANCE

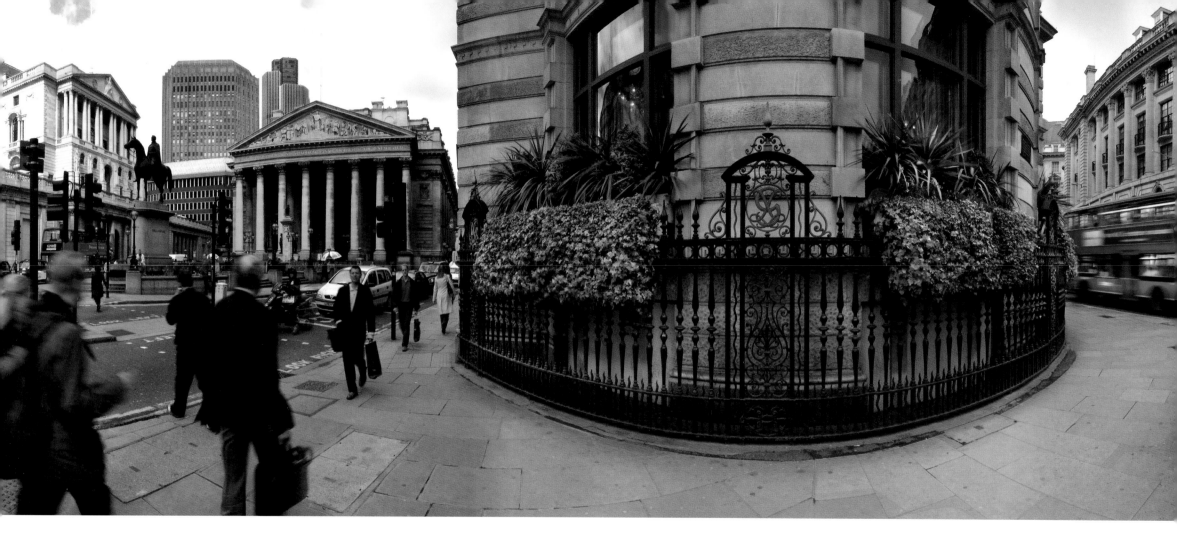

BANK OF ENGLAND

THREADNEEDLE STREET

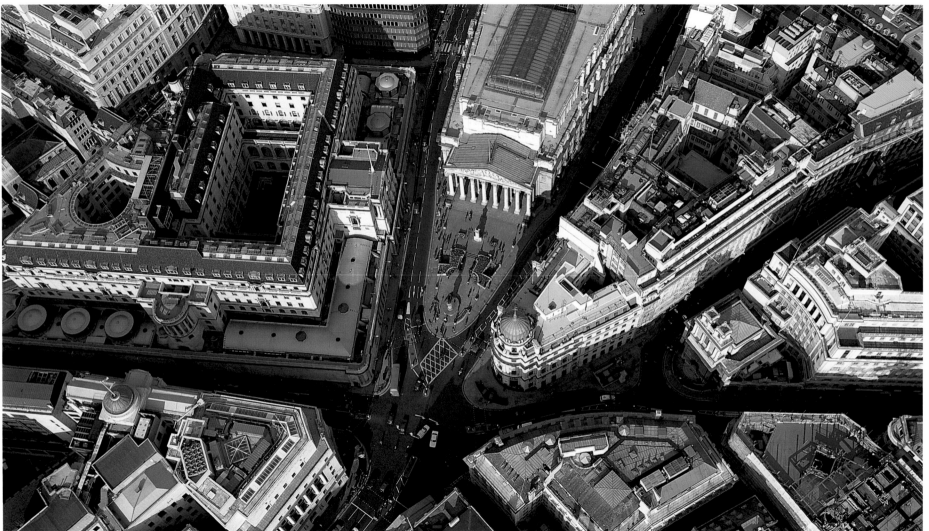

BANK OF ENGLAND

Founded in Cheapside in 1694, the Bank of England moved to its current base in Threadneedle Street, at the hub of the City, in 1734. The 3-acre site includes three floors of subterranean vaults where an unspecified fortune in gold bullion is stored. Britannia, the seal of the bank, has appeared on every bank note issued for over 300 years.

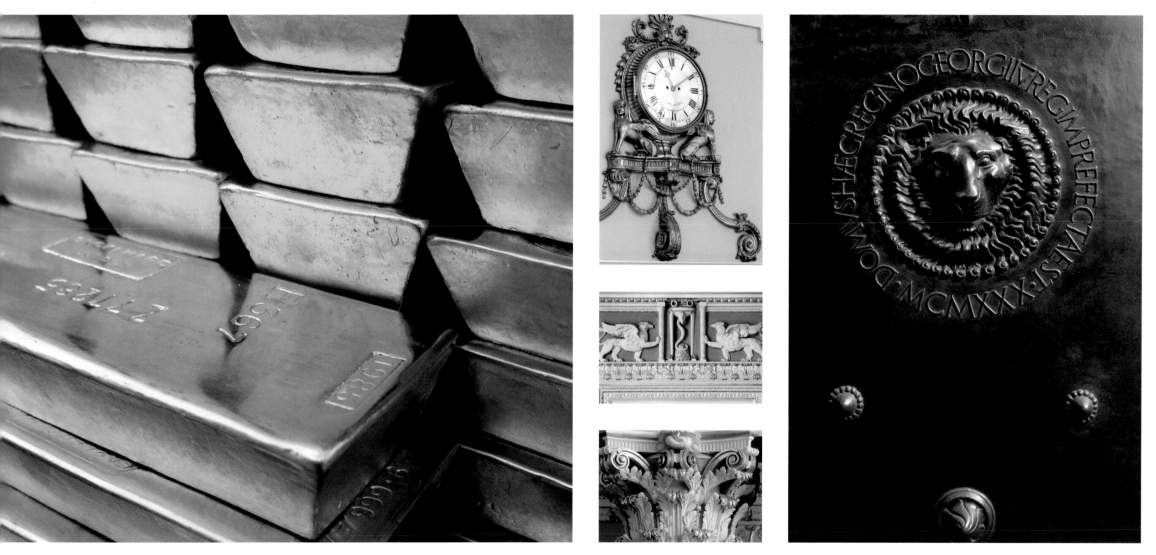

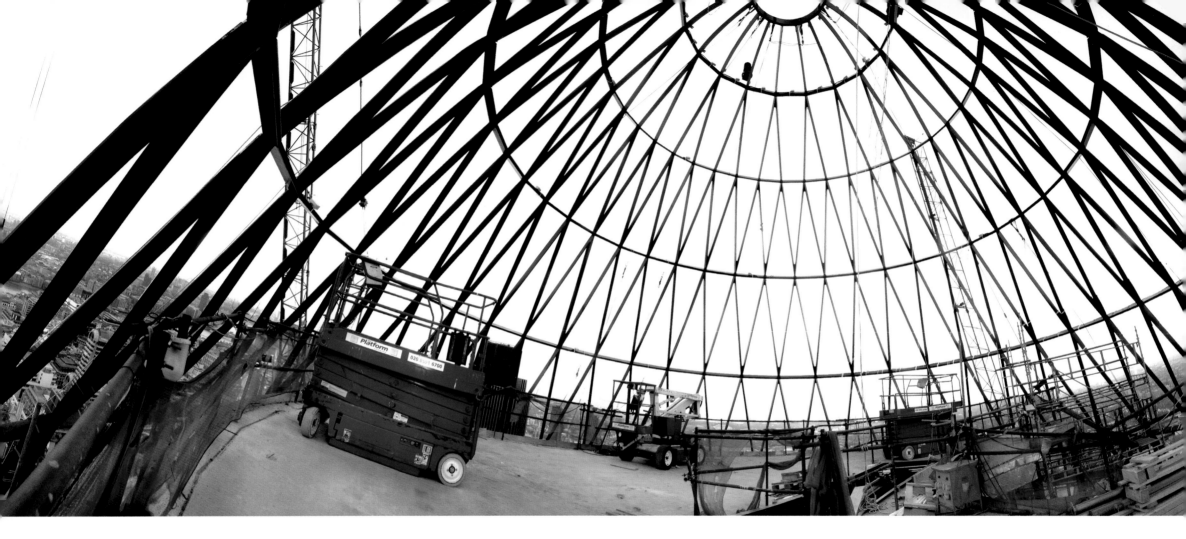

CONSTANT CONSTRUCTION WORK means the face of the City of London is ever-changing. Here, fearless builders, many of them former professional climbers, prepare to fit glass to the final story of the Foster and Partners-designed Swiss Reinsurance building. Its idiosyncratic shape has led Londoners to nickname the building "The Gherkin" (pickle). The building houses six-story-high "sky gardens" containing plants and trees.

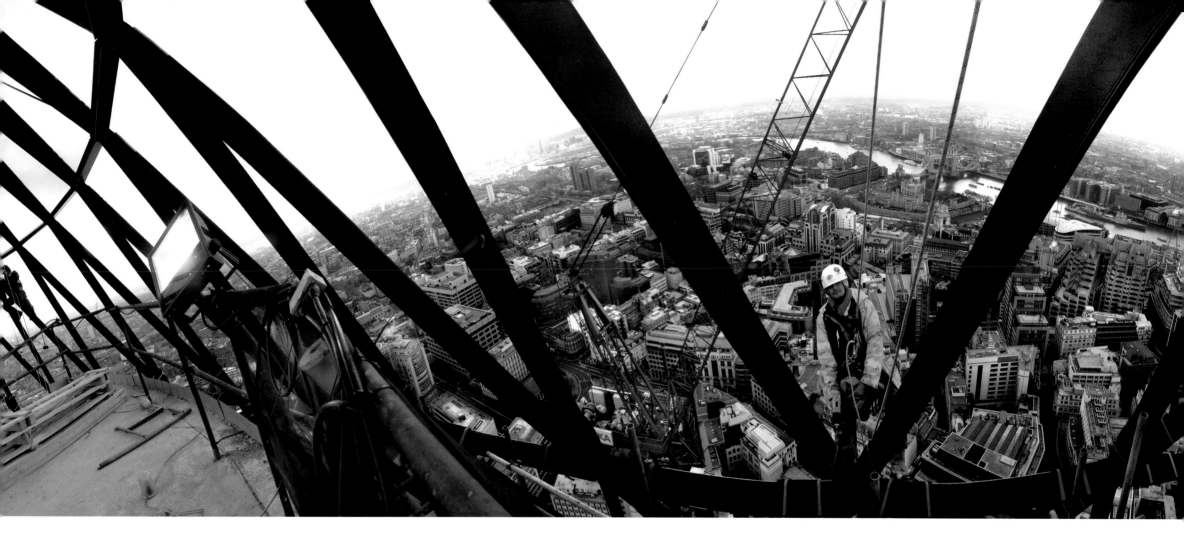

SWISS RE BUILDING CITY OF LONDON

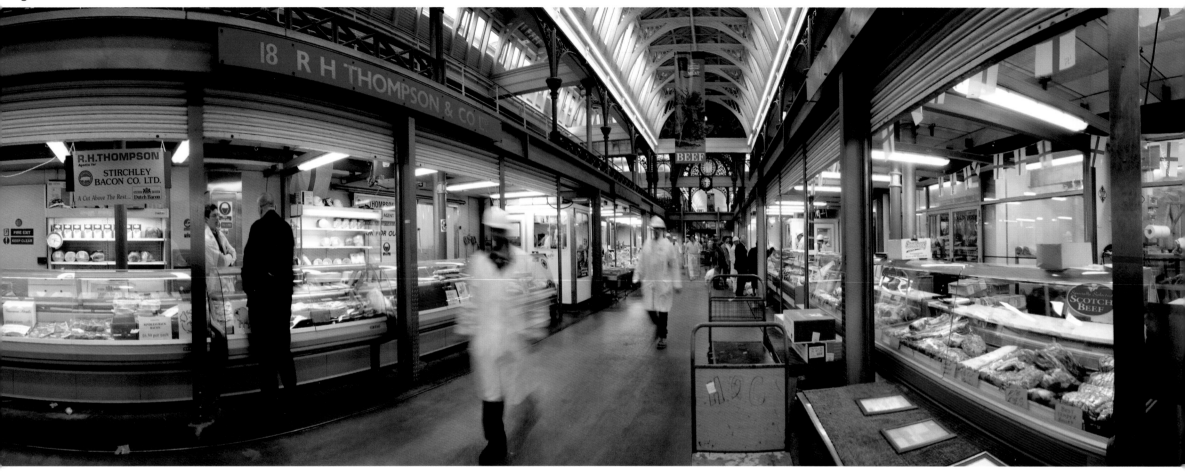

ALTHOUGH THREATENED BY PROGRESS and increased property prices, Smithfield has been London's premier meat market for 800 years, and approximately 150,000 tons of produce are traded in the market each year. A livestock market occupied the site as early as the tenth century; in 1173, William FitzStephen, a clerk to Thomas à Becket, described it as "a smoth field where every Friday there is a celebrated rendezvous of fine horses to be sold."

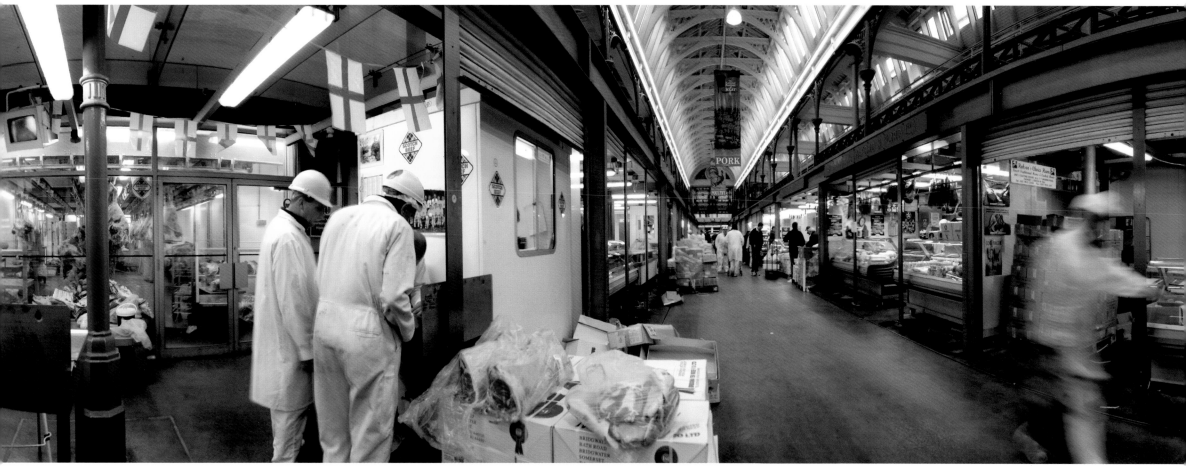

SMITHFIELD MARKET

HOLBORN

CHICKEN
WINGS
$3-00
A BAG.

LIFFEY

LAMB

LAMB

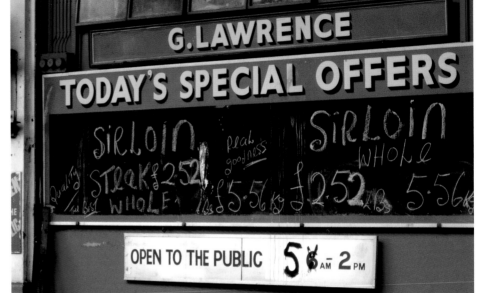

G.LAWRENCE
TODAY'S SPECIAL OFFERS

SIRLOIN
STEAK £2.52
WHOLE £5.56 kg

real
goodness

SIRLOIN
WHOLE
£2.52 LBS 5.56 kg

OPEN TO THE PUBLIC 5 AM - 2 PM

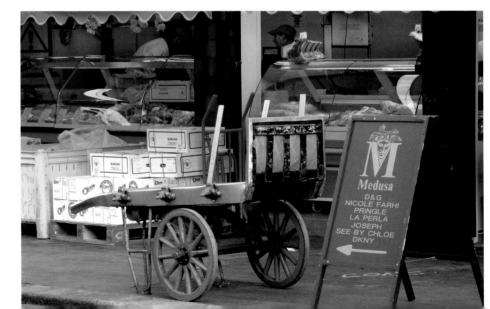

Medusa
D&G
NICOLE FARHI
PRINGLE
LA PERLA
JOSEPH
SEE BY CHLOE
DKNY

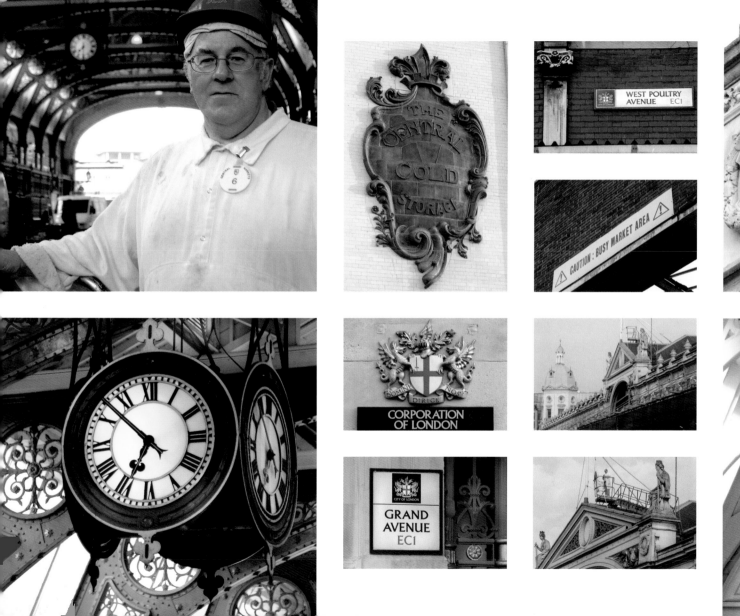

A 1,066-FOOT STEEL BRIDGE linking the City of London at St Paul's Cathedral with the Tate Modern art gallery at Bankside, the Millennium Bridge is the first new pedestrian-only crossing over the Thames in more than a century. Designed by Foster and Partners and sculptor Sir Anthony Caro, the 13-foot-wide aluminum walkway is supported by cables which dip below the deck halfway across, allowing fantastic views of London.

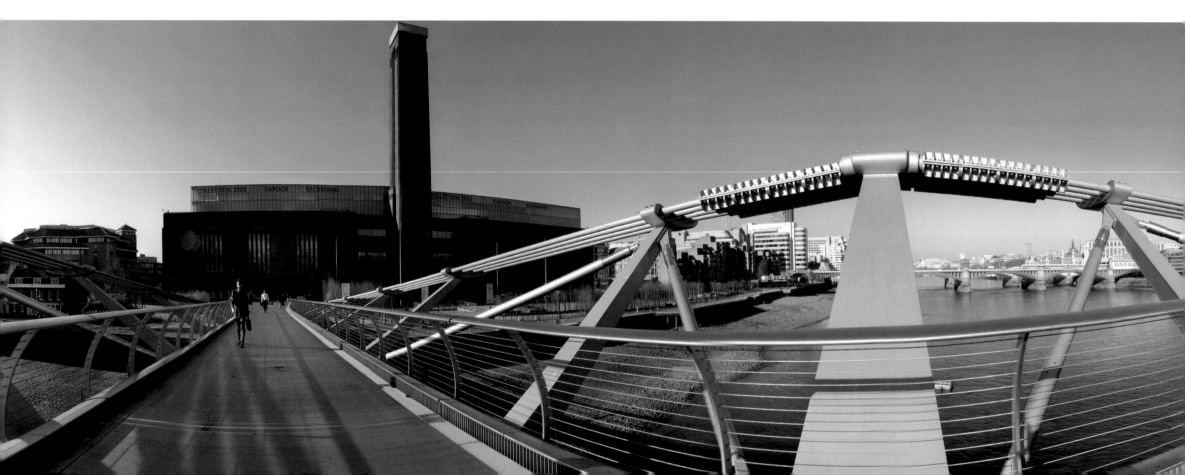

MILLENNIUM BRIDGE

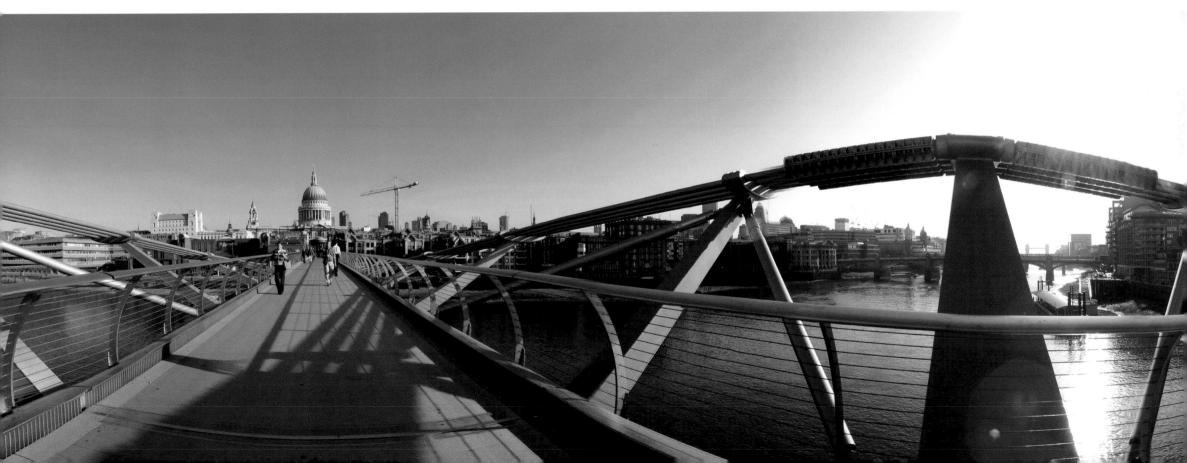

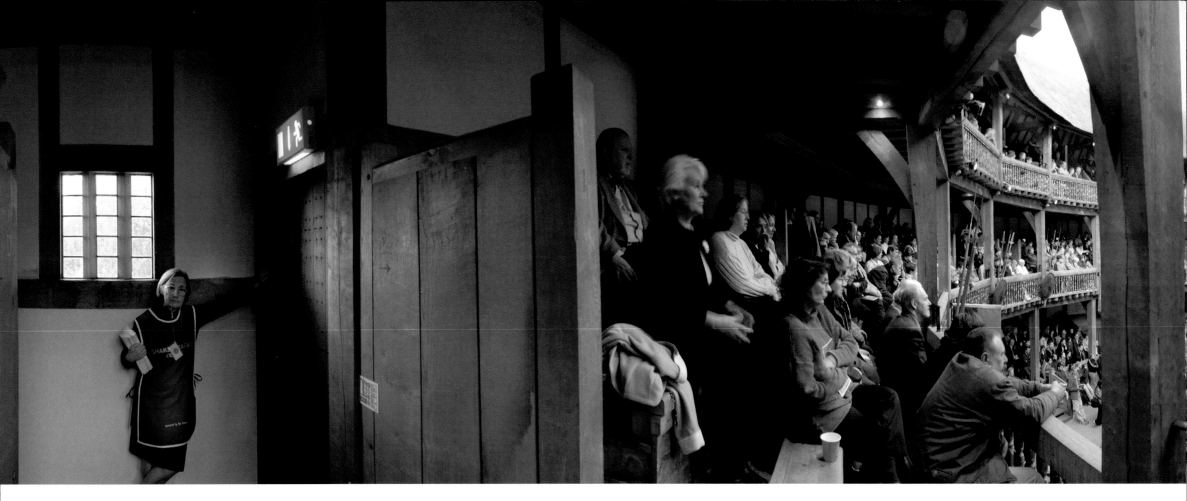

BUILT IN 1598–99 by Cuthbert and Richard Burbage, the original Globe Theater numbered Shakespeare among its shareholders. After burning down in 1613, when a cannon fired during the performance of *Henry VIII* set the thatch alight, the theater was rebuilt, only to be closed by the Puritans in 1642. The Globe was reconstructed and reopened to its original thatched, in-the-round design in 1993, thanks to the efforts of American actor Sam Wanamaker. Performers form a unique connection with the audience and, against their natural English reserve, groundlings standing near the stage are allowed to heckle.

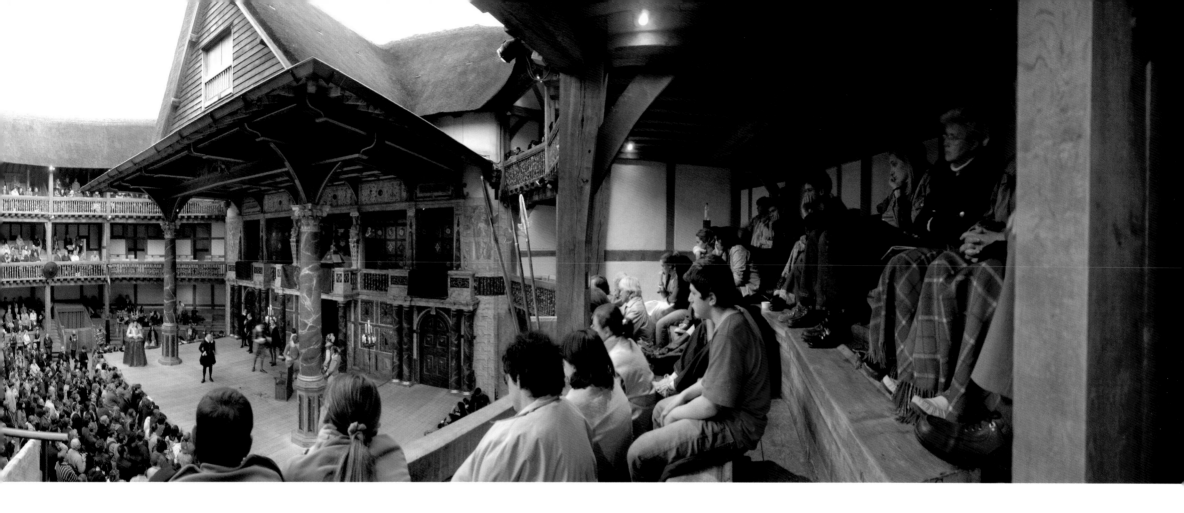

THE GLOBE THEATER BANKSIDE

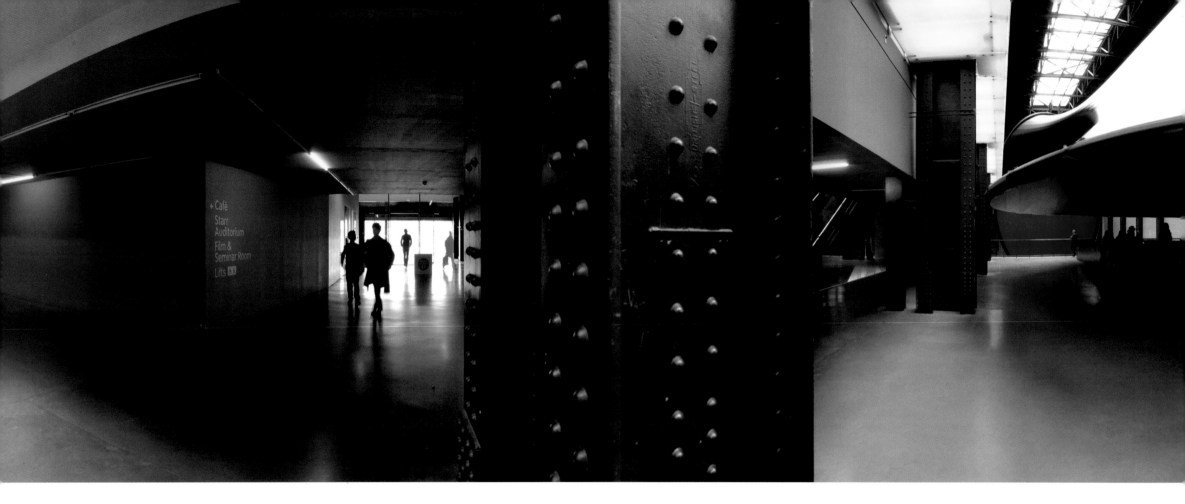

ORIGINALLY THE BANKSIDE POWER STATION, an architectural creation of Sir Giles Gilbert Scott, who also designed Battersea Power Station and the classic British red telephone box, this brick building was transformed into the Tate Modern art gallery at the end of the second millennium. From October 2002 to April 2003, its main Turbine Hall was occupied by Marsyas, an enormous sculpture by Bombay-born artist Anish Kapoor. More than 492 feet long and 98 feet high, it consisted of a red PVC membrane stretched across three steel rings into the shape of a giant trumpet.

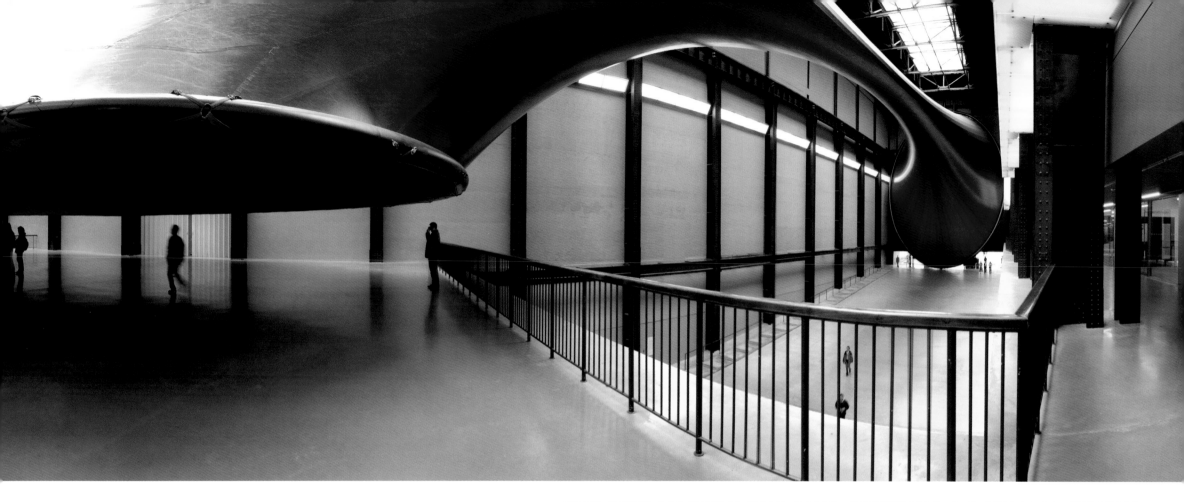

THE TATE MODERN BUILDING CONTAINS 4.2 MILLION BRICKS

TATE MODERN BANKSIDE

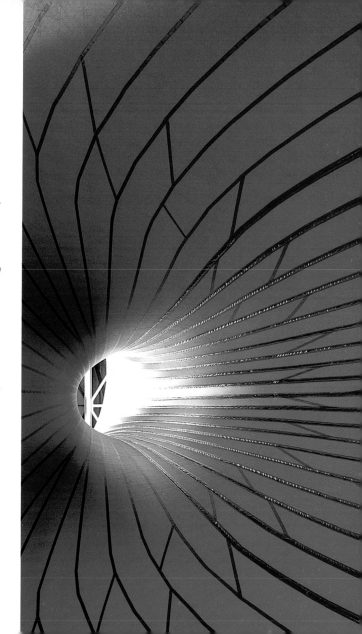

Marsyas is in the form of a continuous membrane, where space, color and form are not separate. This work explores the problem when color becomes space, when space becomes form, and form becomes color. When one is confronted by the reality, it is confounding. — **Anish Kapoor**

A GOOD THING IS SOON SNATCHED UP

HASTE IS SLOW.

WISDOM IS RARE

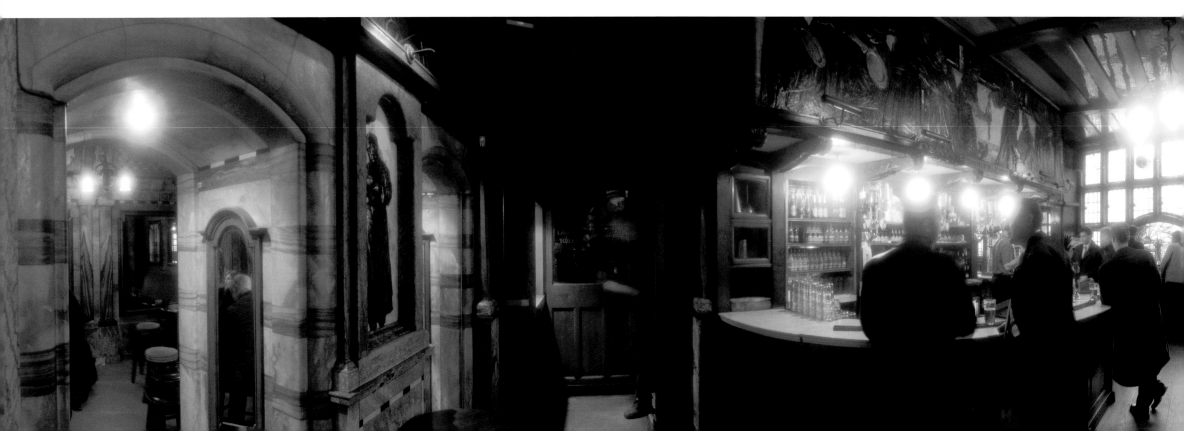

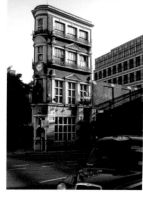

THE BLACK FRIAR PUB BLACKFRIARS

STANDING ON THE NORTH SIDE of Blackfriars Bridge, on the site of a former monastery, the glorious Black Friar is the only art nouveau pub in central London. It dates from 1875, and its ornate interior is decorated with jolly fat friars and pensive monks, molded in marble and bronze, as well as quirky mottos and slogans. Some drinkers claim the Black Friar is haunted.

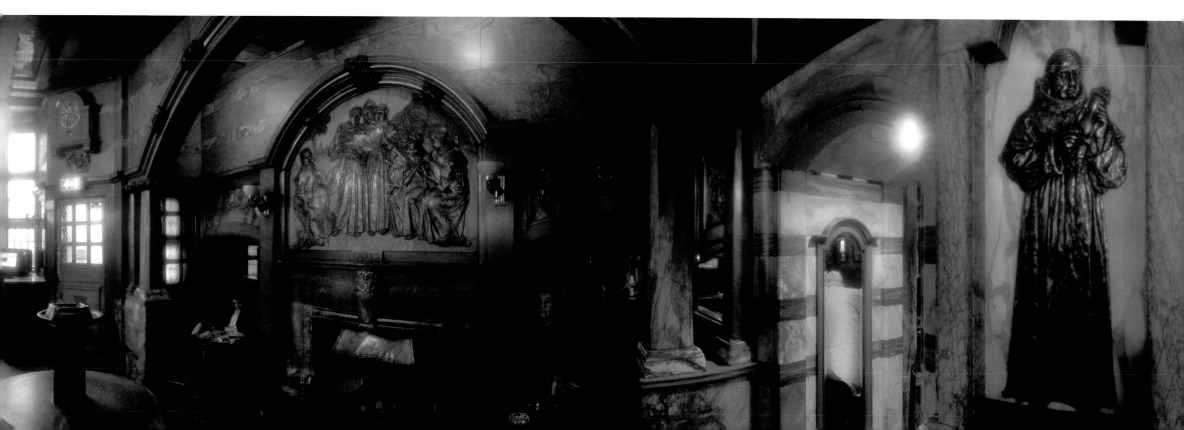

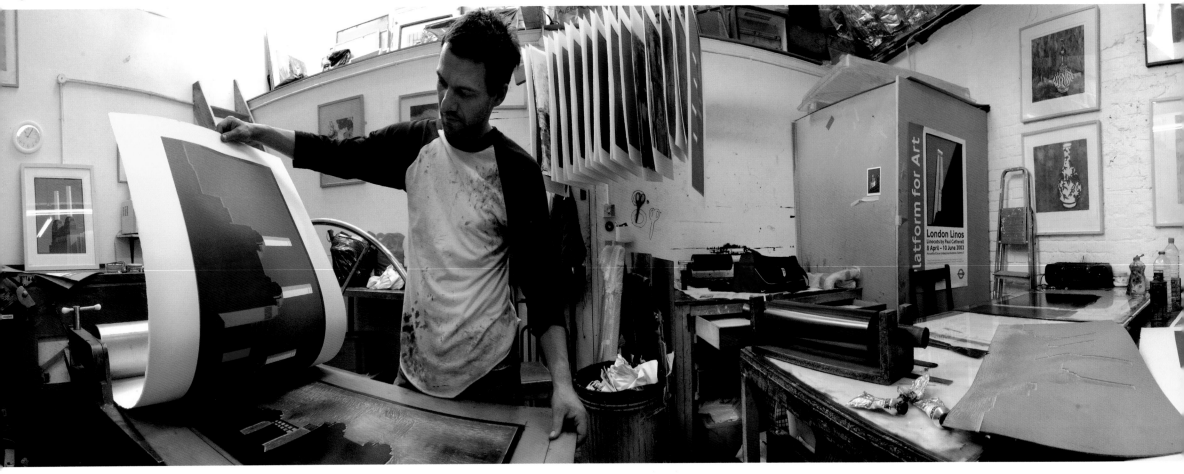

AT HIS SOUTH LONDON STUDIO, Paul Catherall specializes in distinctive lino prints of the city's landmarks and architectural icons. Using a clean, sharp palette inspired by commercial art of the 1950s and 1960s, he has turned monuments such as Tate Modern, Battersea Power Station and the London Eye into affordable art.

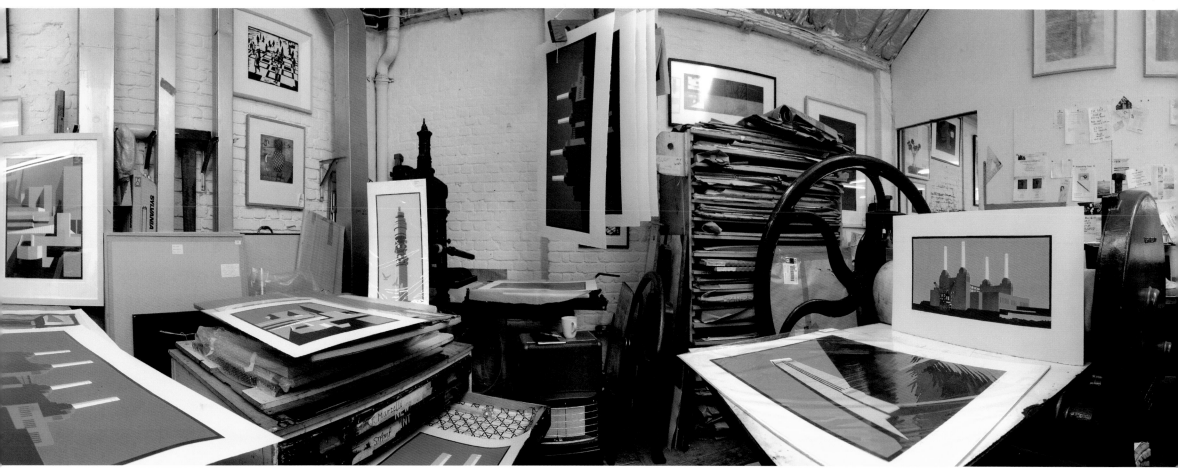

ARTIST'S STUDIO CLAPHAM

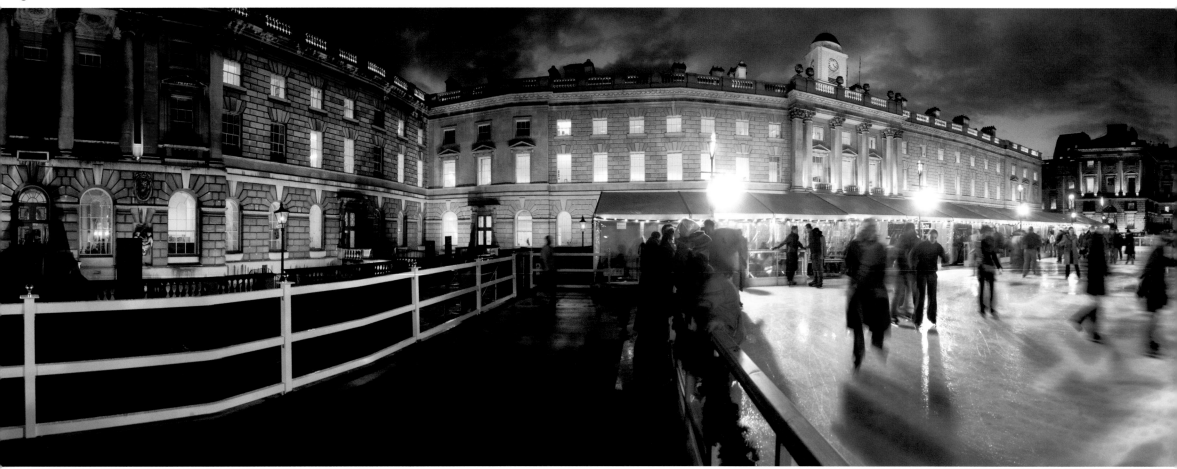

ORIGINALLY THE FIRST RENAISSANCE PALACE in England, today's building stands on the site of an earlier Tudor Palace that was demolished in 1775. Until 1973 it was home to the General Register of Births, Deaths and Marriages; now it houses the Courtauld Institute art galleries. Every Christmas the central courtyard, which looks more like St Mark's Square, Venice than London, is transformed into a public skating rink.

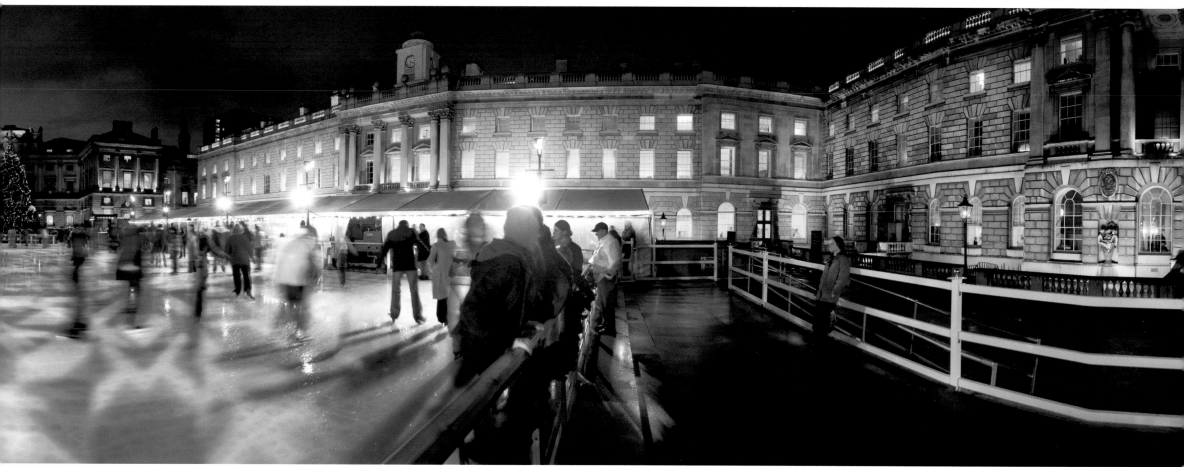

SOMERSET HOUSE THE STRAND

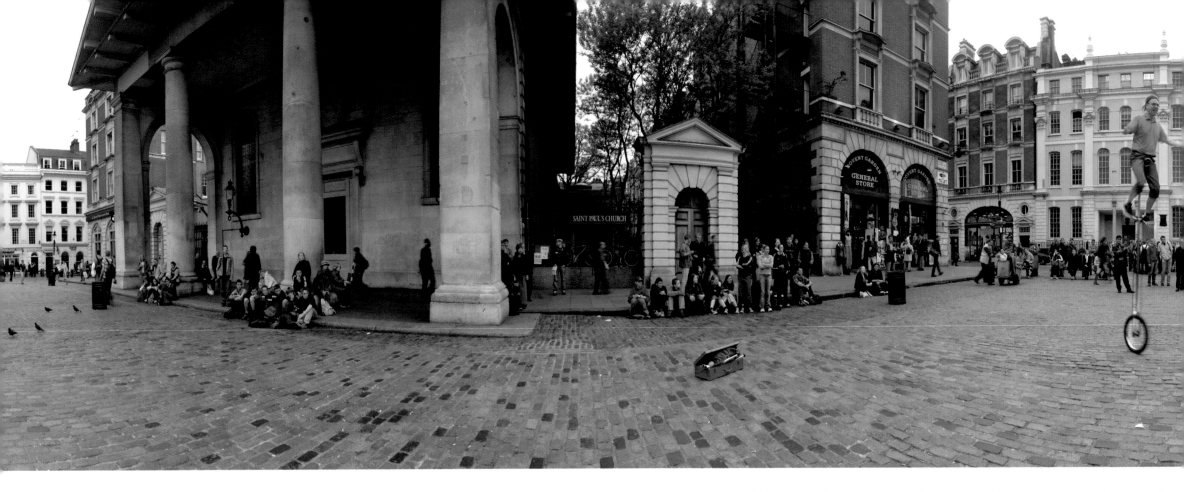

ORIGINALLY a seventeenth-century flower and fruit market, and then dominated by brothels in the eighteenth century, Covent Garden has evolved into an unashamed tourist trap of souvenir stores, expensive eateries and strictly-timetabled street entertainers.

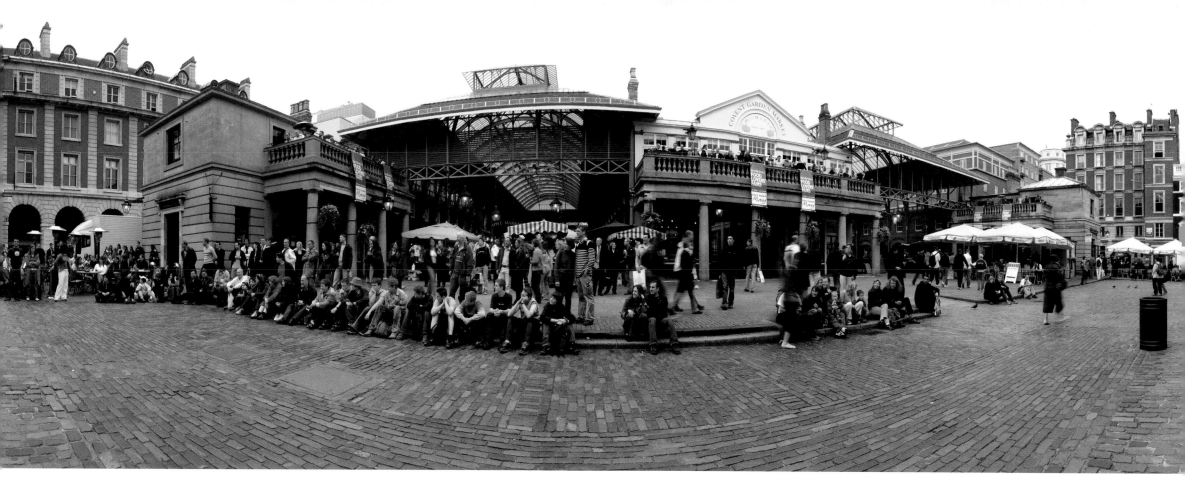

COVENT GARDEN WEST END

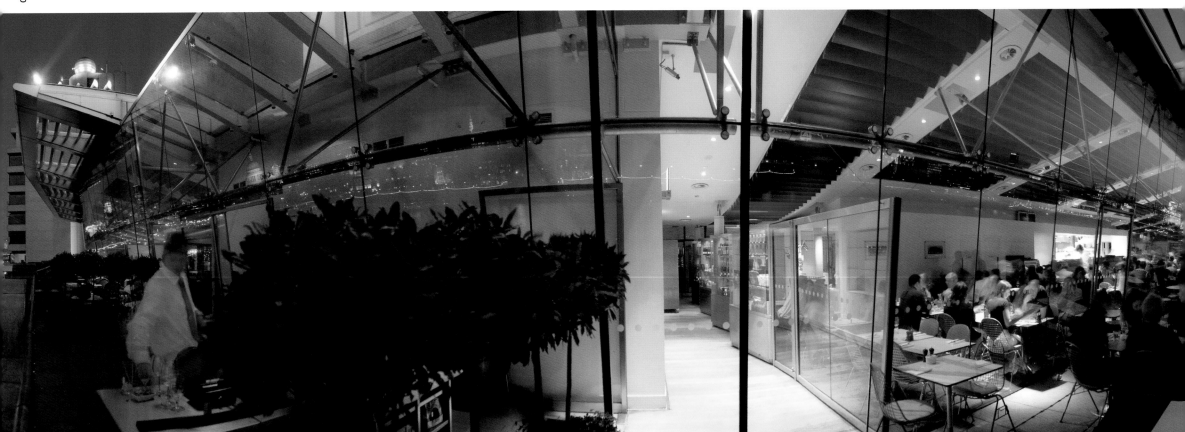

BUILT IN THE LATE 1920s by the Liebig Extract of Meat Company, the Oxo Tower was originally to carry the name of their meat stock product, Oxo, in neon lights. This was forbidden, as riverside advertising was not permitted, so the architect, Albert W Moore, arranged windows to spell out the word on all four sides of the tower. Diners eating outside at the exclusive top-floor restaurant arguably enjoy the best view in all of London.

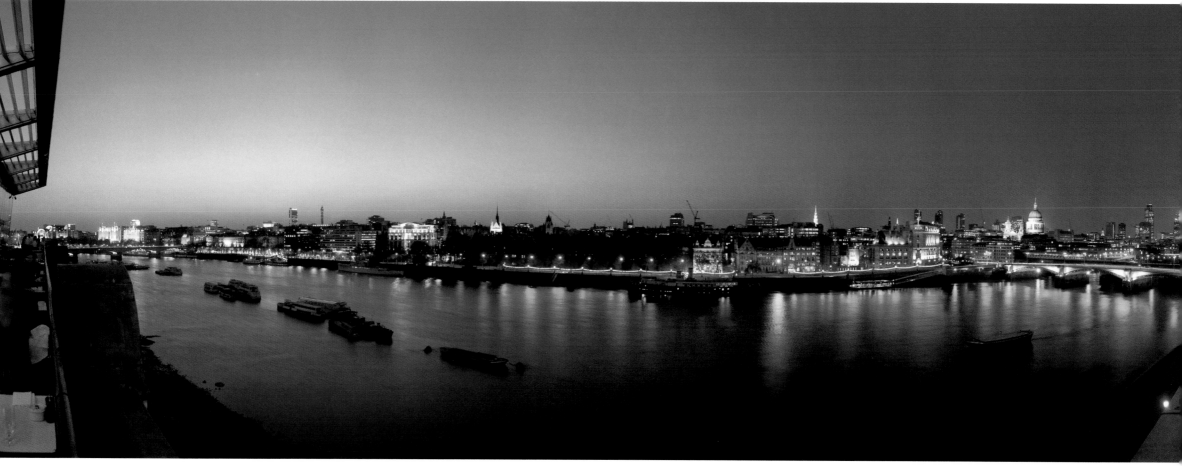

OXO TOWER SOUTH BANK

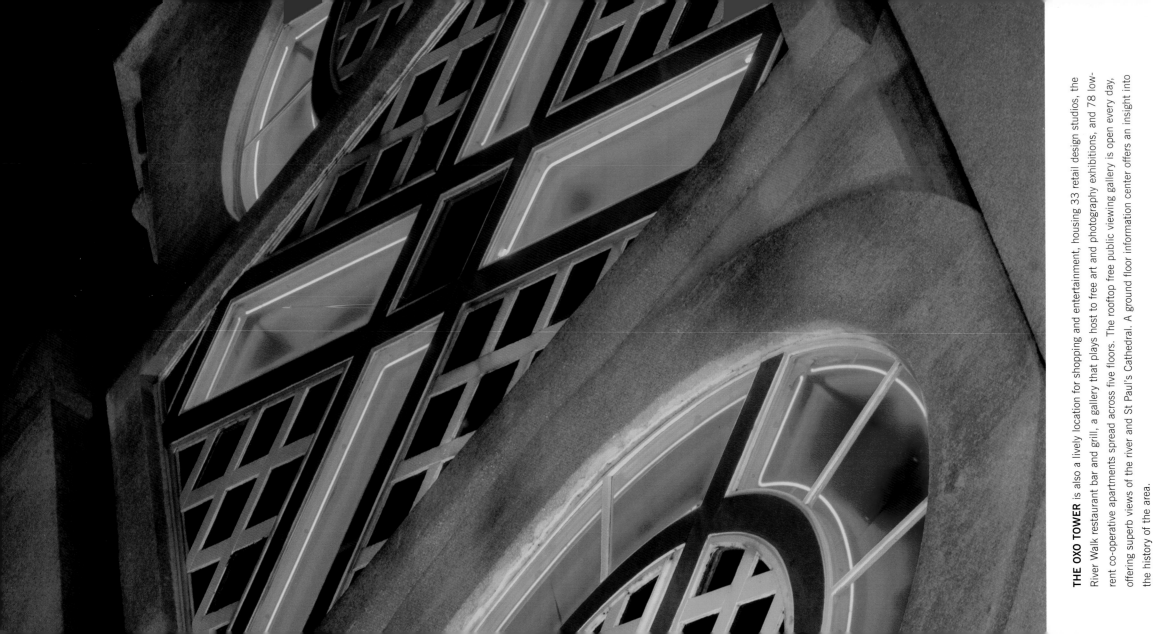

THE OXO TOWER is also a lively location for shopping and entertainment, housing 33 retail design studios, the River Walk restaurant bar and grill, a gallery that plays host to free art and photography exhibitions, and 78 low-rent co-operative apartments spread across five floors. The rooftop free public viewing gallery is open every day, offering superb views of the river and St Paul's Cathedral. A ground floor information center offers an insight into the history of the area.

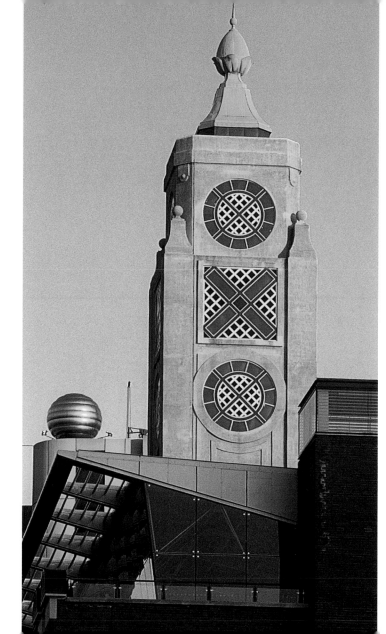

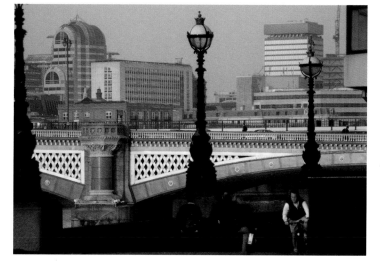

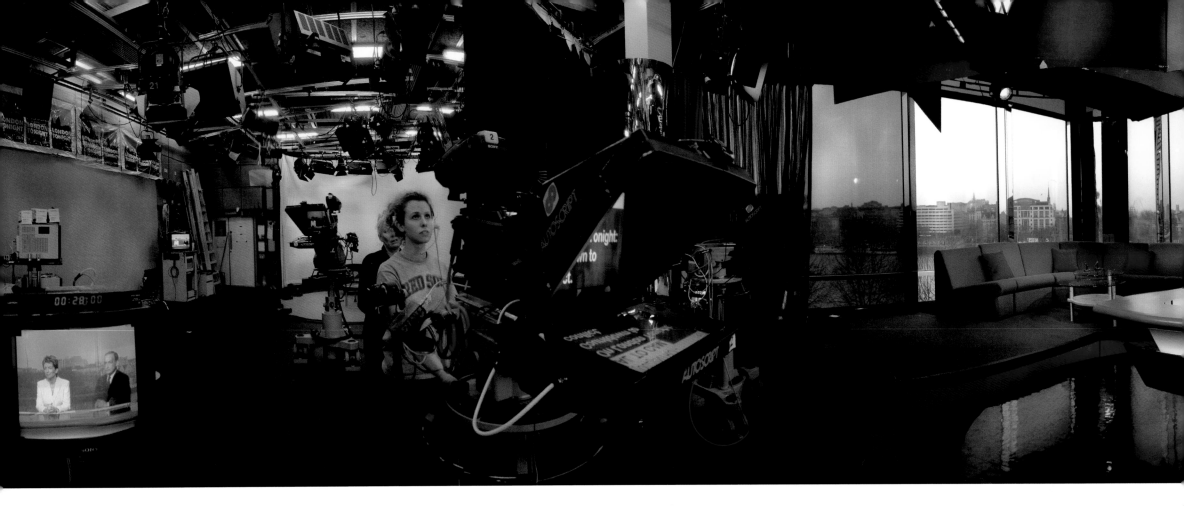

NEWSREADERS Anna Maria Ashe and Alastair Stewart prepare to go on air from the *London Tonight* studios in London Television Center. The evening news program broadcasts seven days per week, 52 weeks per year and is produced by London News Network.

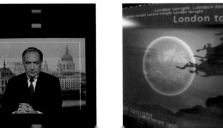

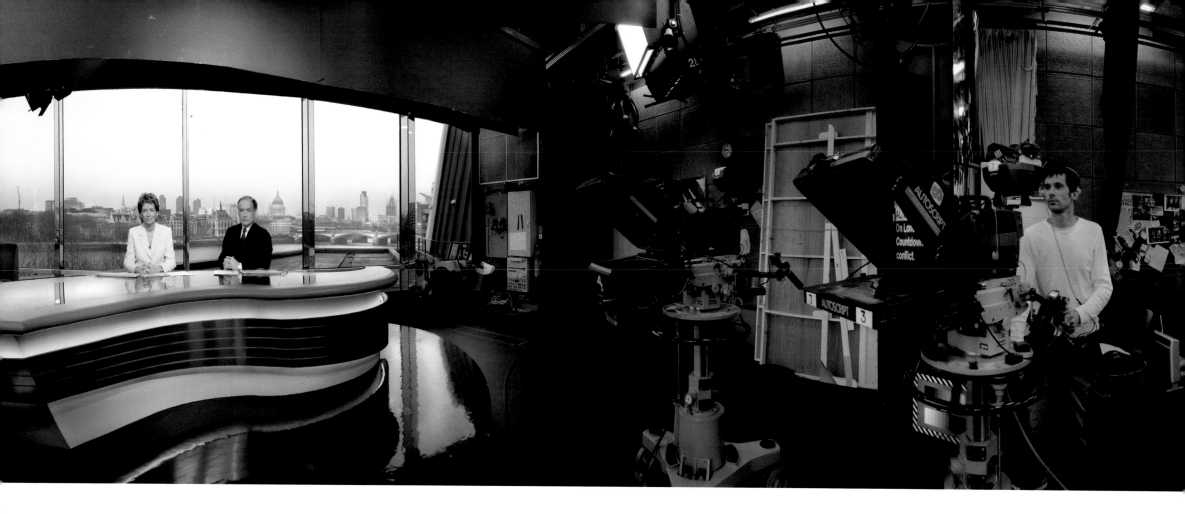

LONDON TONIGHT STUDIOS SOUTH BANK

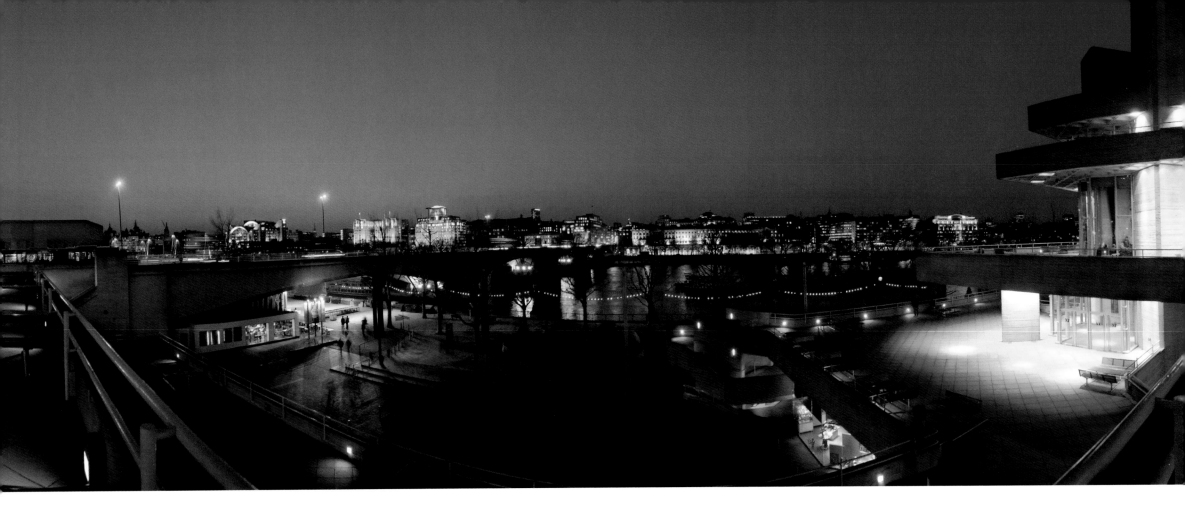

COMPRISING THE NATIONAL THEATER (above), the National Film Theater, the Royal Festival Hall and the Hayward Gallery, the South Bank is a labyrinth of concrete halls and walkways and the center of the Arts in London. Critics are sharply divided on the aesthetic merits of this controversial monument to functionalism, but the center, now a listed building, occupies a crucial place in London's cultural life.

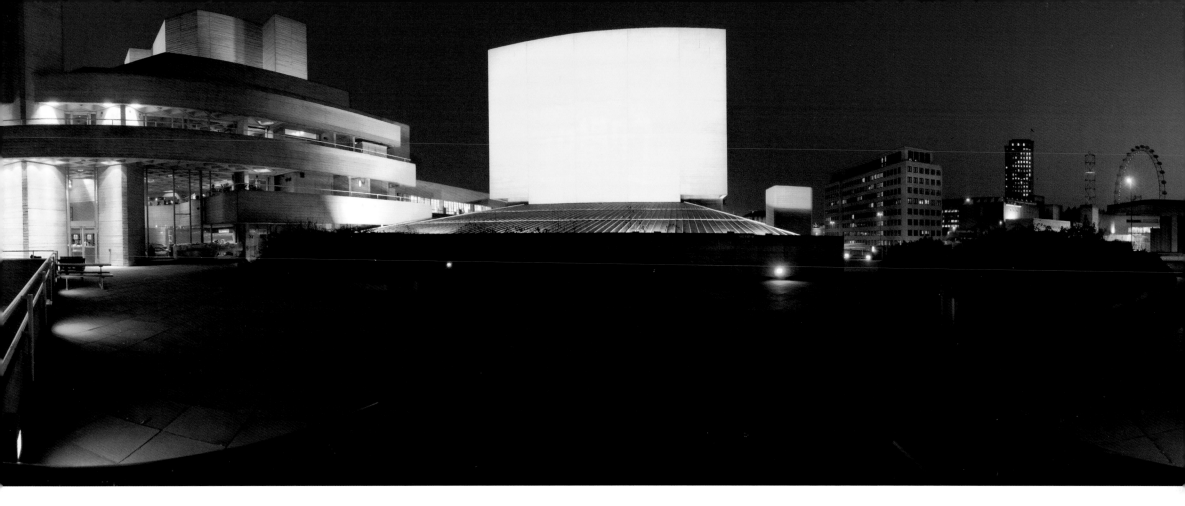

NATIONAL THEATER SOUTH BANK

DEVELOPMENT OF THE SOUTH BANK began with the Royal Festival Hall, which has shops, cafes, music and exhibitions, as part of the Festival of Britain in 1951. The National Film Theater and the internationally renowned Hayward Gallery, which hosts world-class exhibitions were added in 1967, while the National Theater followed ten years later. Less well known and more specialized venues are the Purcell Room, the Queen Elizabeth Hall, and the Poetry Library which contains Britain's largest collection of twentieth-century poetry. Open space can be found at the Jubilee Gardens, on the site where 8.5 million people congregated for the Festival of Britain over 50 years ago.

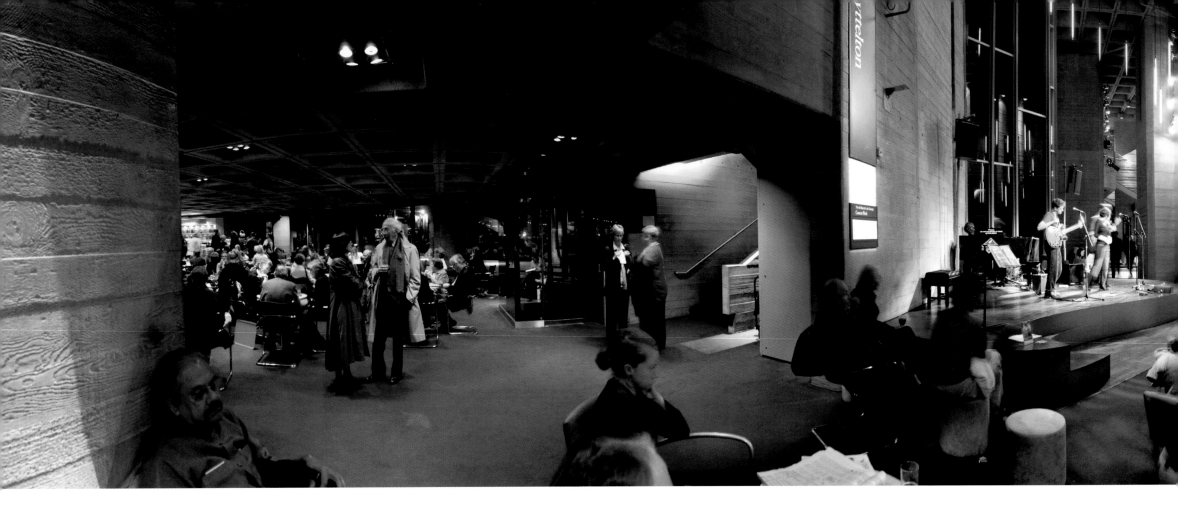

SINGER REBECCA HOLLWEG entertains London's culture vultures in the foyer of the National Theater. The building's entrance hall stages regular free performances as a means of showcasing the cream of the city's upcoming artistic talent.

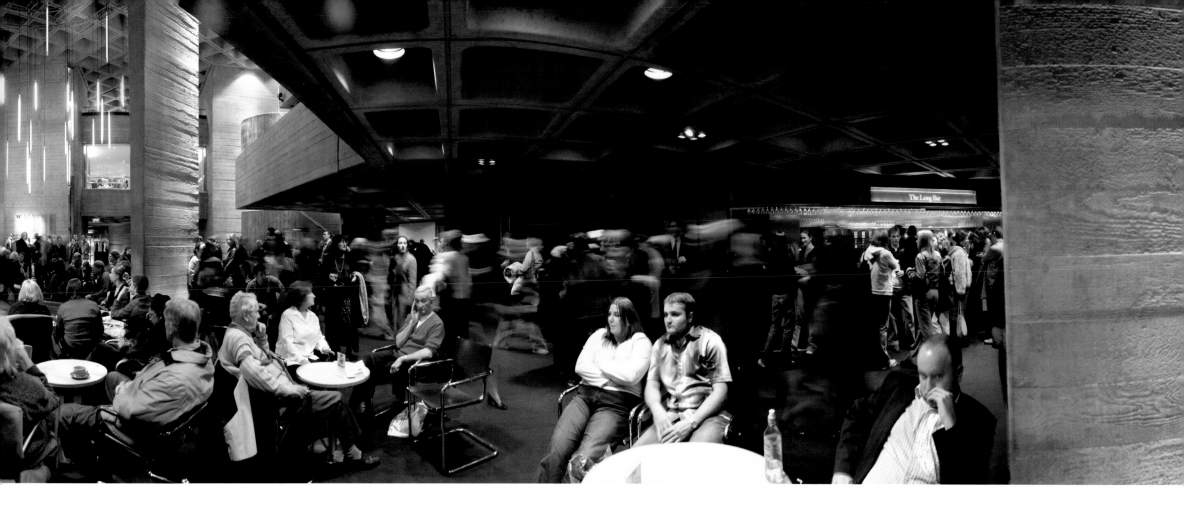

NATIONAL THEATER INTERIOR

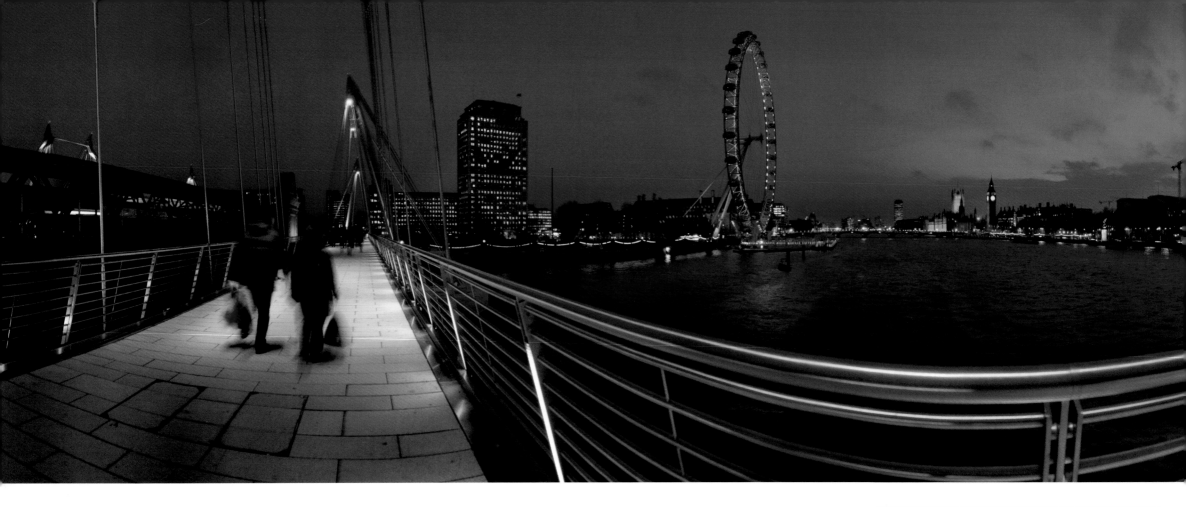

ORIGINALLY A SUSPENSION BRIDGE designed by Brunel, Hungerford Bridge was modernized for the new millennium by architects Lifschutz Davidson. The two multi-span main footbridges are 1,050 feet long and 15 feet wide, and are suspended by arrays of cable stay rods from 82-foot-high inclined steel pylons. Unlike its predecessor, which ran alongside the train line into Charing Cross, it facilitates panoramic views of London.

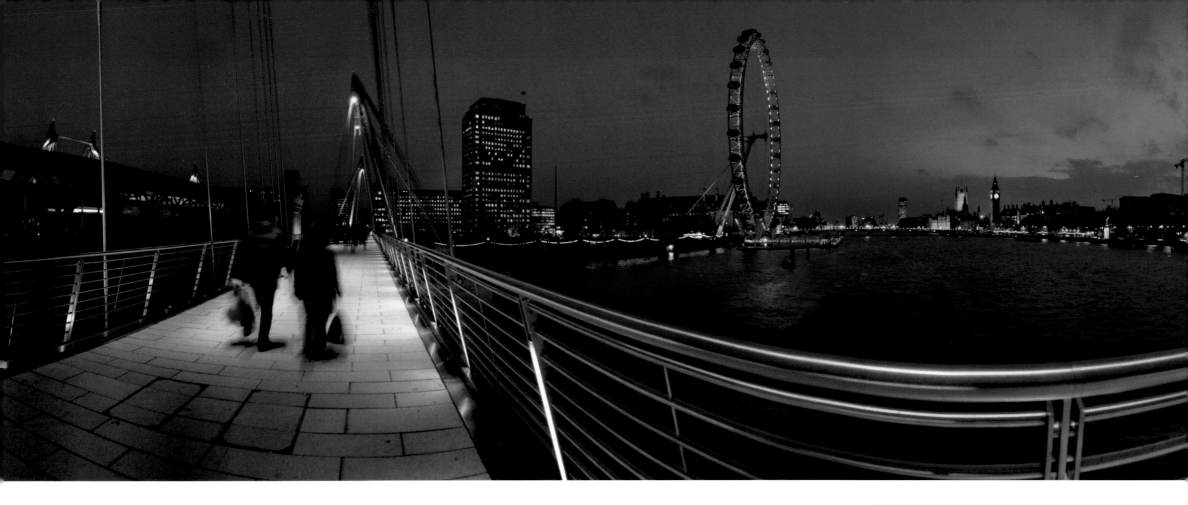

ORIGINALLY A SUSPENSION BRIDGE designed by Brunel, Hungerford Bridge was modernized for the new millennium by architects Lifschutz Davidson. The two multi-span main footbridges are 1,050 feet long and 15 feet wide, and are suspended by arrays of cable stay rods from 82-foot-high inclined steel pylons. Unlike its predecessor, which ran alongside the train line into Charing Cross, it facilitates panoramic views of London.

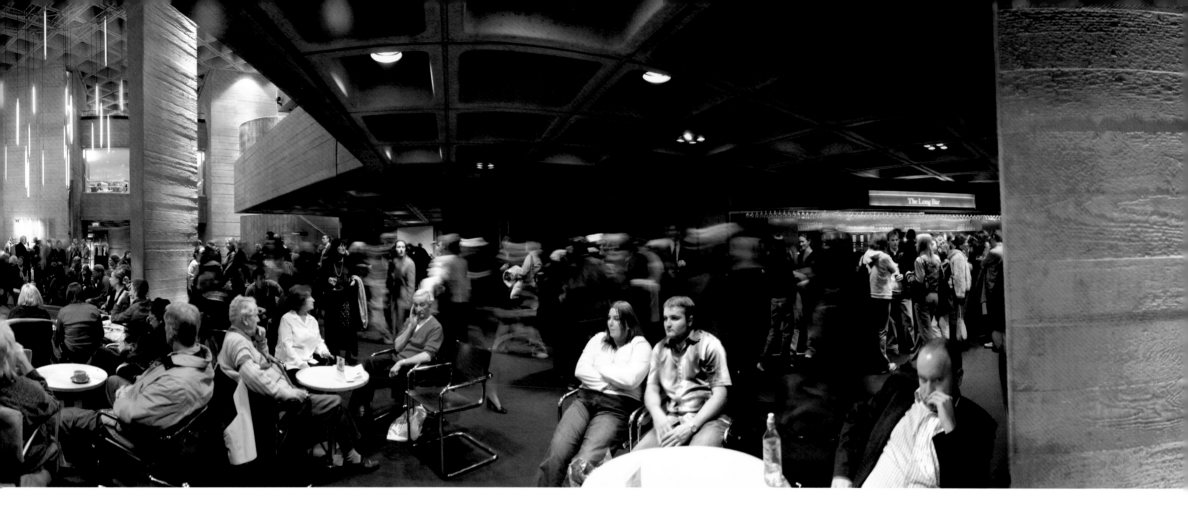

NATIONAL THEATER INTERIOR

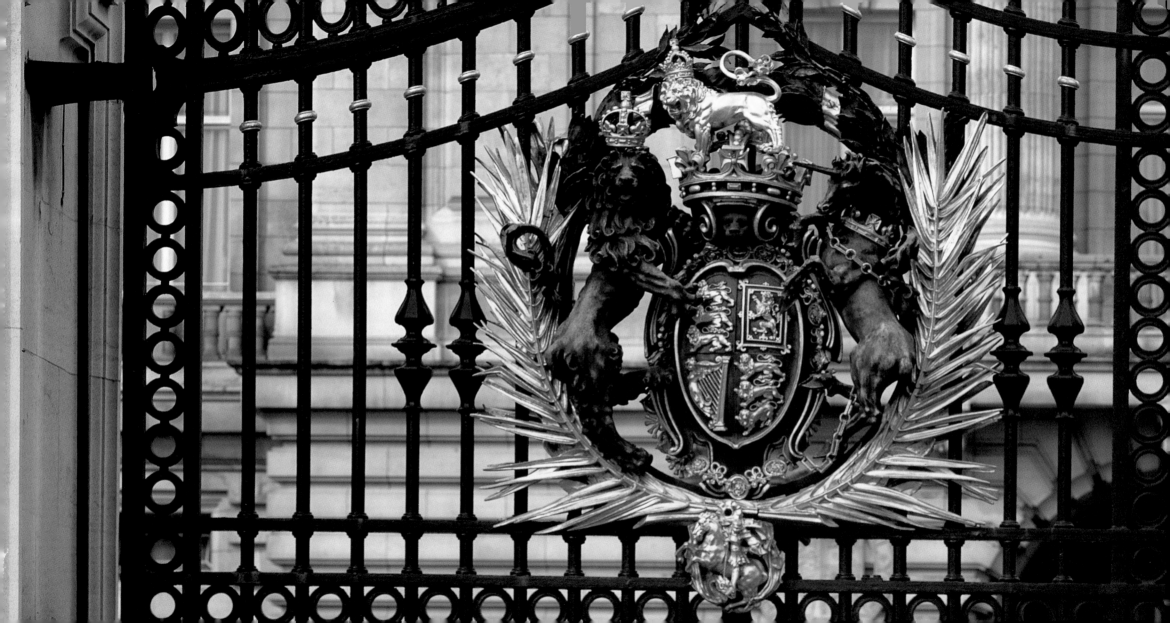

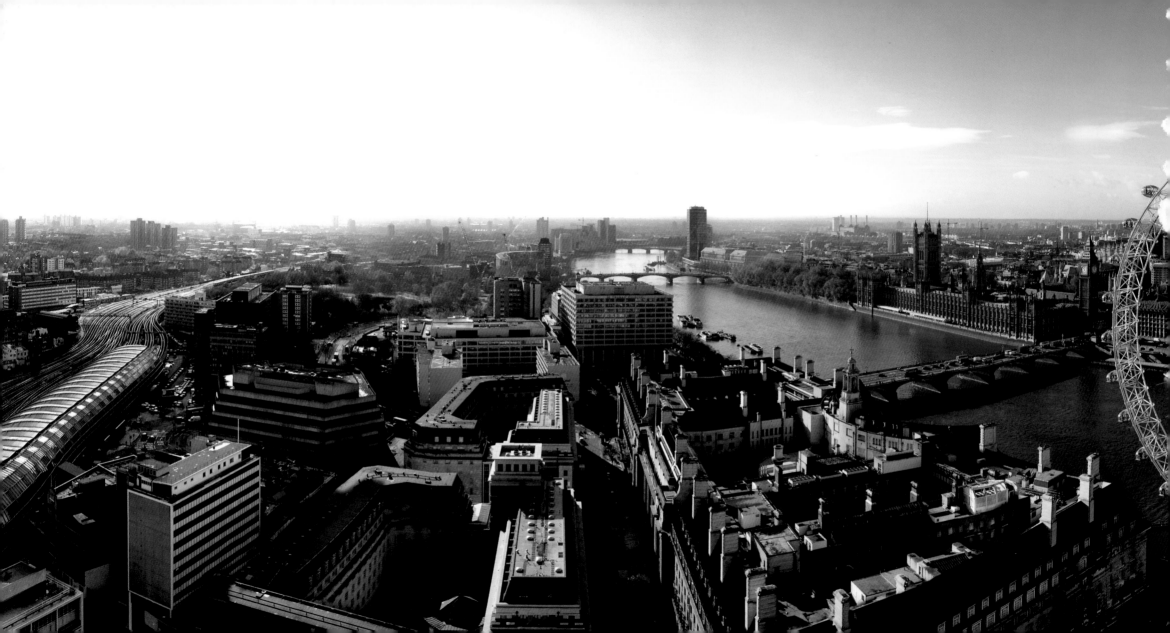

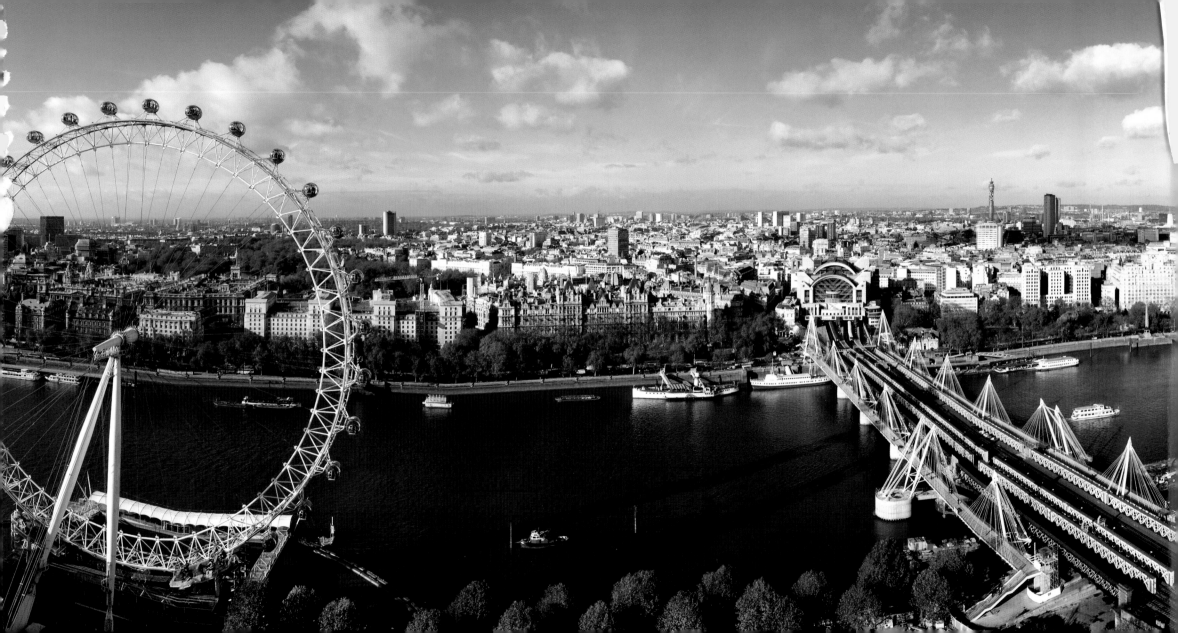

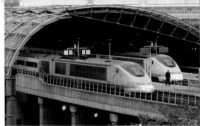

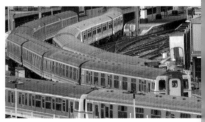
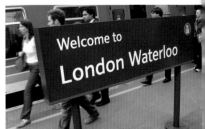

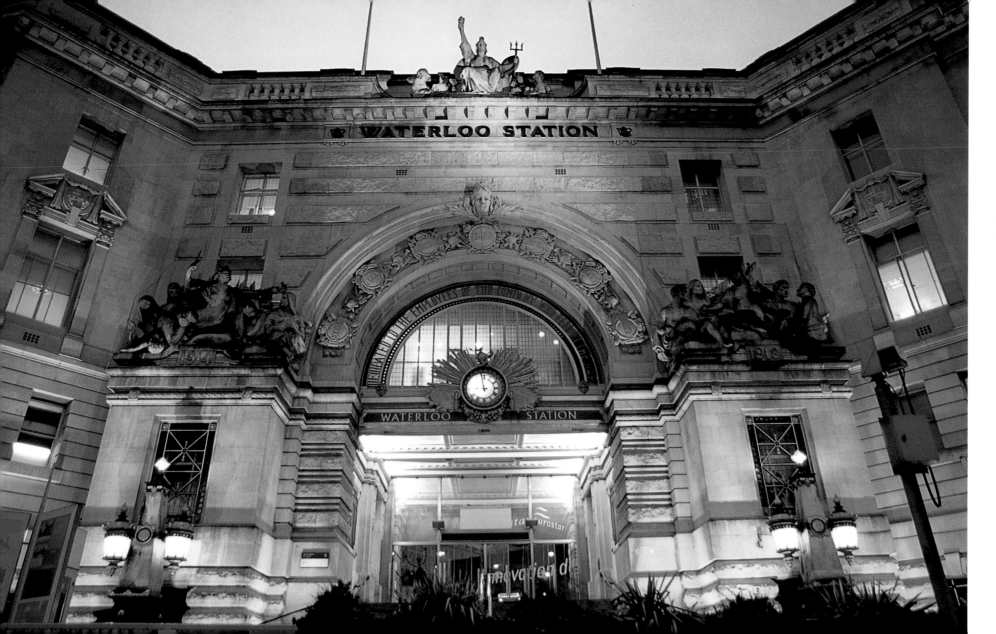

WATERLOO STATION Opened in 1848 by the London and South Western Railway, Waterloo is one of the hubs of commuter London, with scores of thousands of workers from south of the capital pouring from its 22 platforms five days per week. Since 1993, Waterloo has also been the gateway from continental Europe to Britain, with around seven million visitors per year journeying through the Channel Tunnel on Eurostar.

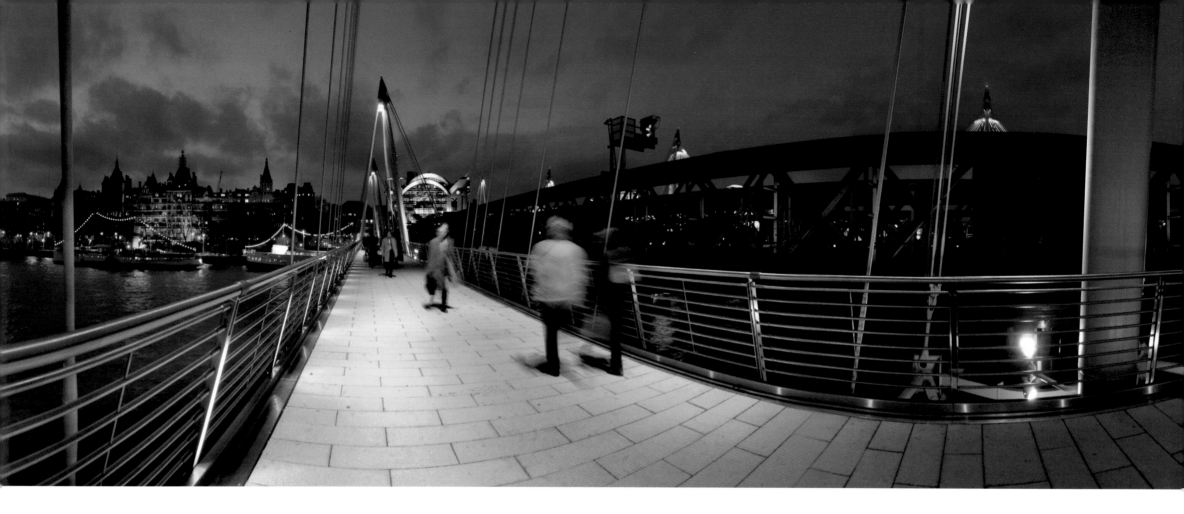

HUNGERFORD BRIDGE

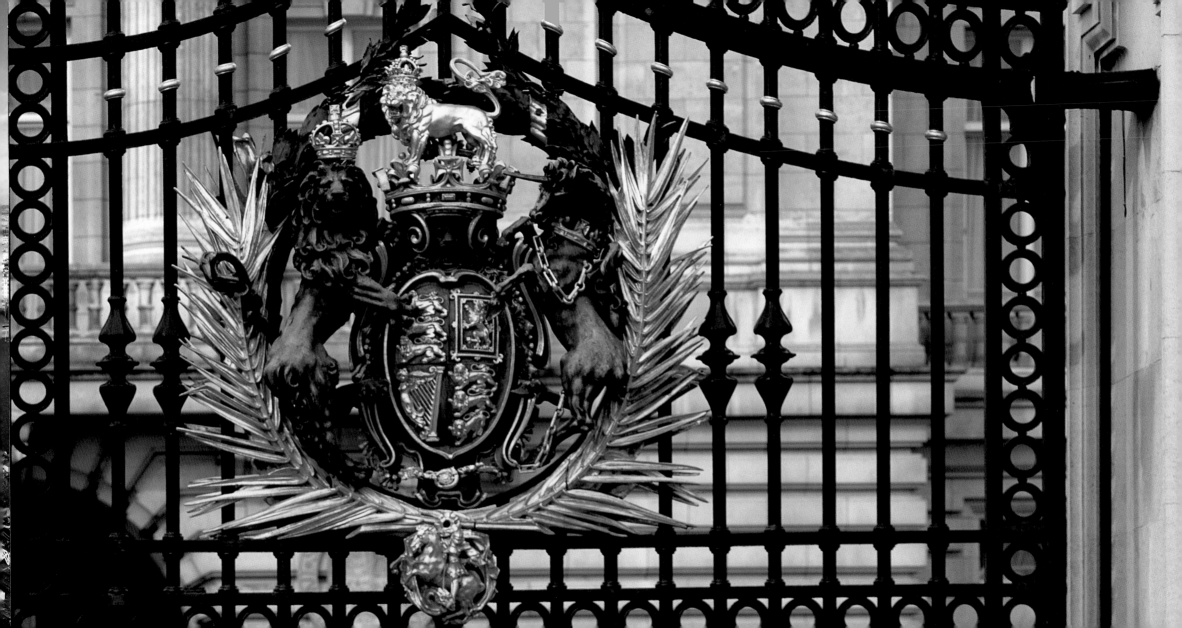

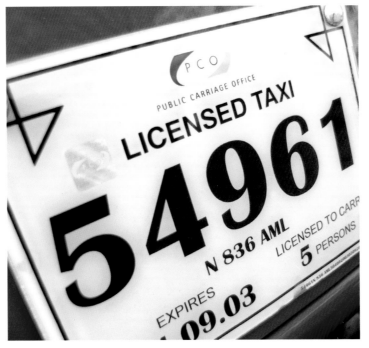

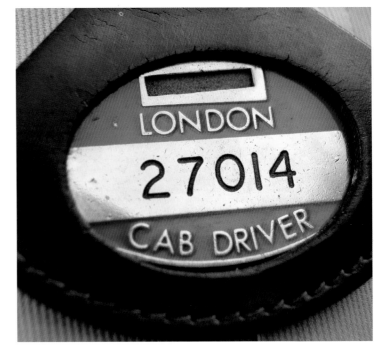

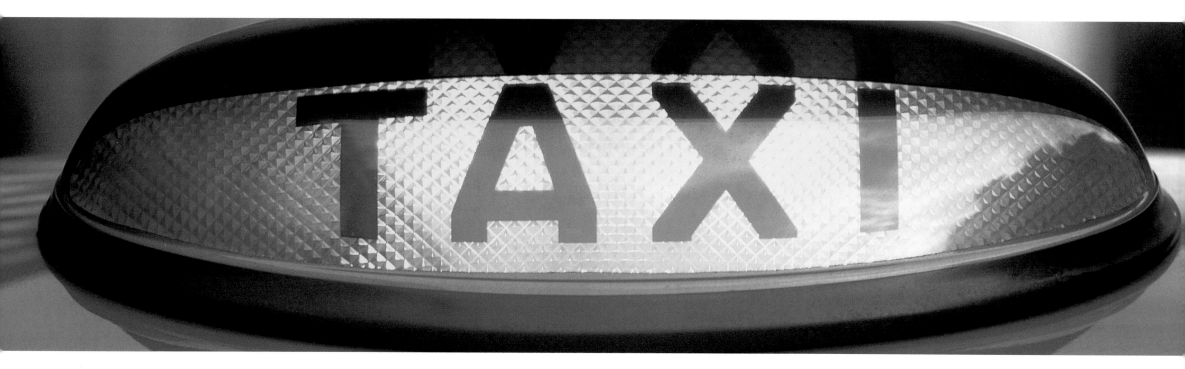

THE FRENCH HACKNEY CARRIAGE or cab (*cabriolet*) first appeared on London streets in 1820. Nowadays the spacious, familiar black taxi, or "cab" is one of the capital's most familiar sights. There are more than 20,000 licenced taxis plying their trade in the capital, and every single driver has spent three to four years doing The Knowledge, the process of learning every one of London's complex streets and highways that is tested by a final exam.

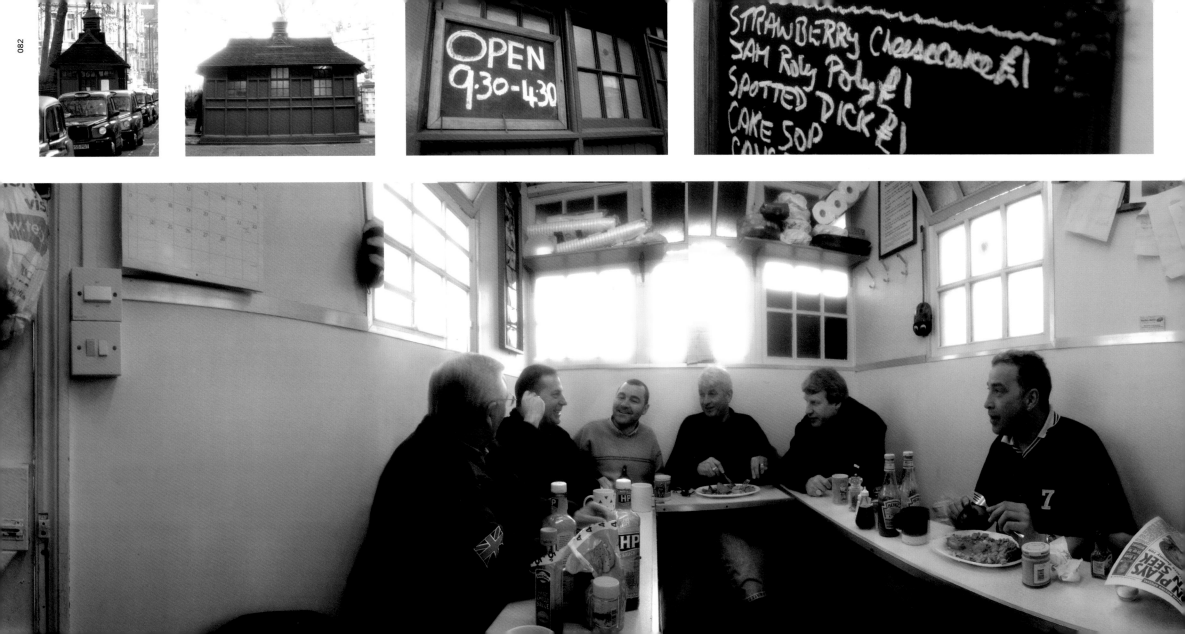

OPEN
9:30-4:30

STRAWBERRY CheeseCake £1
JAM Roly Poly £1
SPOTTED DICK £1
CAKE 50p

CABBIES' SHELTER VICTORIA

TAXI DRIVERS HAVING LUNCH at an old-fashioned cabbies' shelter in Grosvenor Gardens near Victoria, central London. A Grade II listed building dating from 1870, this compact café and rest area is made of the sturdiest English oak. Solid, traditional meals are served up to working cabbies, with beef stew and dumplings, ham and eggs, and jam roly-poly, a steamed dessert, all being house specialities.

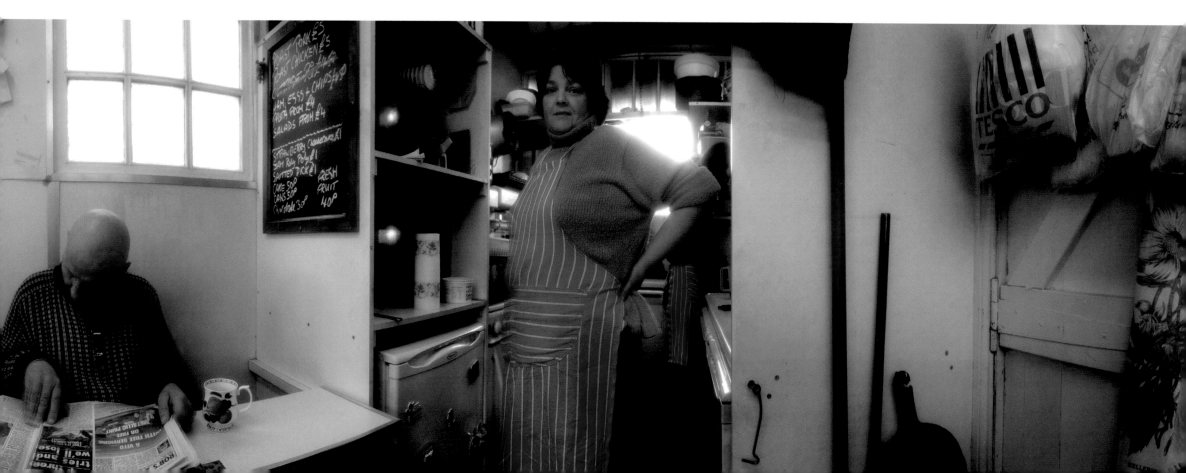

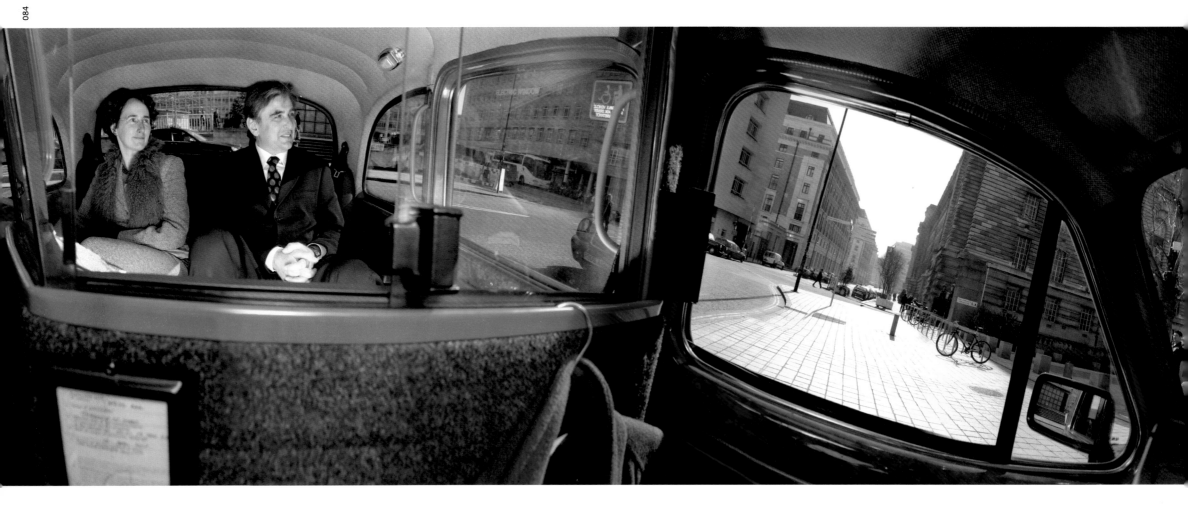

TERRY, A TAXI DRIVER FOR 25 YEARS, arrives at the London Eye with passengers David Marks and Julia Barfield, the visionary husband-and-wife architect team who designed and created the Eye. The couple pursued their dream for six years until the spectacular Eye, or Millennium Wheel, was finally raised to stand 443 feet above the Thames in October 1999.

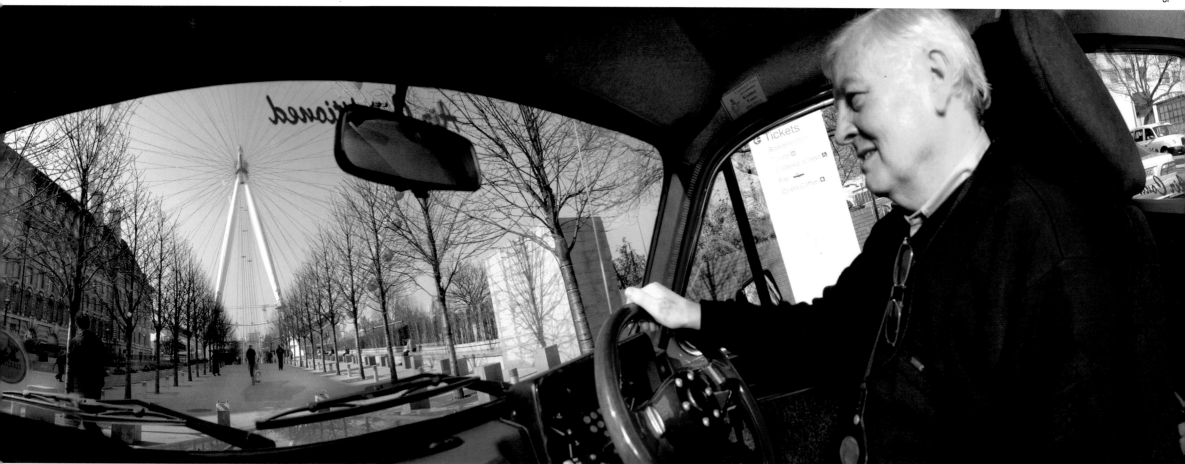

LONDON TAXI

THE HUB AND SPINDLE AT THE CENTER OF THE EYE WEIGHS 369 TONS, ABOUT THE SAME AS A BOEING 747

LONDON EYE

SOUTH BANK

CONCEIVED TO CELEBRATE THE MILLENNIUM, the 443-foot-high London Eye is the tallest observation wheel in the world. The Eye took 16 months to be constructed by a team from six European countries. The 64 spoke cables are 2¾ inches in diameter and contain 121 separate strands. The foundation under the legs contains 2,425 tons of concrete and 44 piles.

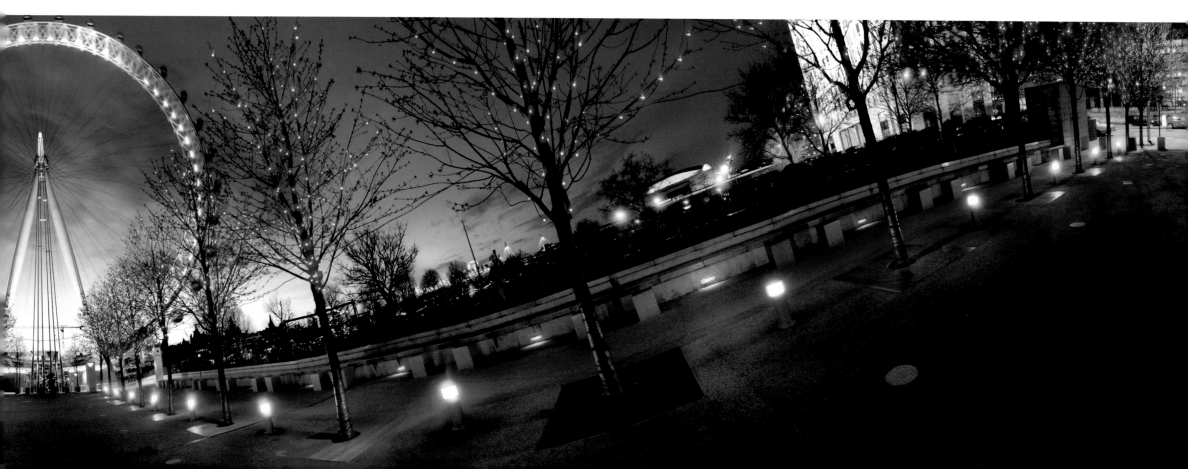

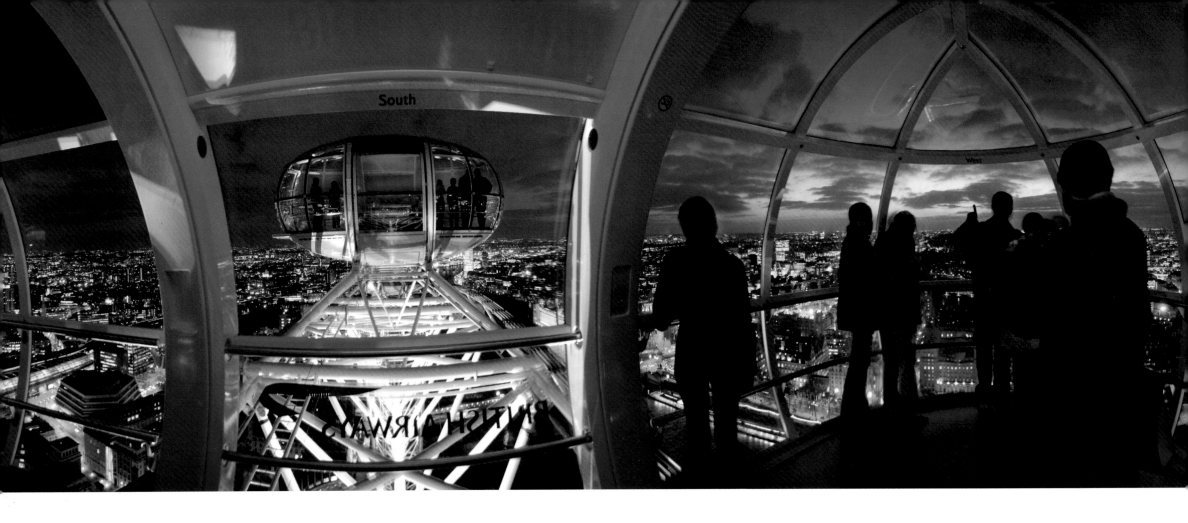

THE 32 COMPUTER-STABILIZED CAPSULES carry up to 17,000 visitors per day on flights lasting 30 minutes. On a clear day visitors can see 25 miles, into seven counties. The capsules can be hired for private parties, and the Eye carried four million visitors in 2002. The capsules were built by a ski lift manufacturer in France and the entire population of an Alpine village was used to test the boarding procedure.

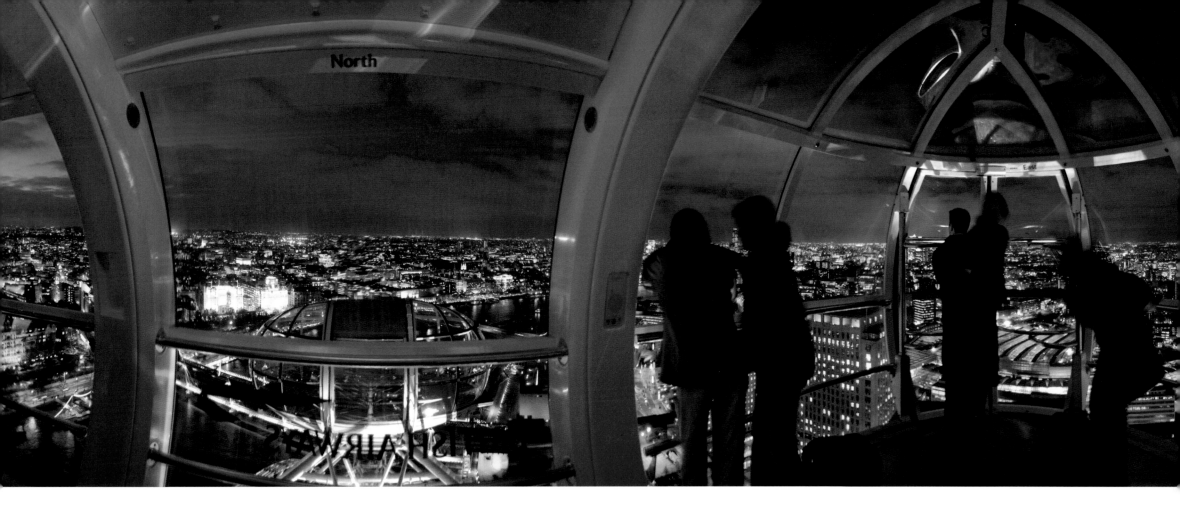

THE EYE TURNS AT 10¼ INCHES PER SECOND, ABOUT ½ MILE PER HOUR.

BIG BEN (overleaf) The 13-ton hour bell of this great clock rang out across London for the first time in 1859. Big Ben cracked just two months after going into service, hence its distinctive, but less-than-perfect tone.

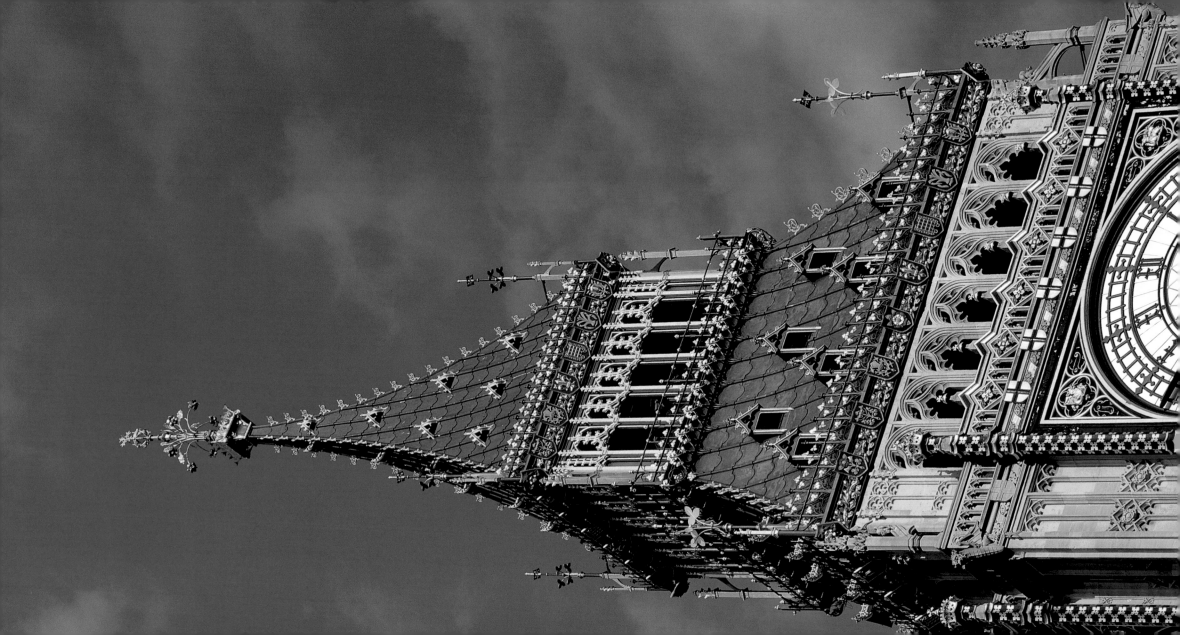

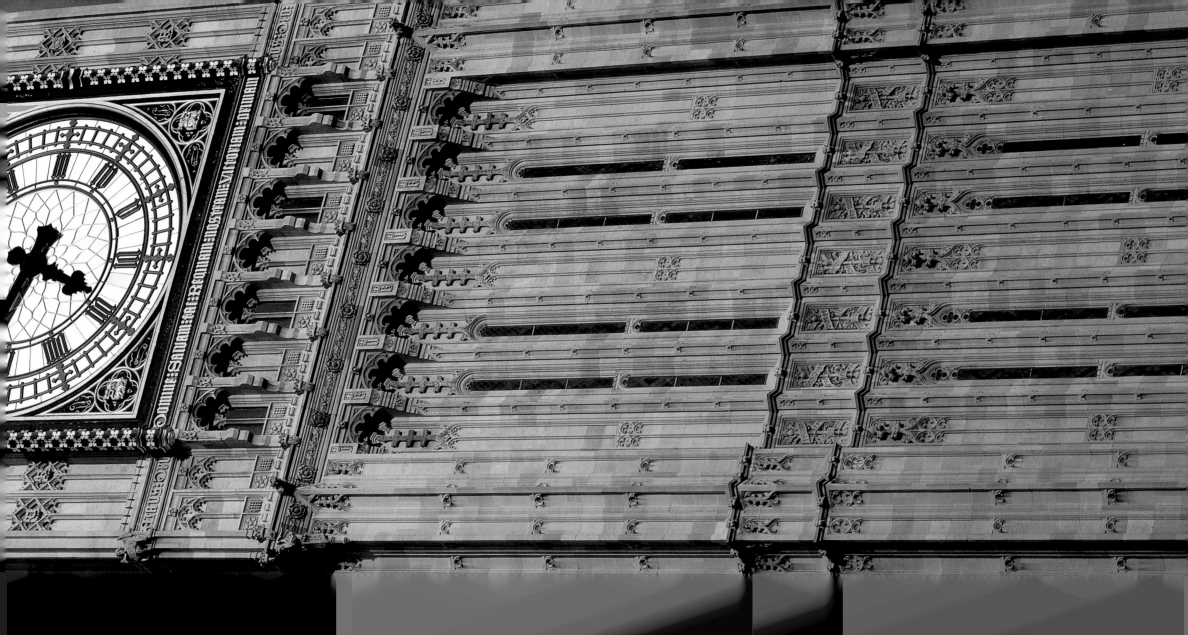

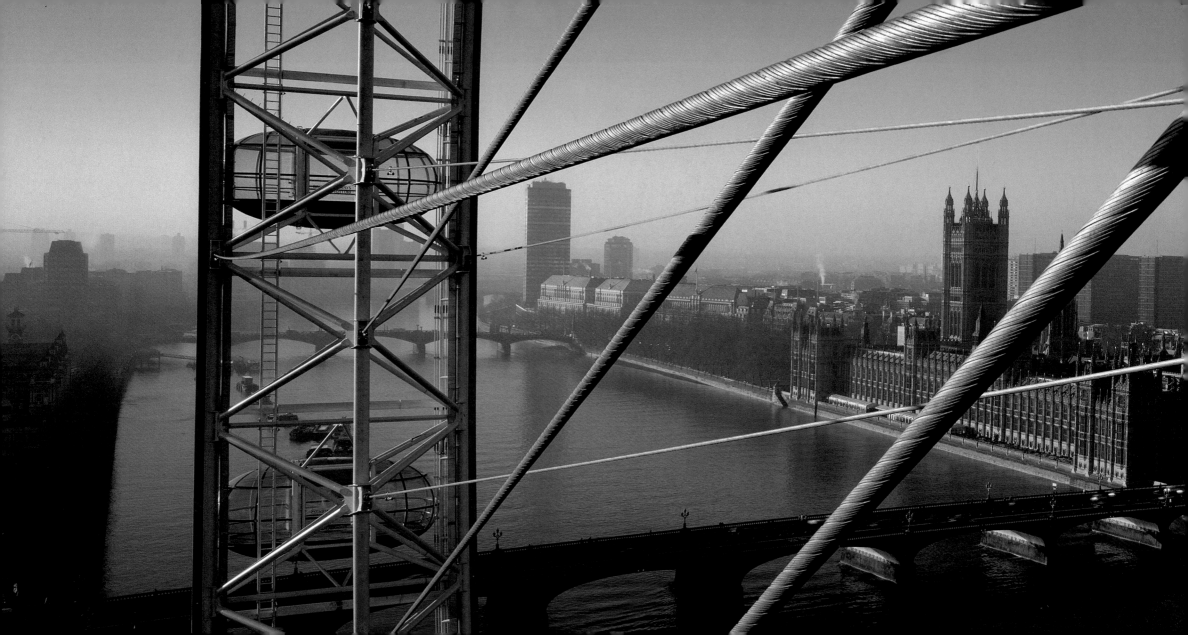

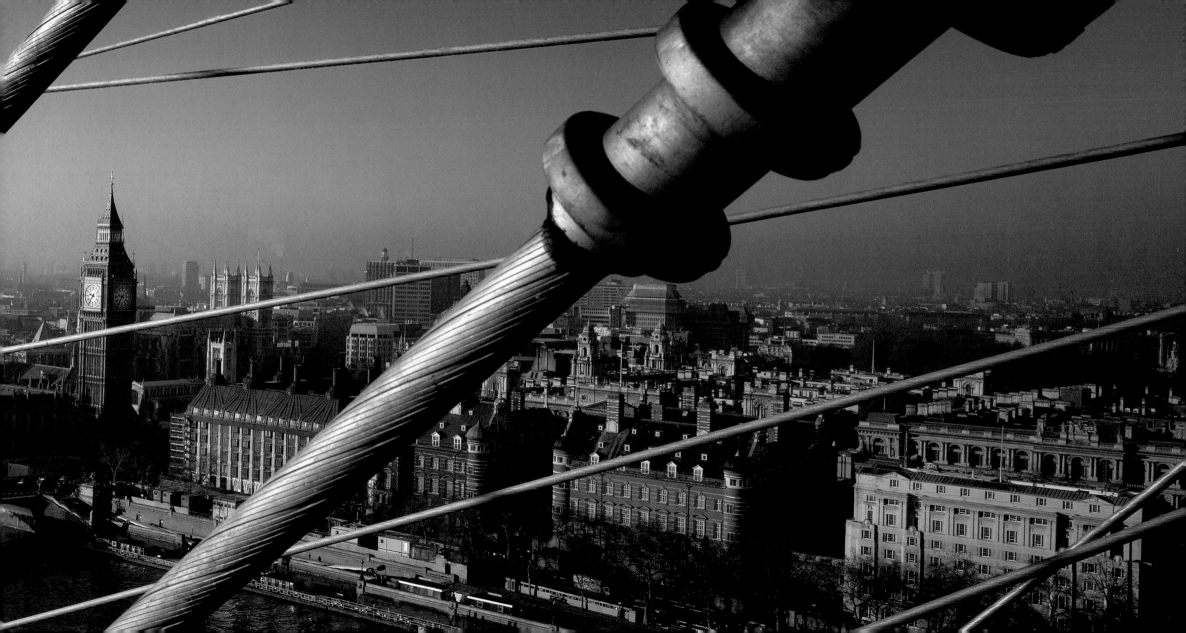

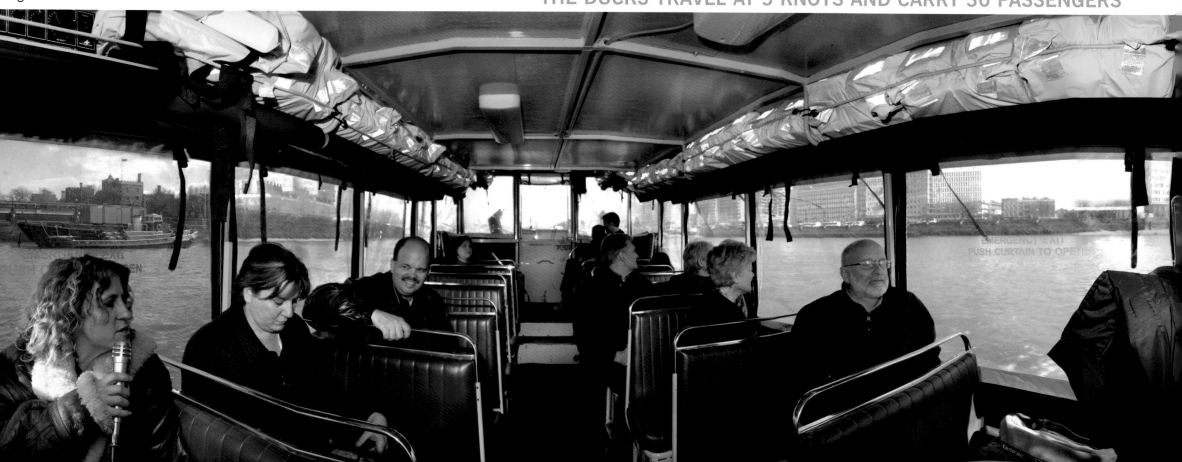

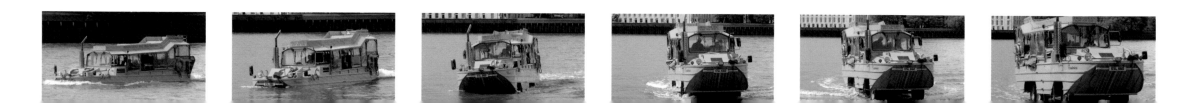

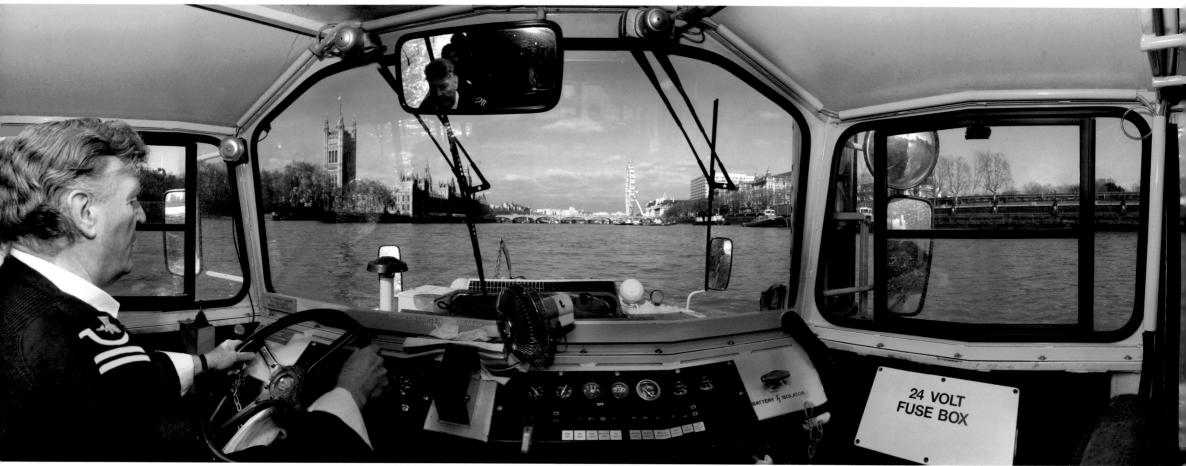

24 VOLT
FUSE BOX

DUCK TOURS

THE NAME DUCK TOURS evolved from the previous name for these peculiar amphibious craft: DUKWS. Ex-military vehicles, more than 21,000 were built to carry British troops for the D-Day landings. Now, five have been requisitioned to carry tourists past Parliament and through Trafalgar Square before taking to the Thames for the second half of the 70-minute tour of London.

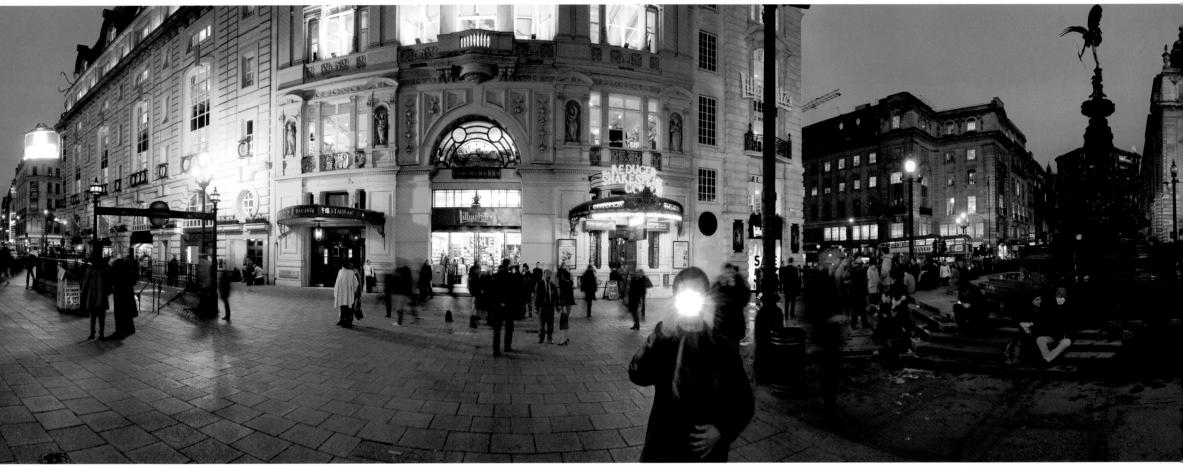

FAMOUS FOR ITS BRIGHT LIGHTS, and a tourist Mecca, Piccadilly Circus contains a famous bronze statue of a winged archer atop a fountain. The figure is called Eros, the god of love, but was designed in the nineteenth century as a monument to Lord Shaftesbury, a noted philanthropist. To the right of the neon signs, Shaftesbury Avenue leads into theaterland.

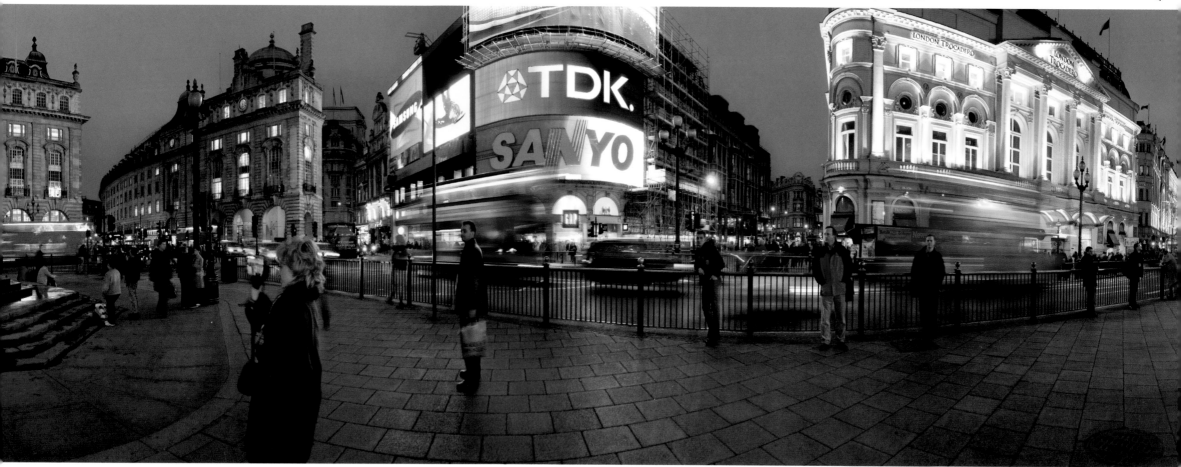

PICCADILLY CIRCUS WEST END

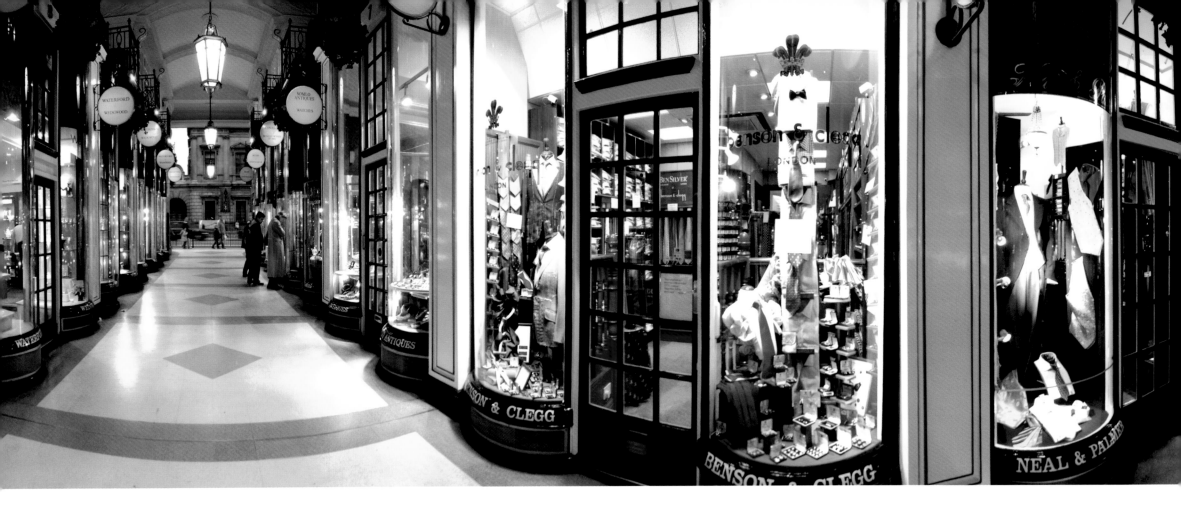

BUILT IN 1910 IN GEORGIAN STYLE, the meticulous bow-fronted shops of this upmarket arcade are light years away from the bawdy bustle of Piccadilly and Oxford Street. Specializing in bespoke tailors, china, jewelry and luxury goods, this is retail therapy for aristocrats: the *nouveau riche* need not apply. Benson & Clegg, suppliers of buttons and badges to the Prince of Wales, have occupied their site since 1937.

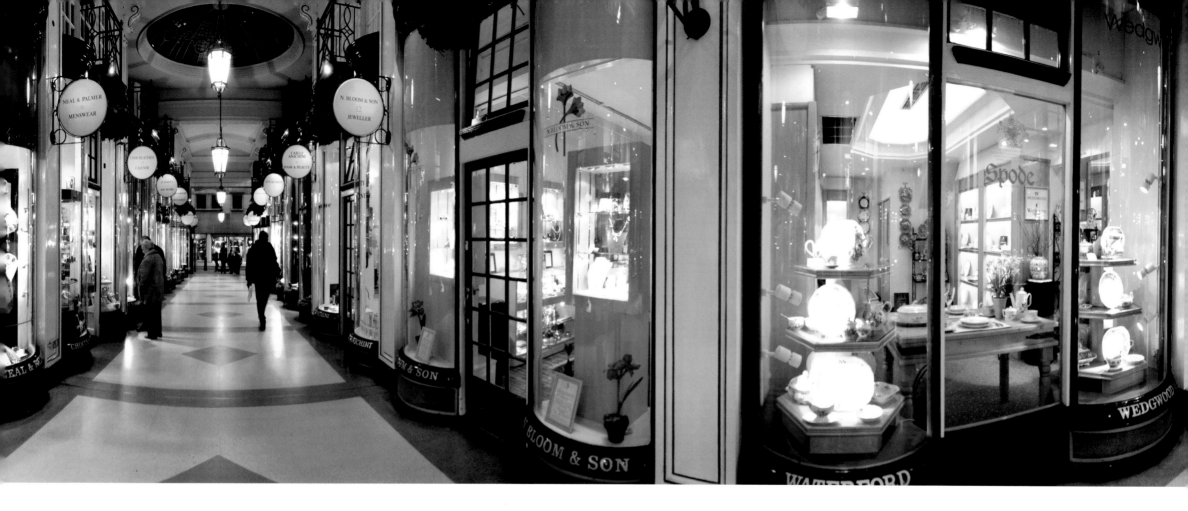

PICCADILLY ARCADE WEST END

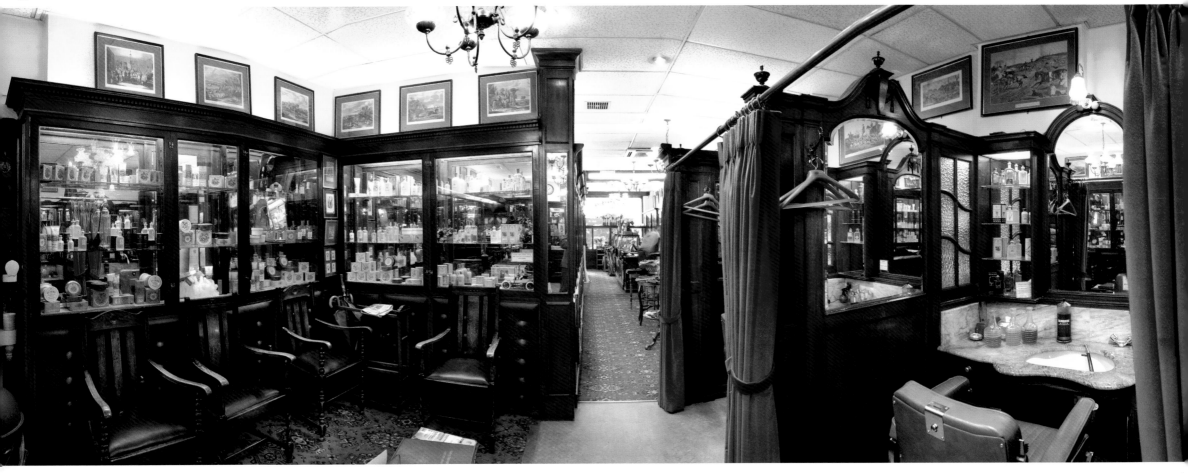

This stately olde worlde barber shop has scarcely changed since Mr George Trumper established Geo. F Trumper's, Perfumers and Barbers, in Mayfair's Curzon Street in 1875. The establishment has trimmed the beards and waxed the eyebrows of "London gentlemen and members of the Royal Court" for over 125 years, earning the Royal Warrant from Queen Victoria and five subsequent monarchs.

CLIENTS ARE OFFERED A "SHAVING SCHOOL", WHERE "GENTLEMEN ARE TAUGHT ONE-TO-ONE THE BEST TECHNIQUE FOR THEIR SKIN AND CHOICE OF RAZOR"

101

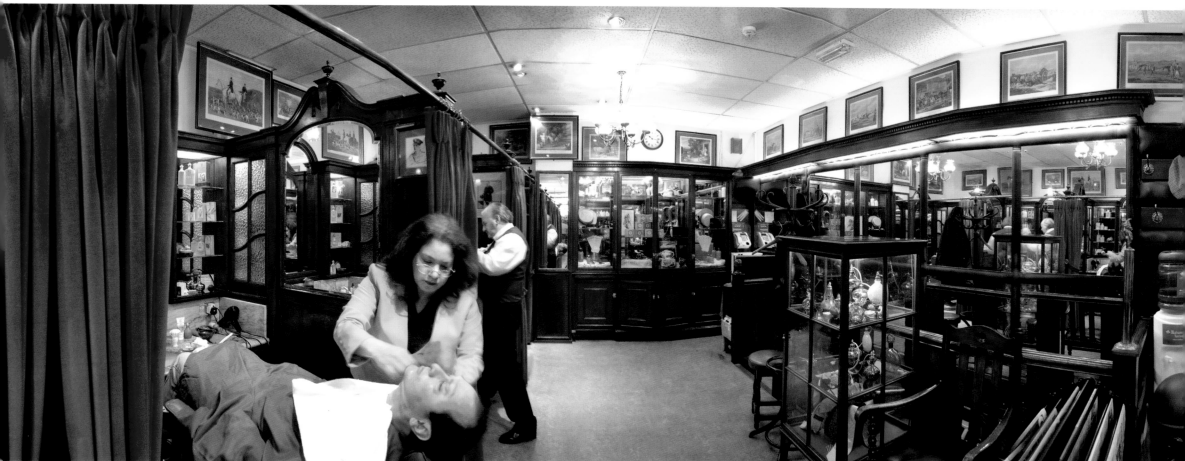

TRUMPER'S BARBERS MAYFAIR

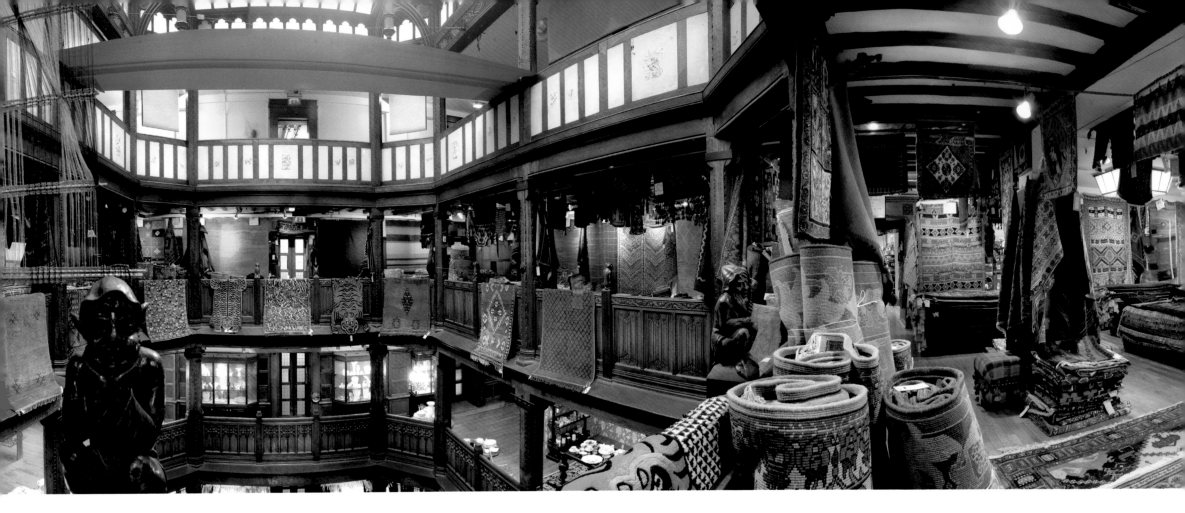

Arthur Lasenby Liberty founded Liberty in Regent Street, one of London's most prestigious department stores, in 1874. It specialized in selling *objets d'art*, fabrics and ornaments from the Orient. In 1924 the store's Tudor Shop was built from the timber of two ships, HMS *Impregnable* and HMS *Hindustan*. The famous rug department, with the air of a Turkish bazaar, occupies a floor of this building.

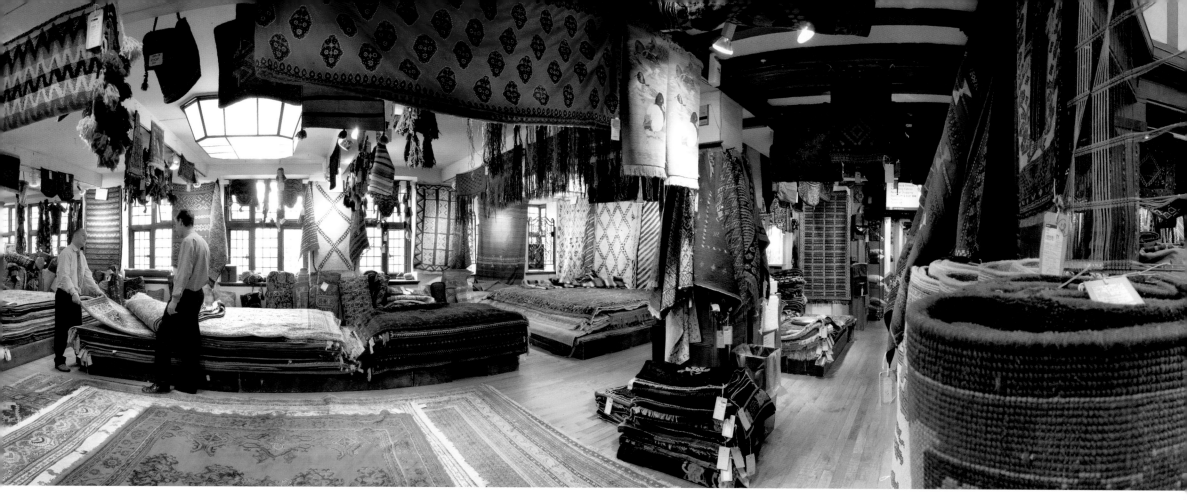

LIBERTY WEST END

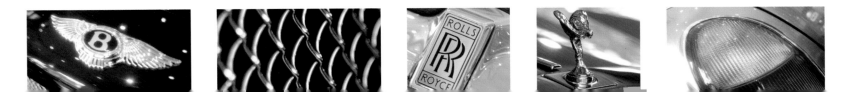

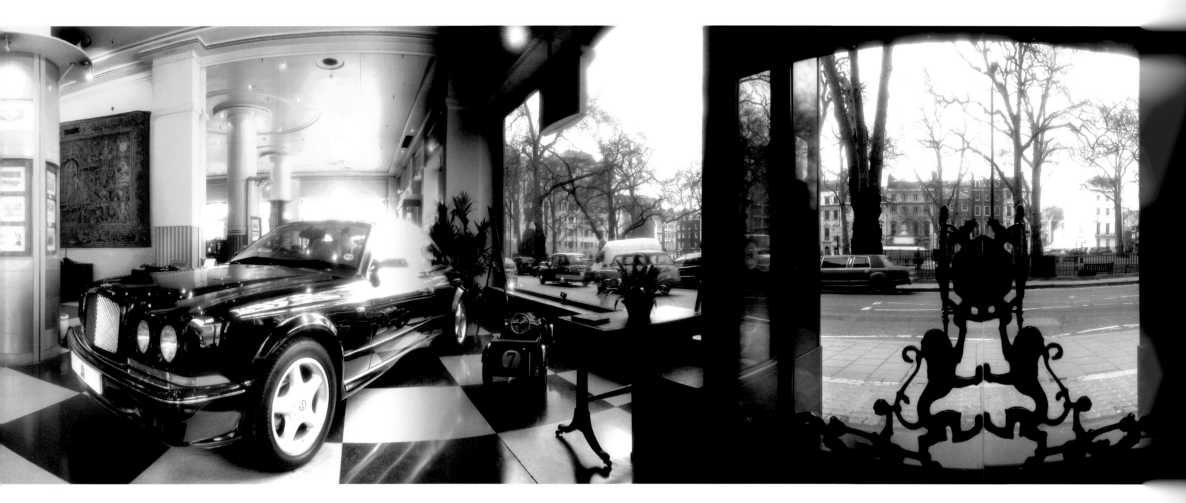

BENTLEY SHOWROOM MAYFAIR

Jack Barclay of, appropriately, Berkeley Square is Britain's oldest Bentley and Rolls-Royce dealership, having started life back in 1927. With Barclay's reputation for dealing only in the most desirable motor cars, succumbing to temptation in the showroom will cost you anything from £100,000 to £300,000.

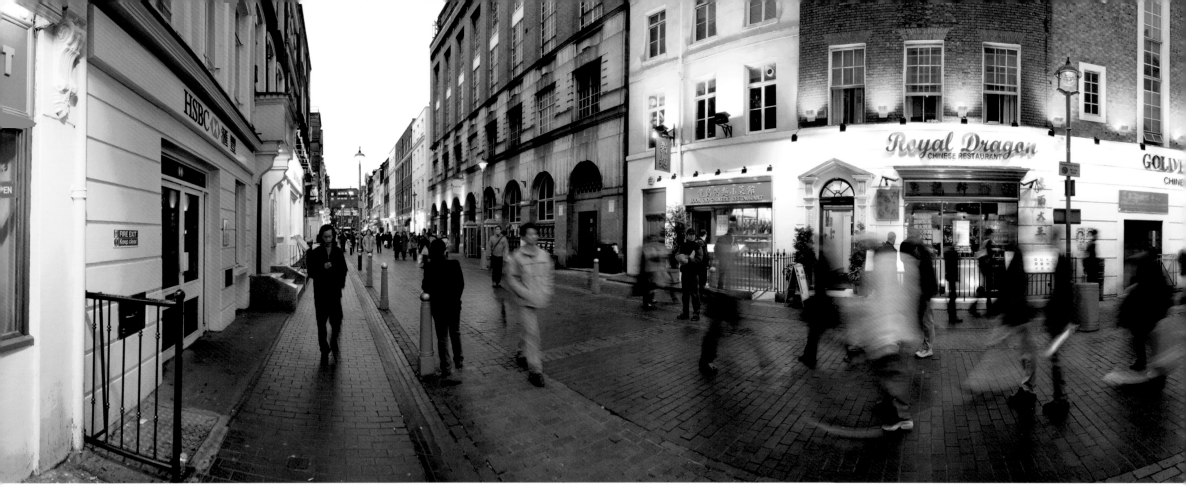

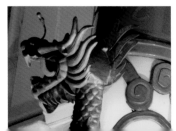

LONDON IS AN EVER-SHIFTING MOSAIC of myriad ethnic groups, and has hosted a vibrant Chinese community since the late nineteenth century. However, the largest influx arrived at the end of the 1950s, when many enterprizing London Chinese bought or leased property in a then scruffy Soho thoroughfare called Gerrard Street and opened restaurants. Unsurprisingly known as Chinatown, the area was later pedestrianized and large, ornate Chinese gates and street furniture were installed.

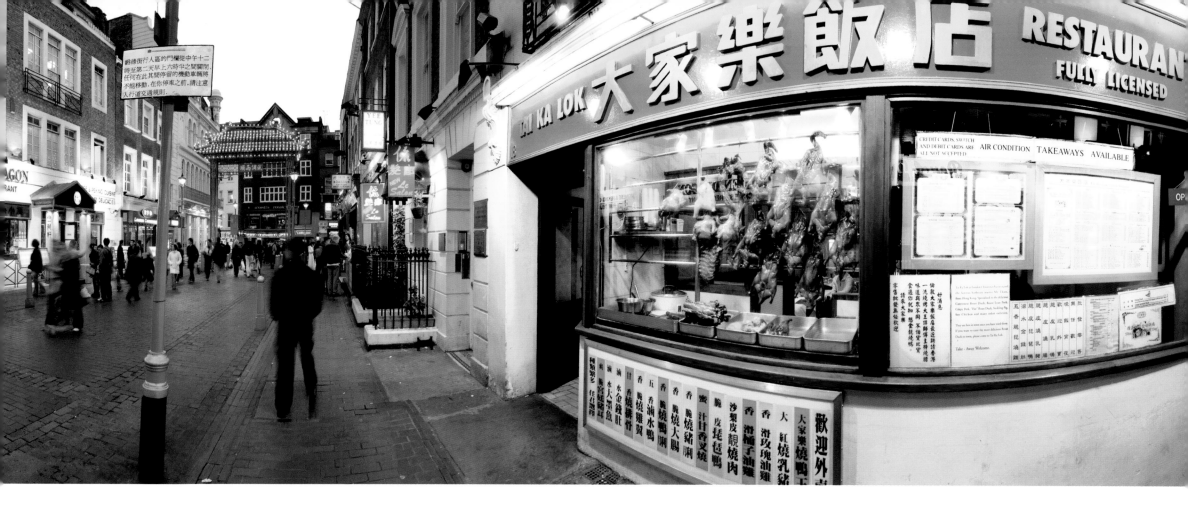

CHINATOWN SOHO

LONDON'S FIRST CHINESE RESTAURANT OPENED IN 1908

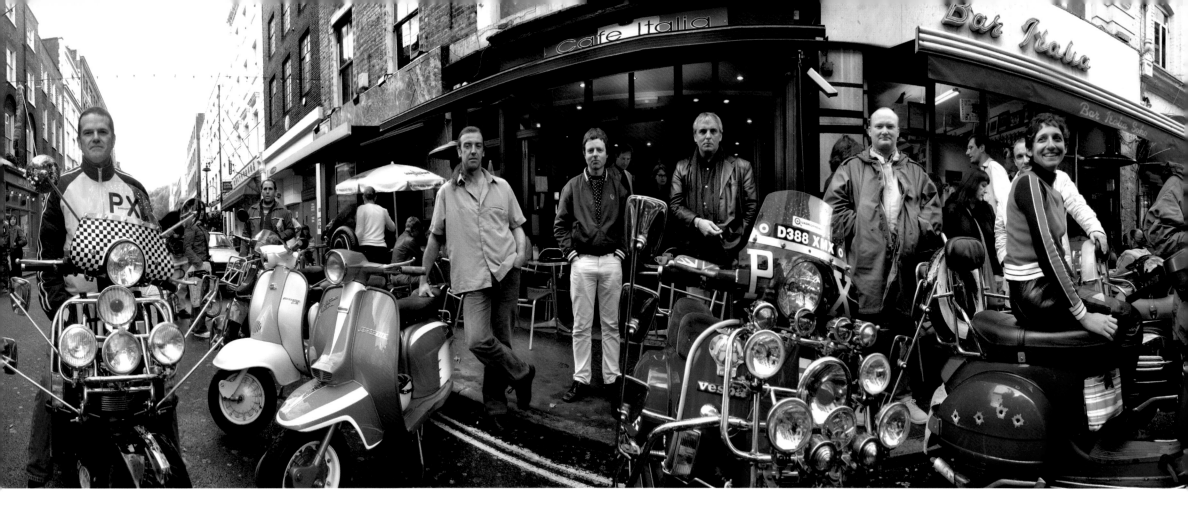

A magnet for fashion victims, early-hours revelers and aficionados of the perfect cappuccino, Frith Street's 24-hour Bar Italia is a place to people-watch and be seen. It's also the base for the Bar Italia Scooter Club, whose members congregate on their Vespas and Lambrettas most Sunday evenings. Around the corner from the sex and sleaze of Soho, this is a very innocent pleasure.

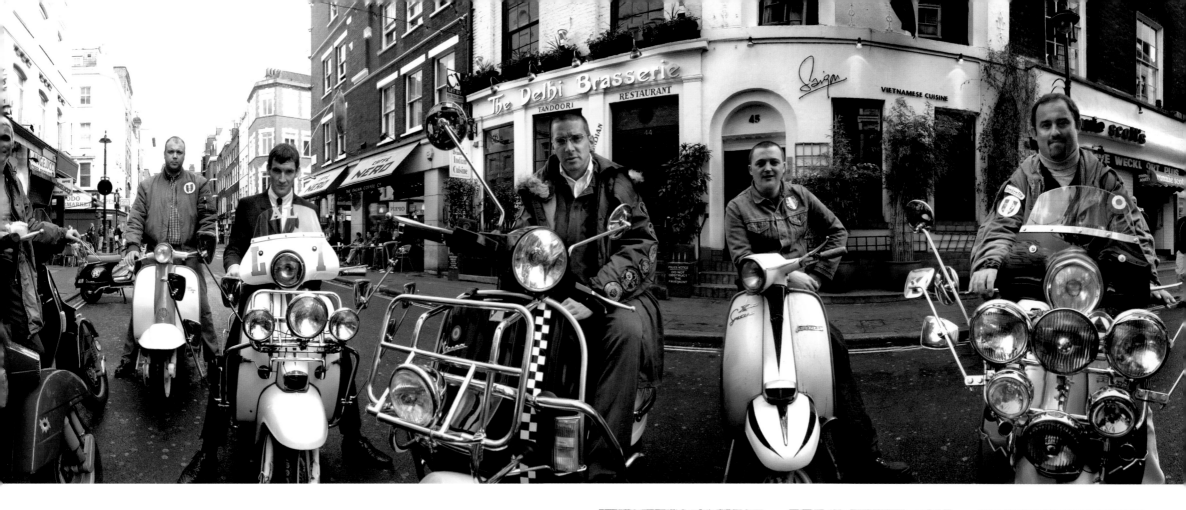

BAR ITALIA SOHO

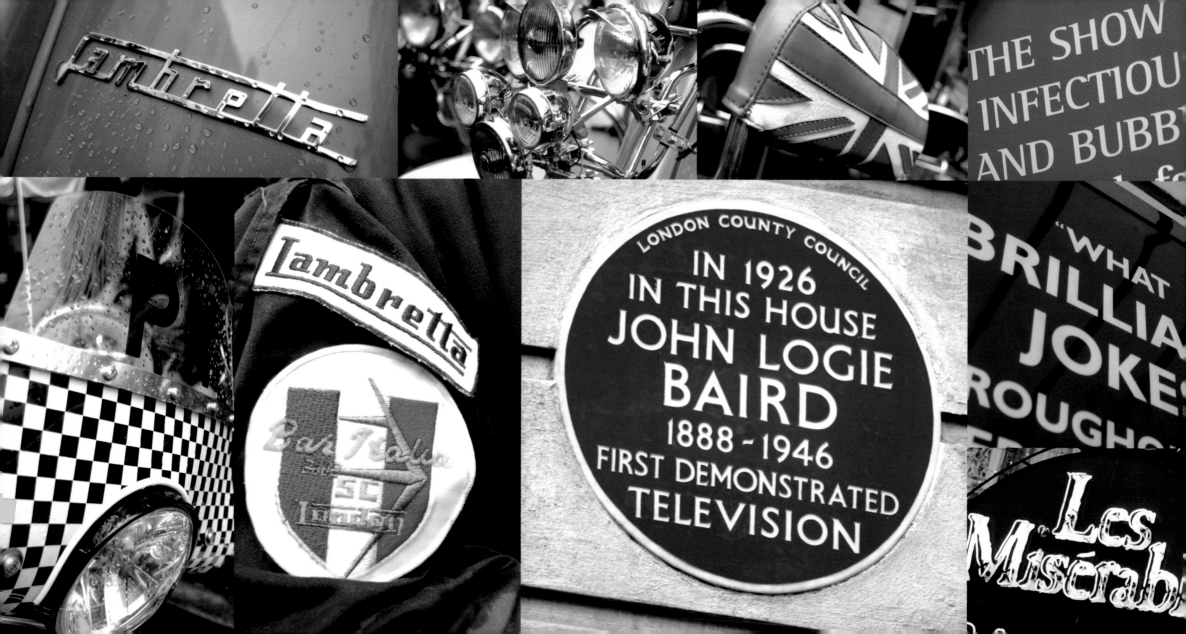

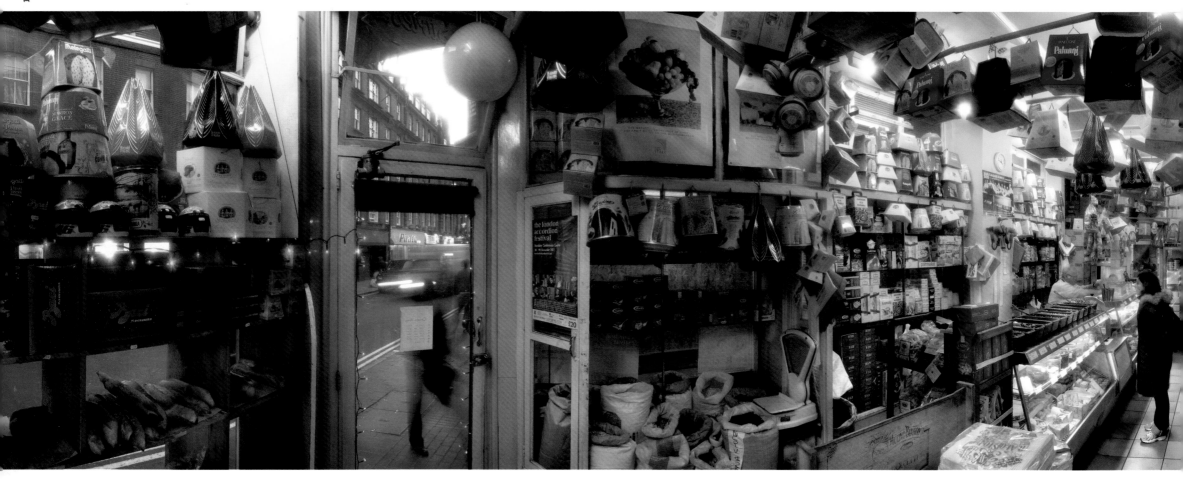

ONE OF THE MANY HIDDEN pleasures of Soho is its numerous delicatessens run by the Italian community, which stock every kind of foodstuff imaginable, and quite a few more besides. Simply duck through the door of one of these capacious Aladdin's caves and lose yourself in sensory overload.

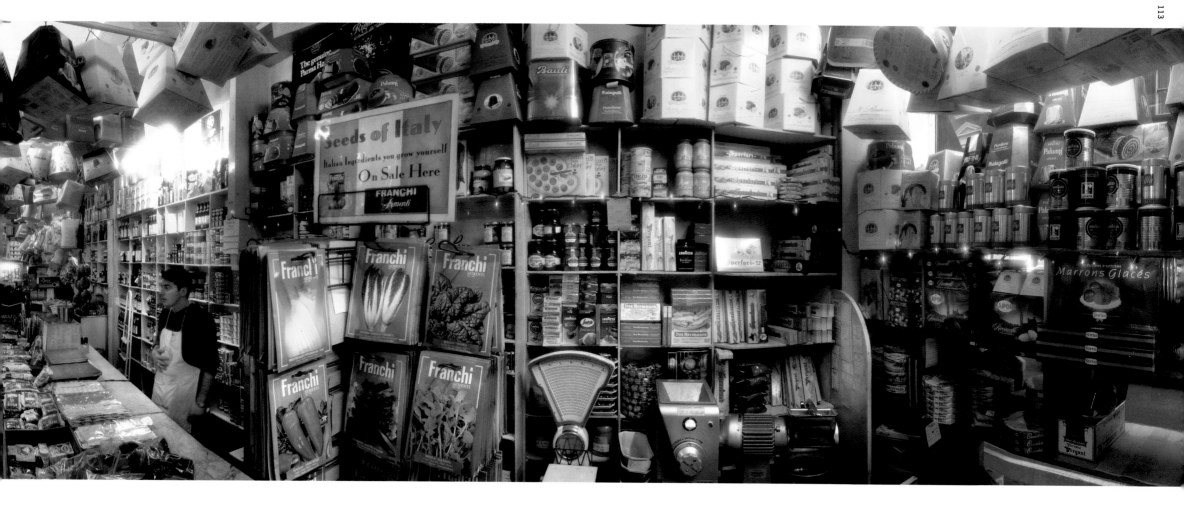

SOHO DELI WEST END

EVERYBODY LOVES LONDON'S GREEN AND SPACIOUS PARKLANDS, and St James's Park, the oldest of the capital's royal parks, consists of 90 acres of beauteous splendor. Joggers, families and workers enjoying a lunchtime sandwich gather in this public space between The Mall to the north, and Birdcage Walk to the south. Pelicans, a gift from a seventeenth-century Russian ambassador, are fed every day at 3pm near Duck Island Cottage.

ST JAMES'S PARK TOOK ITS NAME FROM A HOSPITAL FOR LEPER WOMEN

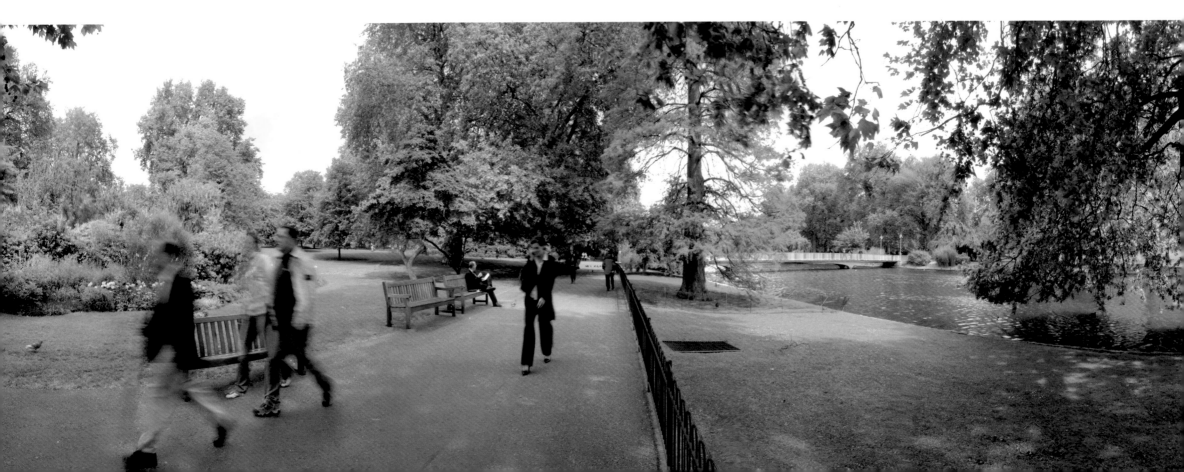

ST JAMES'S PARK WESTMINSTER

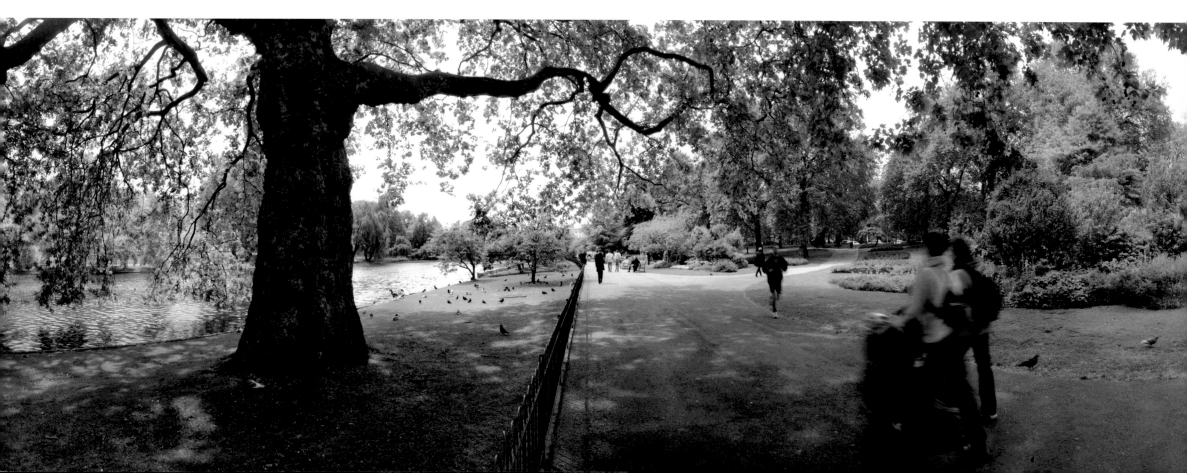

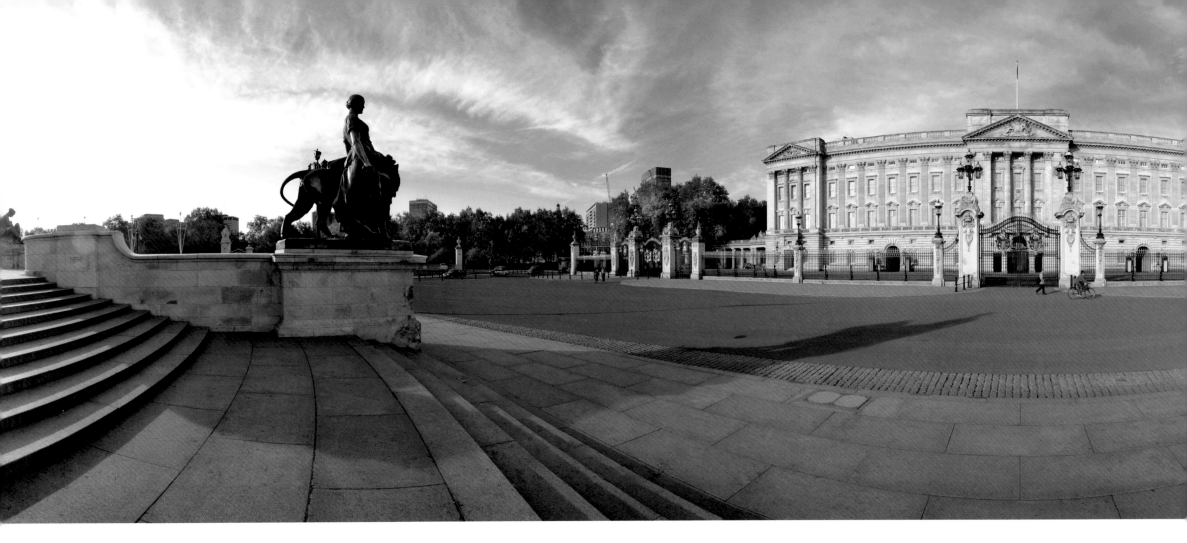

TOURISTS FLOCK DAILY TO THE LONDON HOME of the British royal family, but its inhabitants have not all been keen on the imposing dwelling. "The vast building with its endless corridors and passages seemed pervaded by a curious, musty smell", wrote King George V. "I was never happy there". The Royal Family occupy few of the 600 rooms in the Palace: the Queen and Duke of Edinburgh have a suite of about 12 rooms on the first floor, overlooking Green Park. Each summer the Queen holds three garden parties here, inviting around 8,000 guests.

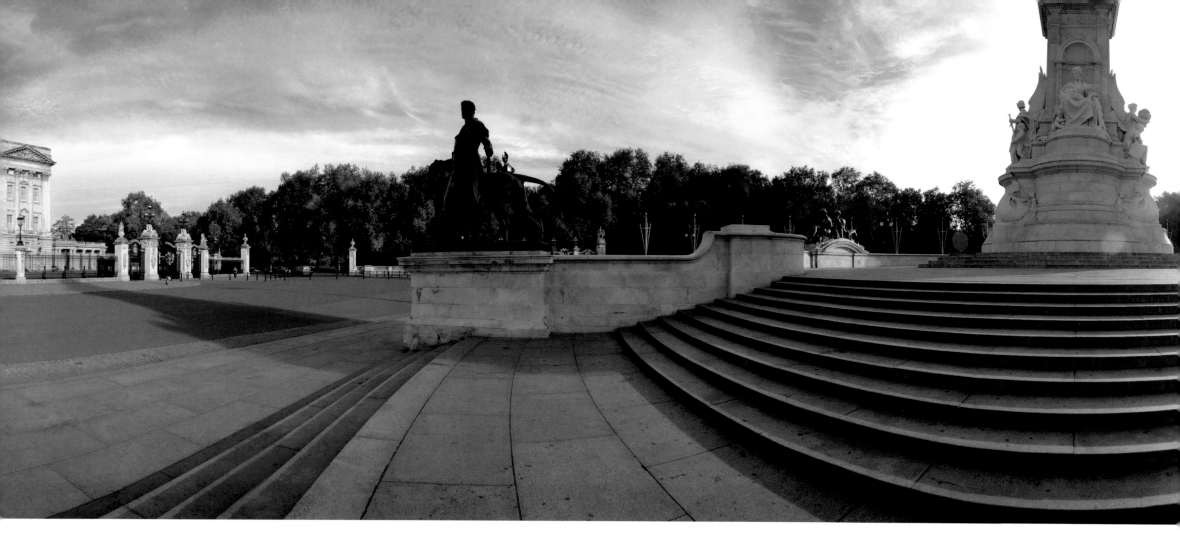

BUCKINGHAM PALACE WESTMINSTER

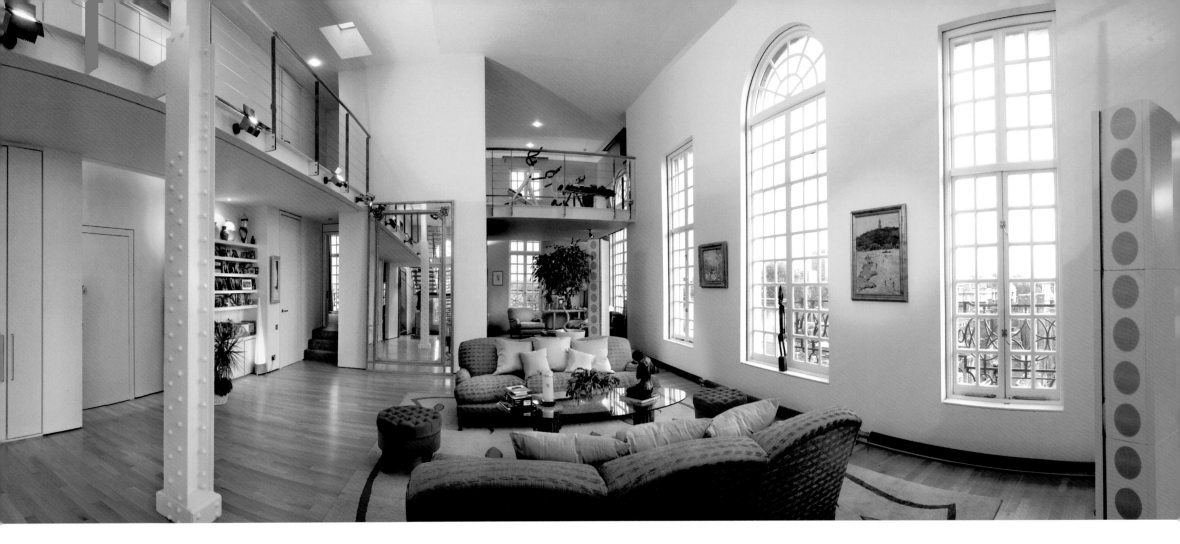

THIS FIFTH-FLOOR PENTHOUSE in Mayfair is the very essence of swanky central London living. Owned by a young entrepreneur businessman and his wife, this fabulous south-facing property, built in 1910, is within walking distance of Green Park, Trafalgar Square and Buckingham Palace.

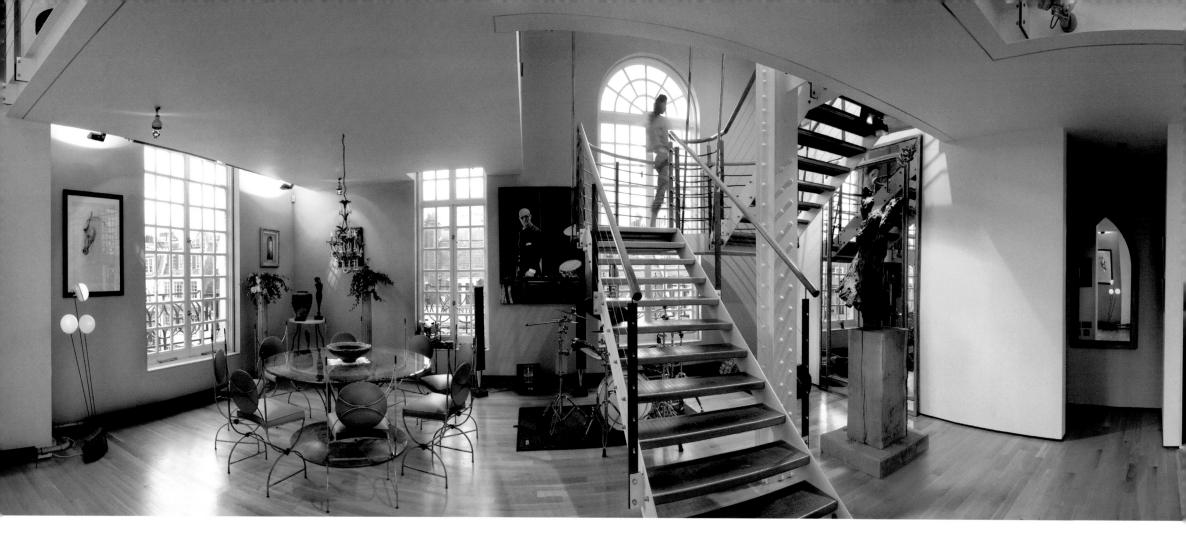

CENTRAL LONDON PENTHOUSE MAYFAIR

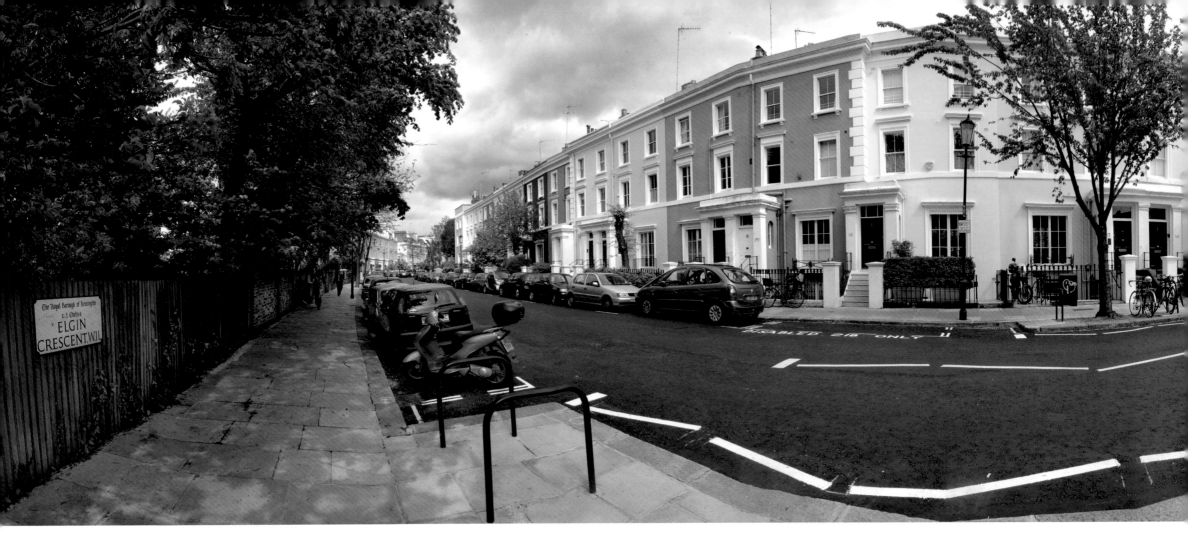

LOCATED AT THE HEART of west London's achingly trendy Notting Hill district, the elegant town houses of Elgin Crescent offer a very English take on comfortable living. Beautifully kept and immaculately tended, these pricy, bijou residences are a short stroll away from the hip restaurants and world famous antiques market at Portobello Road.

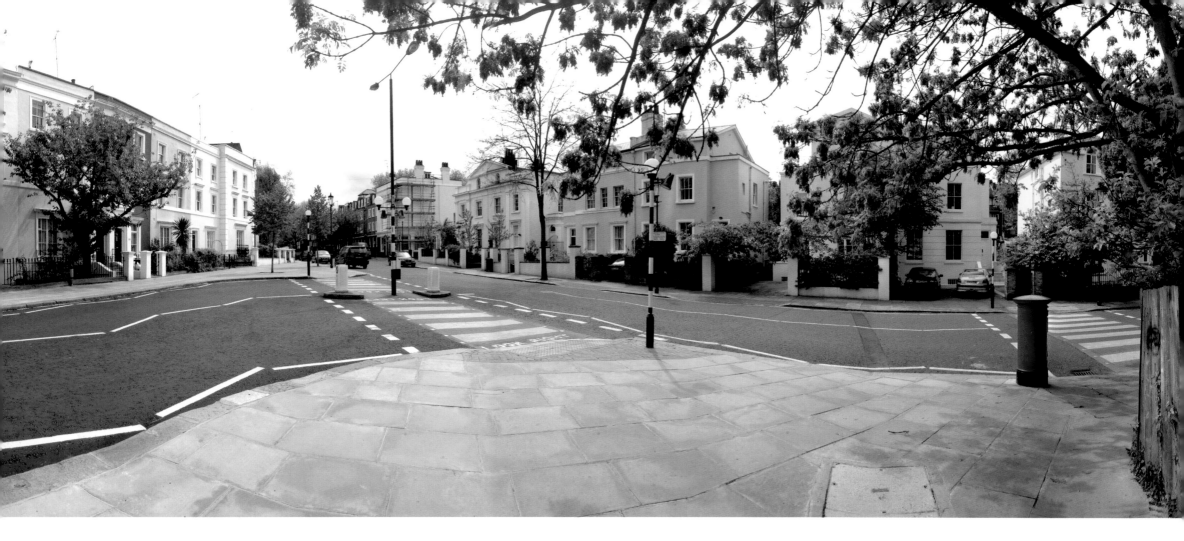

ELGIN CRESCENT NOTTING HILL

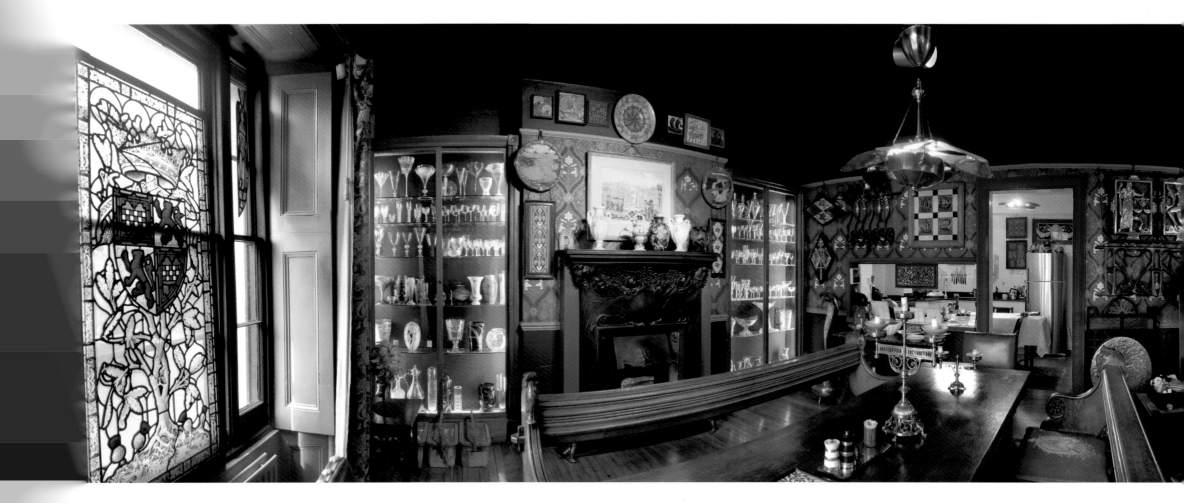

HILL'S PORTOBELLO ROAD is home to many of the capital's most venerable and prestigious antiques dealers, and the sumptuously cluttered Portobello Collector has been trading in rare and Victoriana for over 40 years. At weekends the lively outdoor antiques market attracts rapacious dealers at 5:30am, with the more leisurely locals and tourists sauntering along in the afternoon.

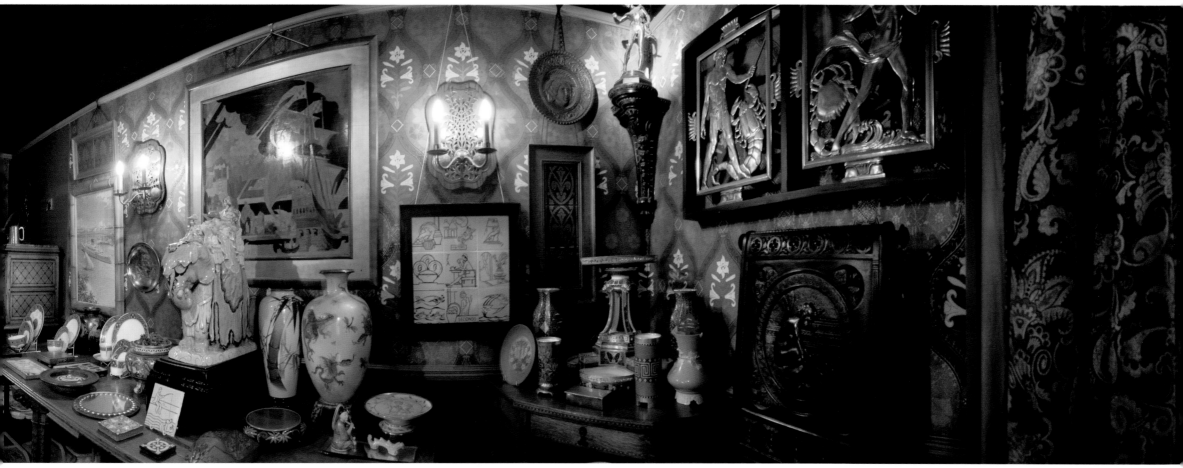

PORTOBELLO COLLECTOR NOTTING HILL

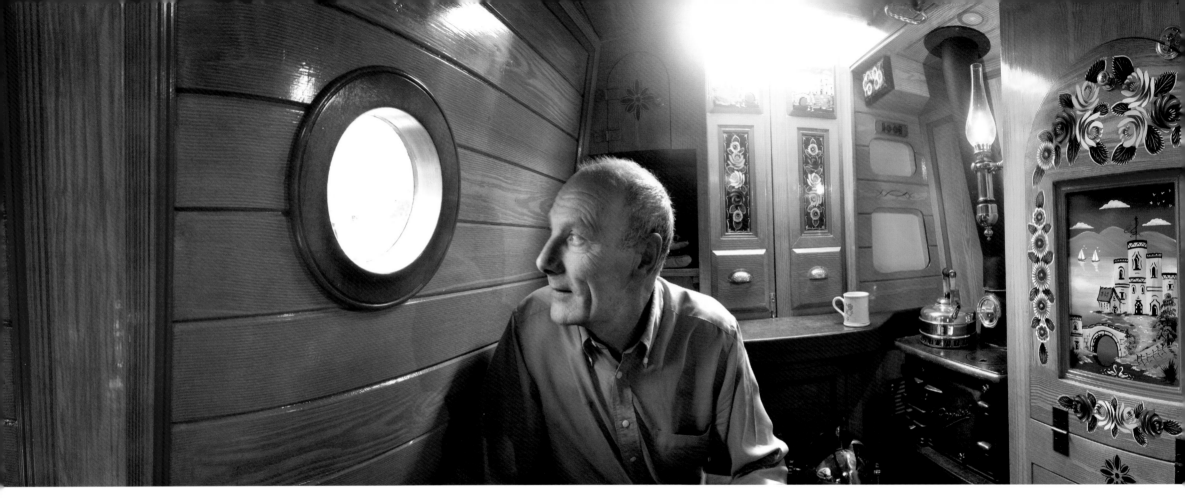

MIKE SITS IN THE BOATMAN'S CABIN aboard his boat *Beauideal*, moored at Little Venice, a leafy suburb of north-west London. In the working days of such boats, families would live in this tiny space, sleeping on beds that folded down from the wall, while the rest of the craft was given over to the cargoes of the Industrial Revolution such as coal, wool and timber. *Beauideal* is 47 feet long and 6 feet, 9 inches wide, and Mike travels the waterways for pleasure.

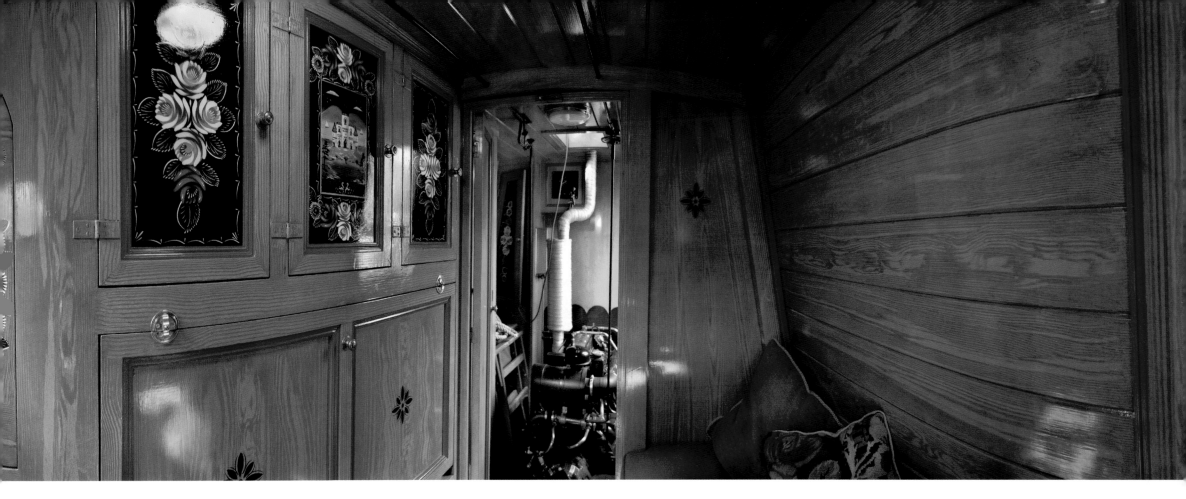

NARROW BOAT
LITTLE VENICE

LONDON HAS 90 MILES OF CANALS

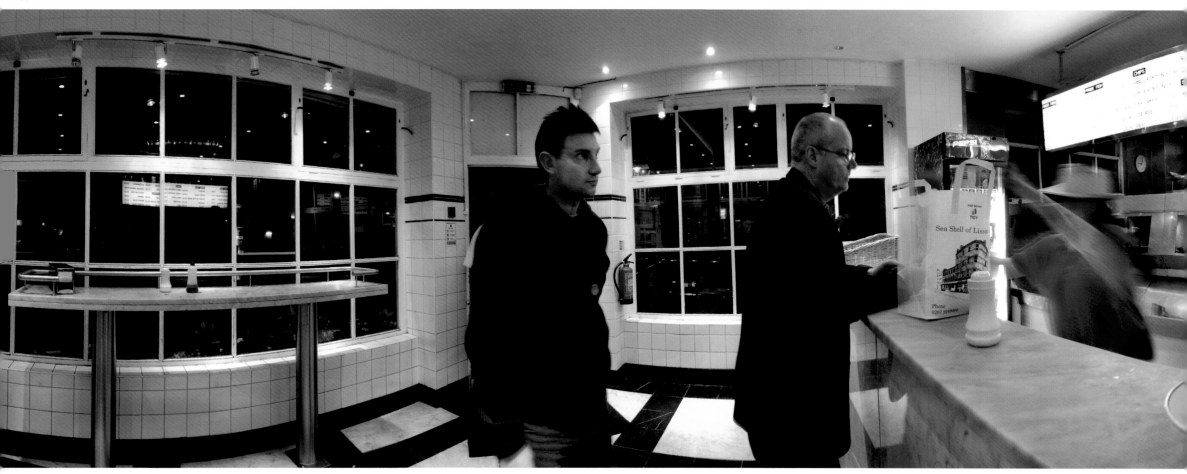

FISH AND CHIPS served in newspaper or a polystyrene tray is a classic British dish, and The Seashell in Lisson Grove, Marylebone serves mouth-watering yet solid portions for people on the move. You can eat your hake or cod perched against the metal tables in the functional shop area, or go for a full sit-down meal in the pink restaurant at the back. Starters include white fish chowder, whitebait and calamari.

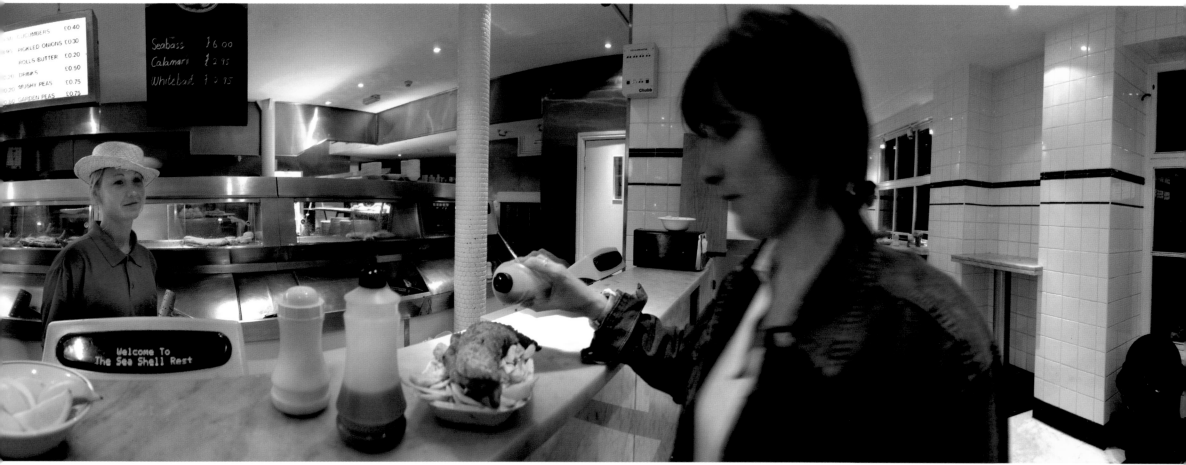

Seabass £6.00
Calamari £2.95
Whitebait £2.95

CUCUMBERS £0.40
PICKLED ONIONS £0.30
ROLLS BUTTER £0.20
DRINKS £0.50
MUSHY PEAS £0.75
GARDEN PEAS £0.75

Welcome To
The Sea Shell Rest

FISH AND CHIP SHOP LISSON GROVE

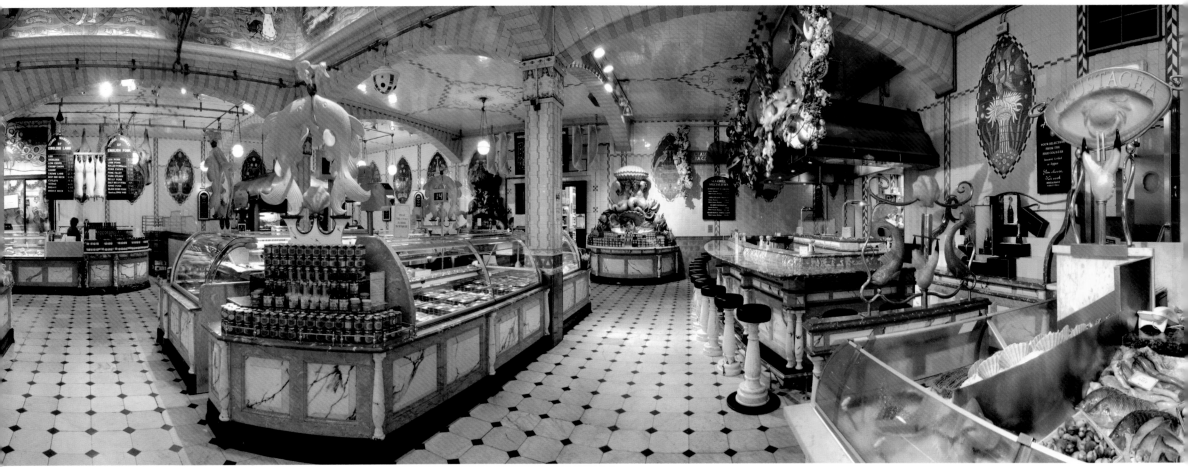

THE WORLD-FAMOUS HARRODS began as a small grocer shop in Knightsbridge in 1849, and food remains a major priority for the original aristocrat's department store. During World War II, the store employed a cookery expert to advise customers how best to use their wartime rations. To the left of the palatial fish hall on the lower ground floor, well-heeled customers can slide onto a high stool and lunch on oysters.

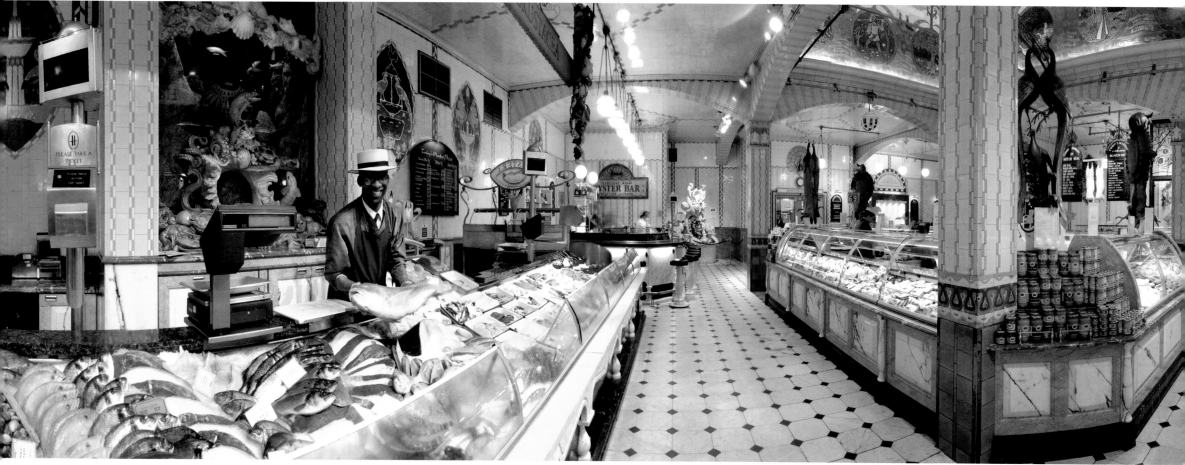

HARRODS FOOD HALL KNIGHTSBRIDGE

LOCATED IN SMART SOUTH KENSINGTON, the Natural History Museum is a center of excellence in taxonomy and biodiversity. Founded in 1811, its 3 acres of gallery space can display only a tiny percentage of the museum's whole collection. If you visit the Life Gallery, below, you will immediately find yourself confronted with an 85-foot skeleton of a Diplodocus dinosaur.

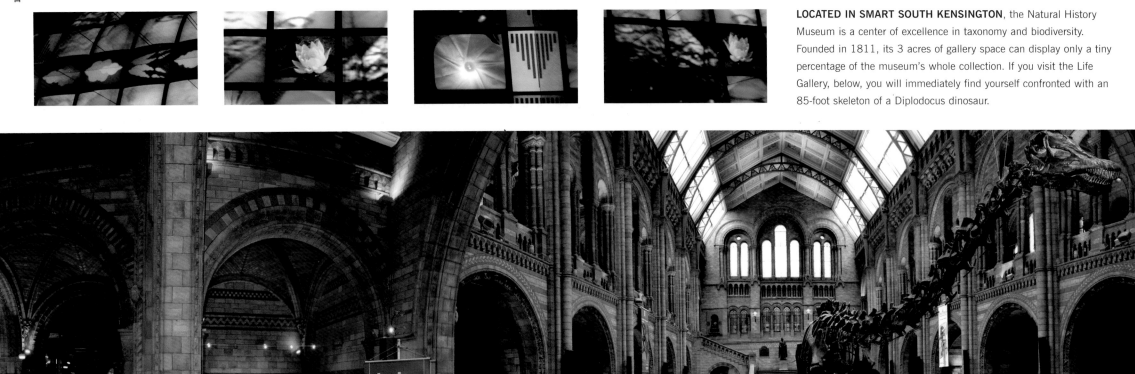

NATURAL HISTORY MUSEUM SOUTH KENSINGTON

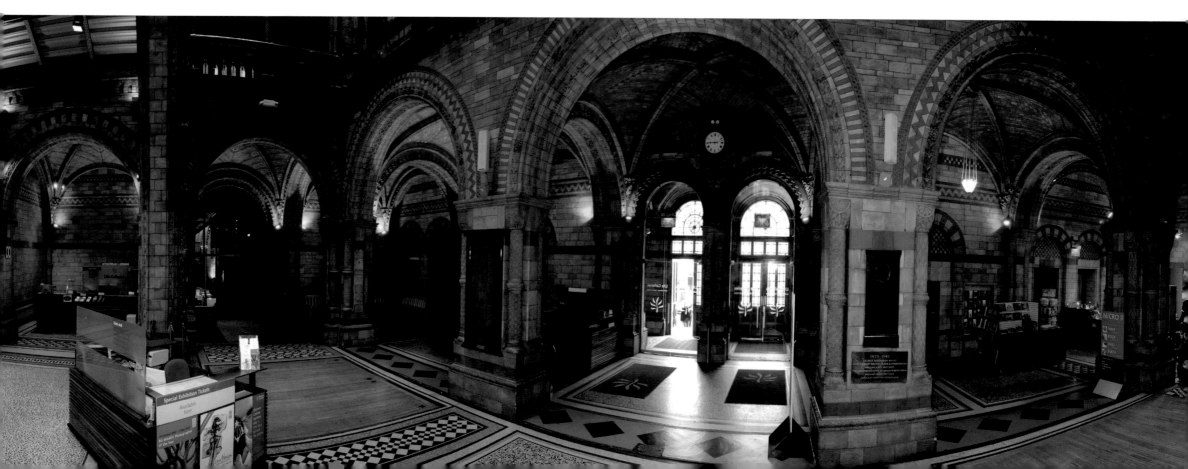

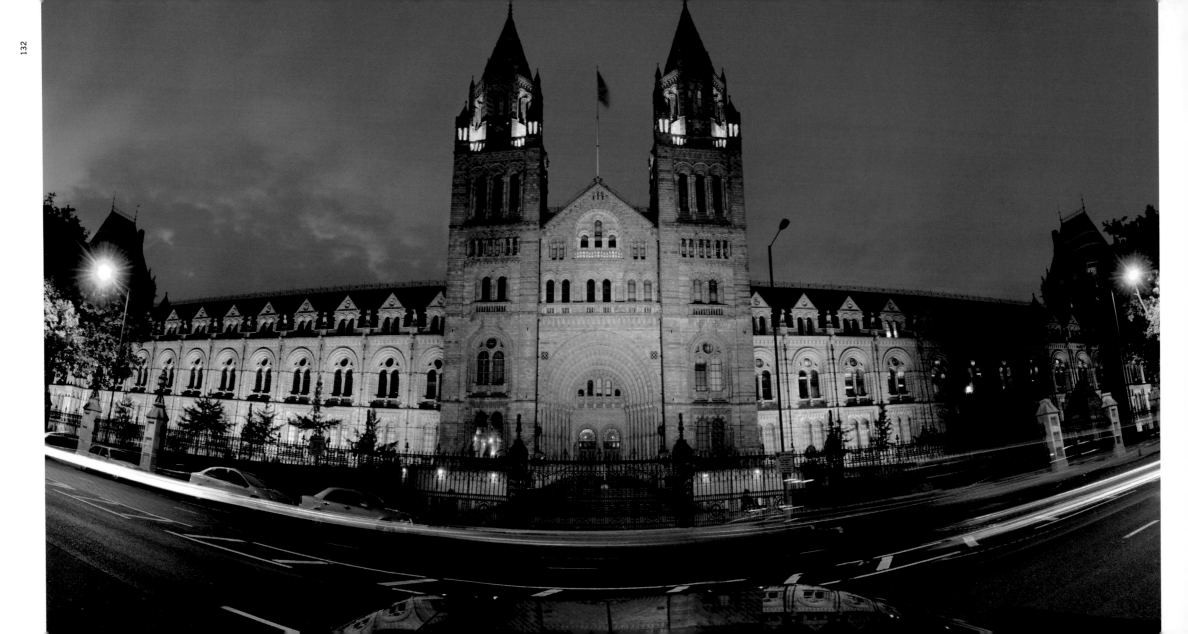

DESIGNED BY CAPTAIN FRANCIS FOWKE and opened in 1811, the Natural History Museum is a splendid architectural achievement. Its central hall, *The London Encyclopaedia* comments, resembles a cathedral nave, embellished as it is with towers and spires, while the interior is crowded with baroque and Gothic ornamentation. The museum's Darwin Center, opened at the turn of the millennium, provides storage space, new laboratories for scientists, and behind-the-scenes access for visitors.

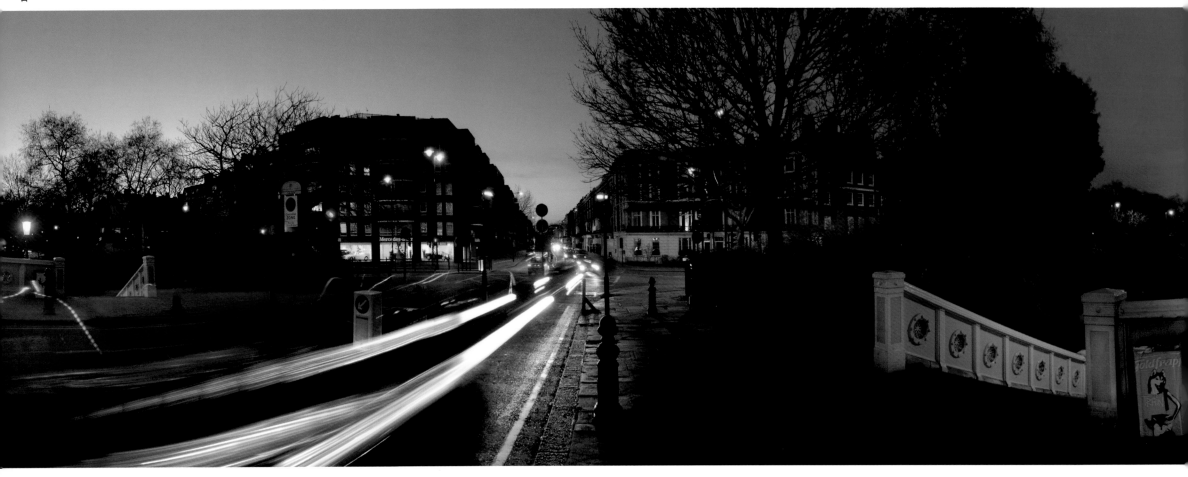

LINKING CHELSEA on the north side of the Thames with Battersea on the south, the gracious Albert Bridge is an elegant iron suspension bridge, which later had pillars, placed under its center when heavy traffic began to threaten its structure. On the north side of the bridge stands a nowadays rare original red telephone box and a rather quixotic notice ordering soldiers to break step when they cross the Albert.

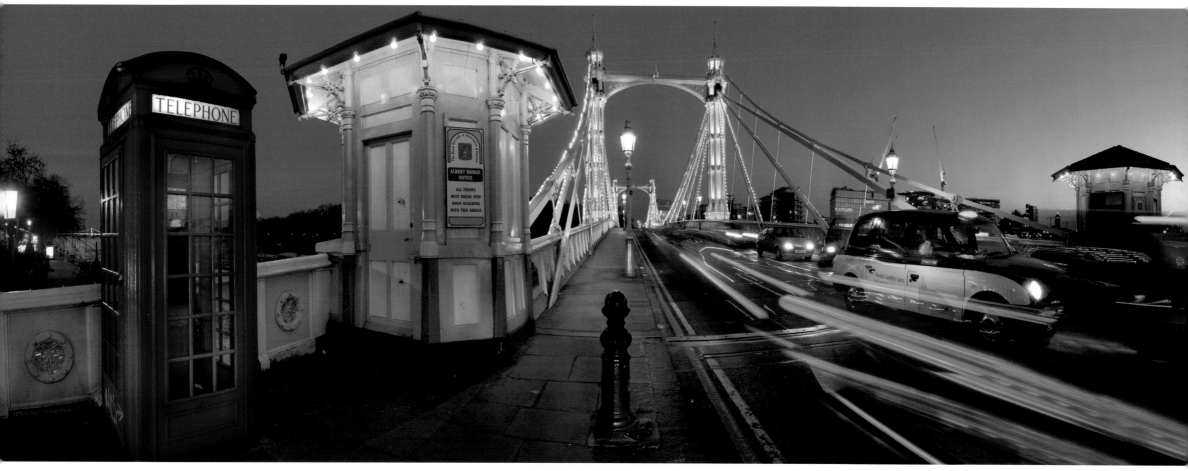

ALBERT BRIDGE

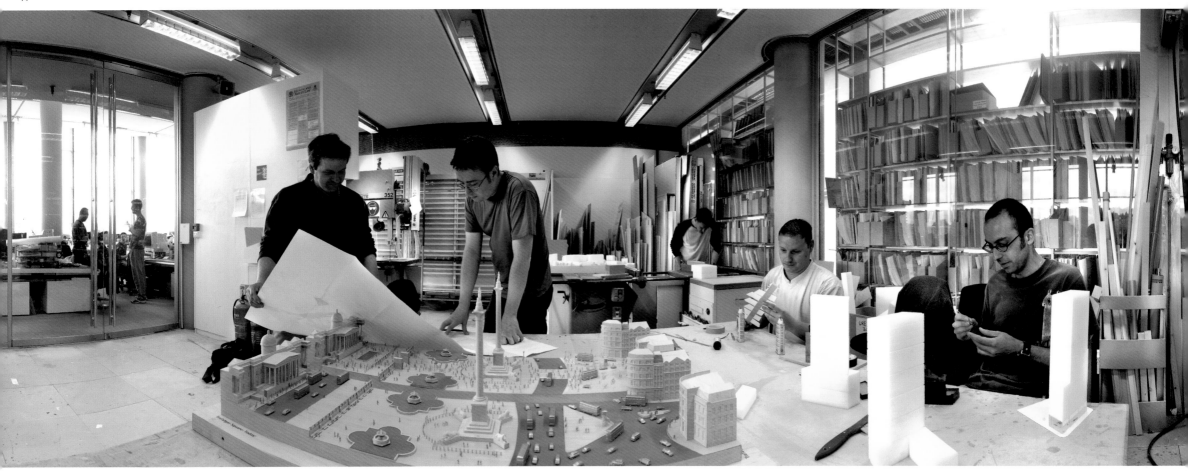

FOSTER AND PARTNERS ARCHITECTS Sir Norman Foster and his colleagues are involved in shaping unique buildings and reinventing London for the twenty-first century. Even in these days of virtual space and digital design, they still use their model shop to produce 3D models to convince often sceptical planners and the public of the merits of their architectural creations. Trafalgar Square is to the left, the Greater London Authority building on the central table.

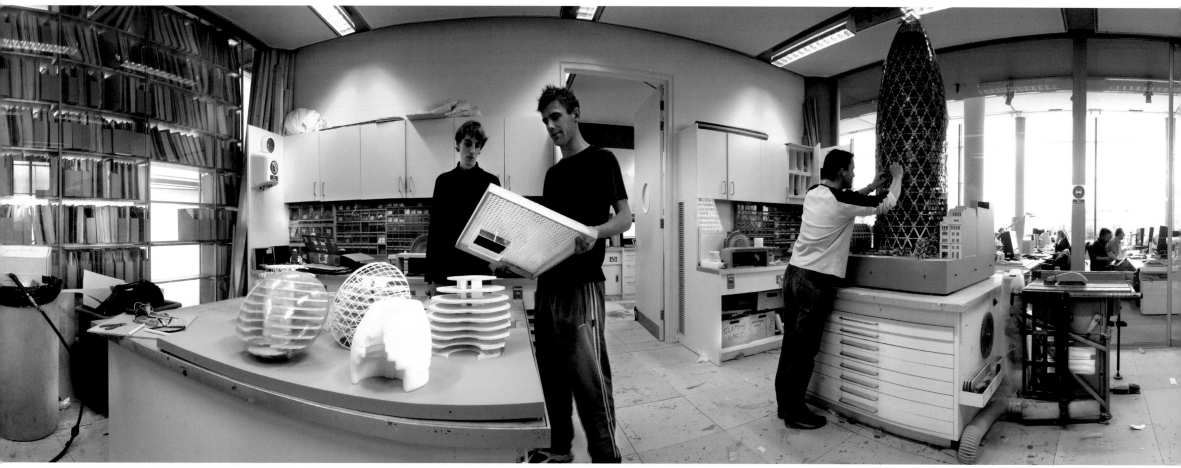

FOSTER'S STUDIO BATTERSEA

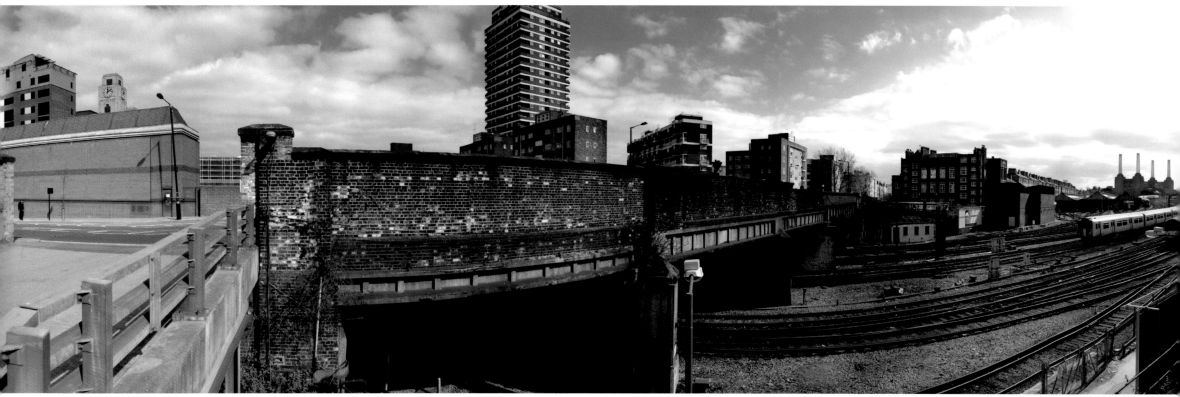

LONDON DEPENDS ON ITS RAIL SYSTEM, and trains cut a mighty swathe through the heart and outskirts of the city. At Pimlico it is striking just how close the commuter trains that burrow from south of the capital into Victoria station come to the redbrick dwellings owned by the Peabody Trust. Co-existing in harmony, this is typical London living.

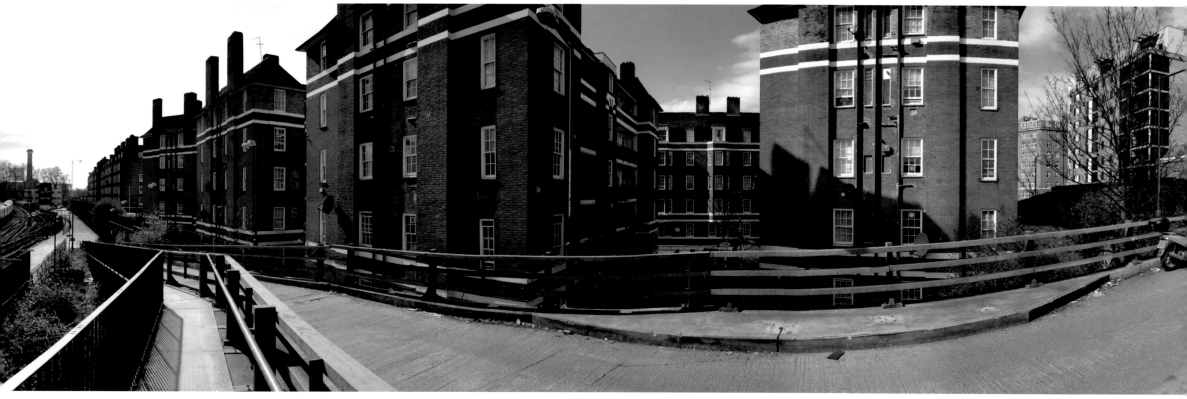

PIMLICO

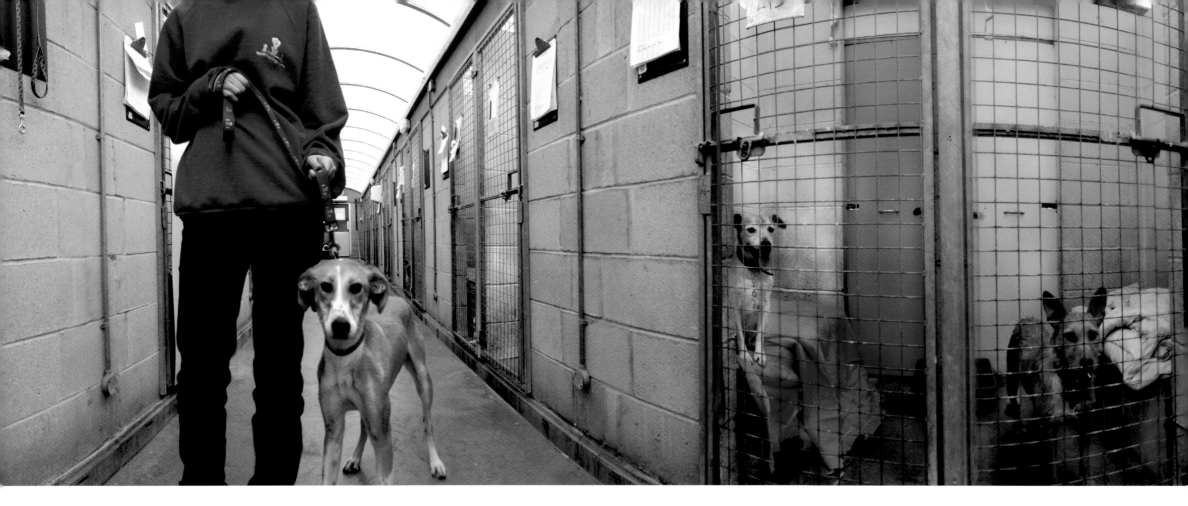

THE ENGLISH ARE RENOWNED across the world for their love of dogs, and the 140-year-old Battersea Dogs Home is a uniquely English institution. Every stray dog picked up by the Metropolitan Police is brought to Battersea, where loving staff look after, retrain and, hopefully, rehome them. On any given day there are between 300 and 600 lost, stray or unwanted dogs at Battersea.

DEDICATED
IN LOVING MEMORY
OF OUR BEAUTIFUL
LITTLE
LUCY II

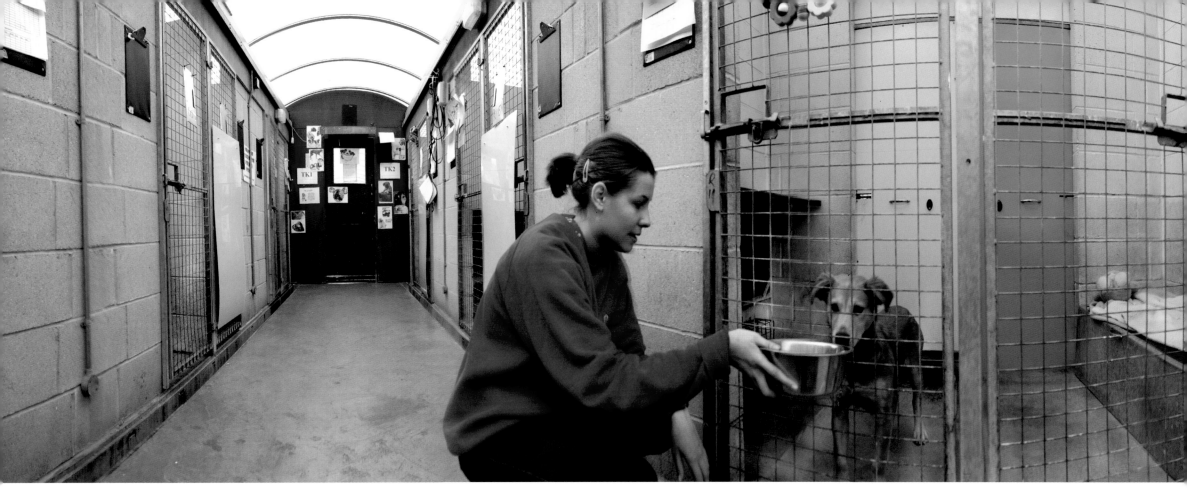

EVERY BATTERSEA DOG IS WALKED FIVE TIMES PER DAY

BATTERSEA DOGS HOME BATTERSEA

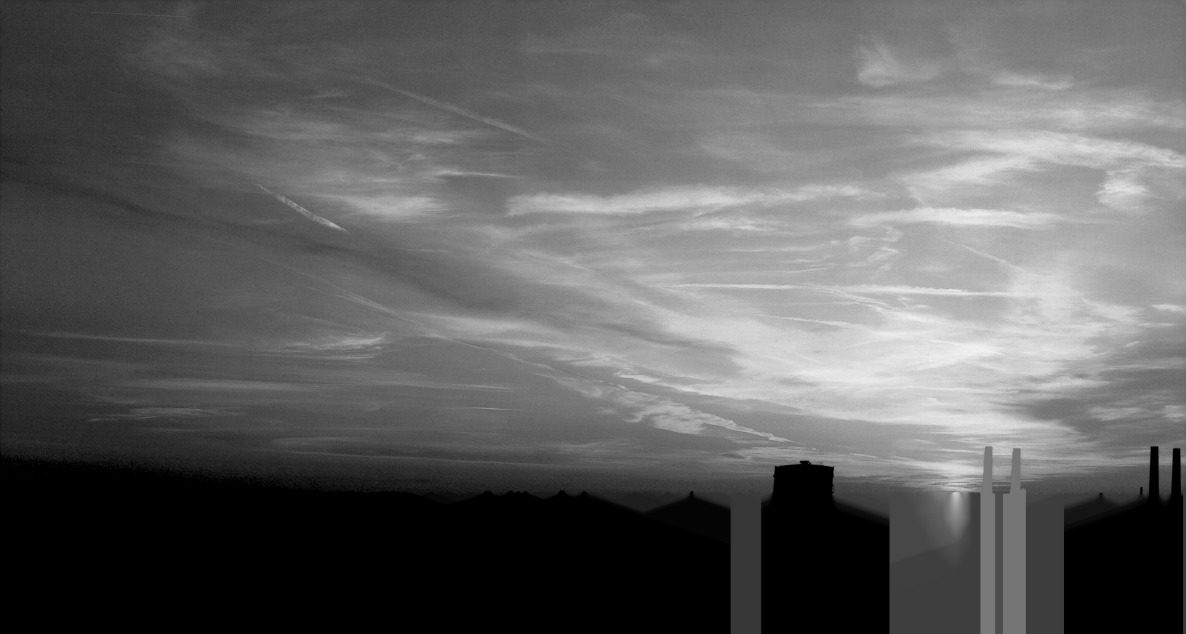

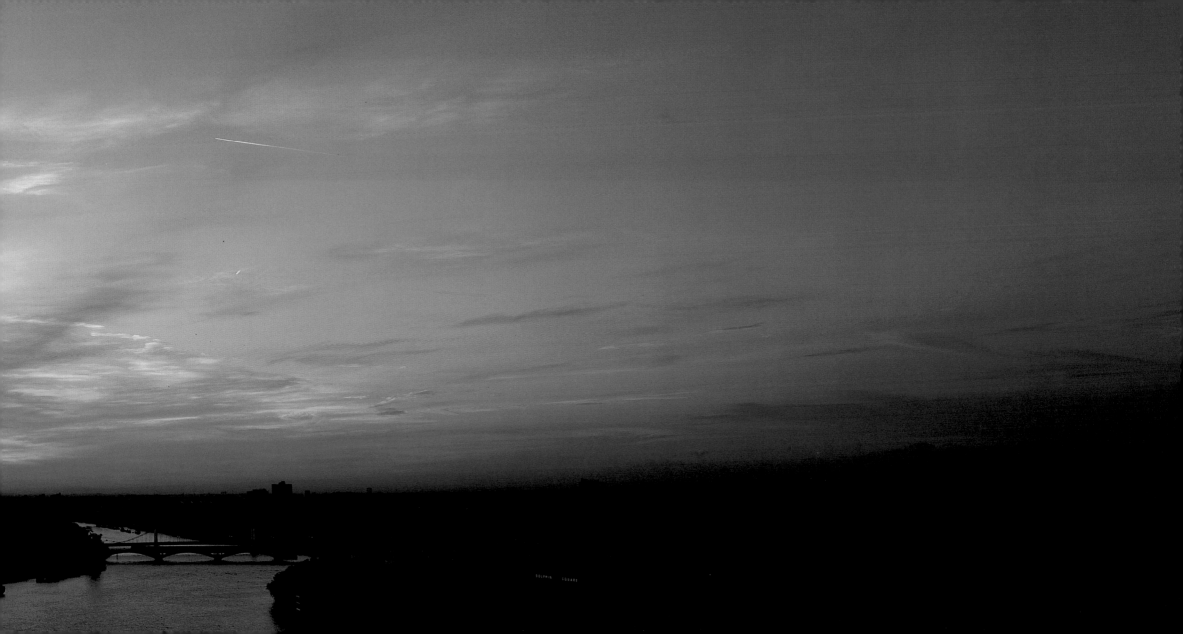

INTERIOR DESIGNERS BEAUDESERT specialize in the design and production of bespoke four-poster beds. The posts are hand-carved and based on eighteenth- and nineteenth-century designs, and the period detail is meticulous. Each bed contains a 10-inch bolt specifically to prevent excess reverberation or shifting.

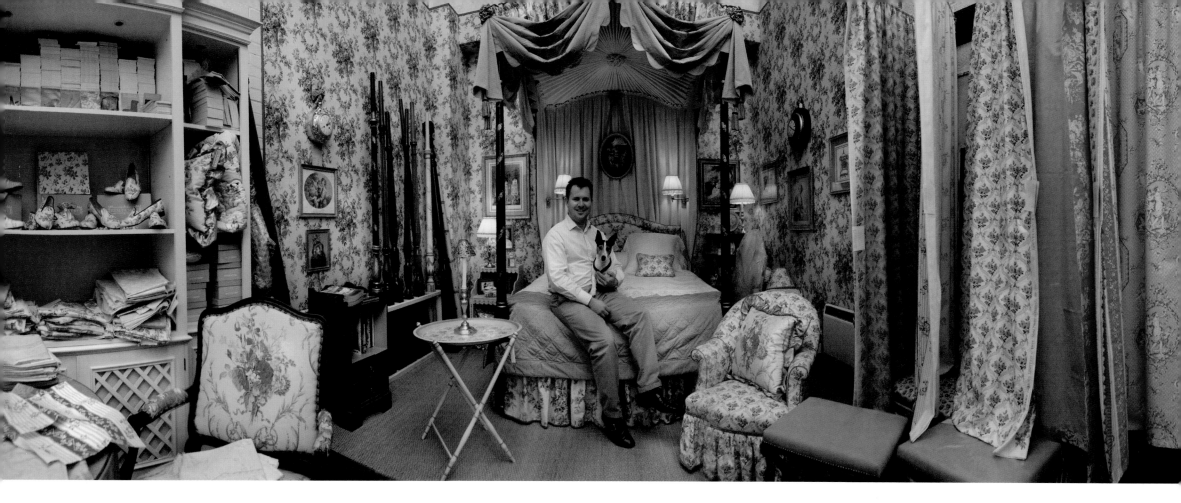

KING CHARLES II ALWAYS SLEPT WITH SIX DOGS, THEREBY INSTIGATING A TREND TOWARDS LARGER BEDS IN HIGH SOCIETY

BEAUDESERT BATTERSEA

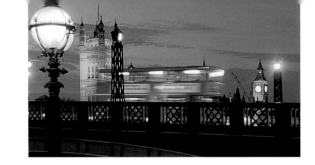

BUS DRIVER LIONEL gave up his job to achieve his ambition of driving a Routemaster bus on the roads of London. In the mid-1990s, the European Commission attempted to ban Routemasters, with their unique open backs, on safety grounds. They failed.

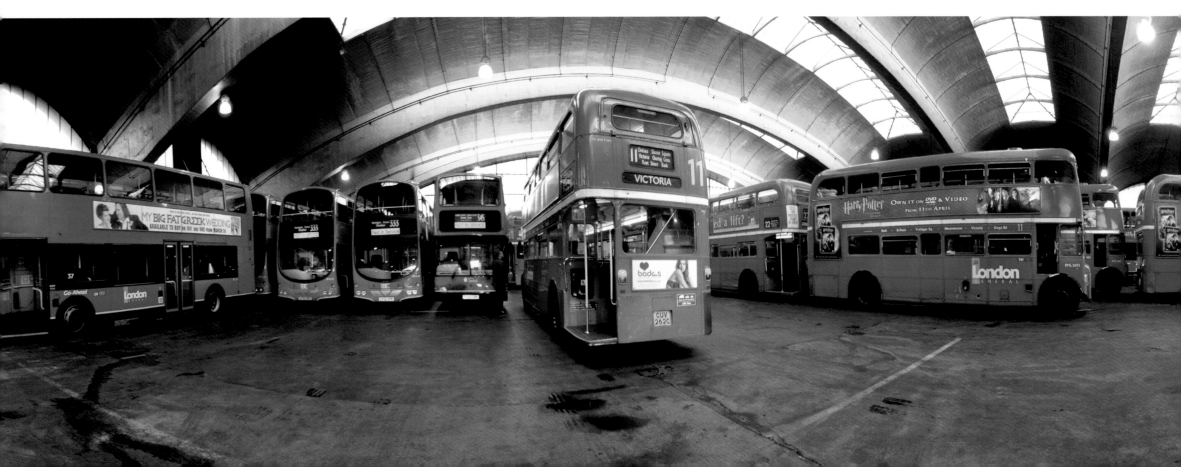

LONDON BUSES STOCKWELL

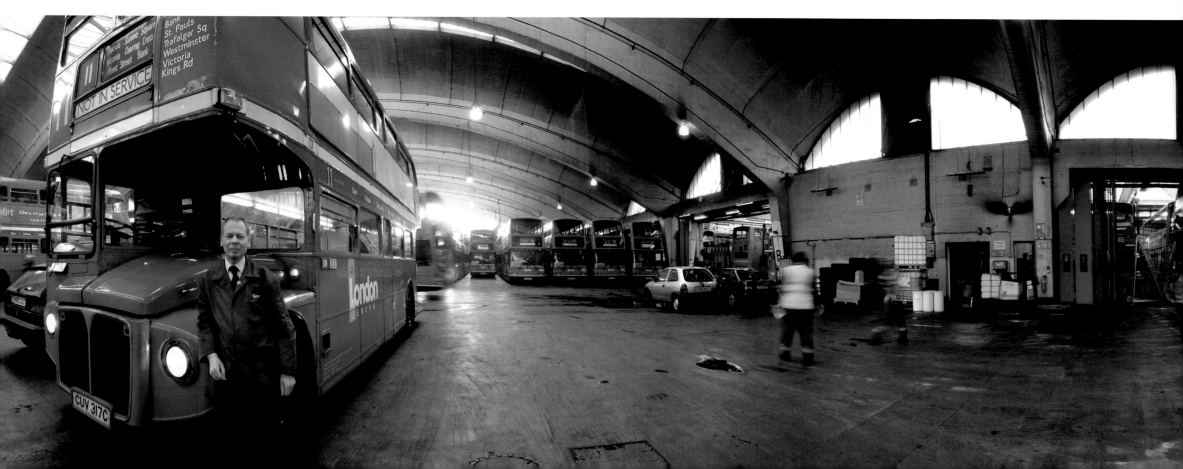

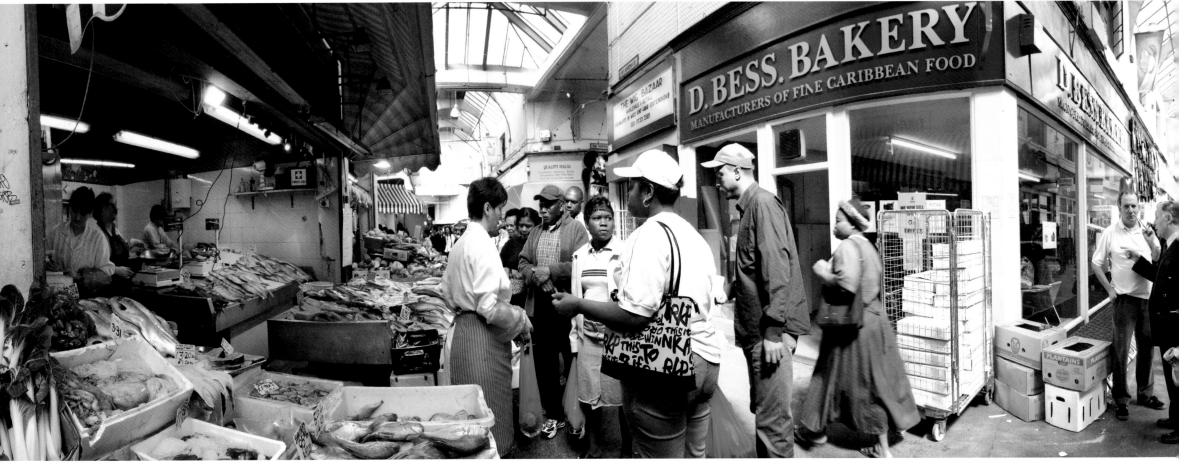

SINCE THE 1950s BRIXTON has been dominated by London's West Indian population. In its bustling covered market, salt fish ackee, beef jerky and yams fight for space with incense sticks and cheap 'n' cheerful Bob Marley T-shirts, as reggae and hip-hop boom out of ghetto-blasters. It's had its social problems, but Brixton remains a community like no other in London.

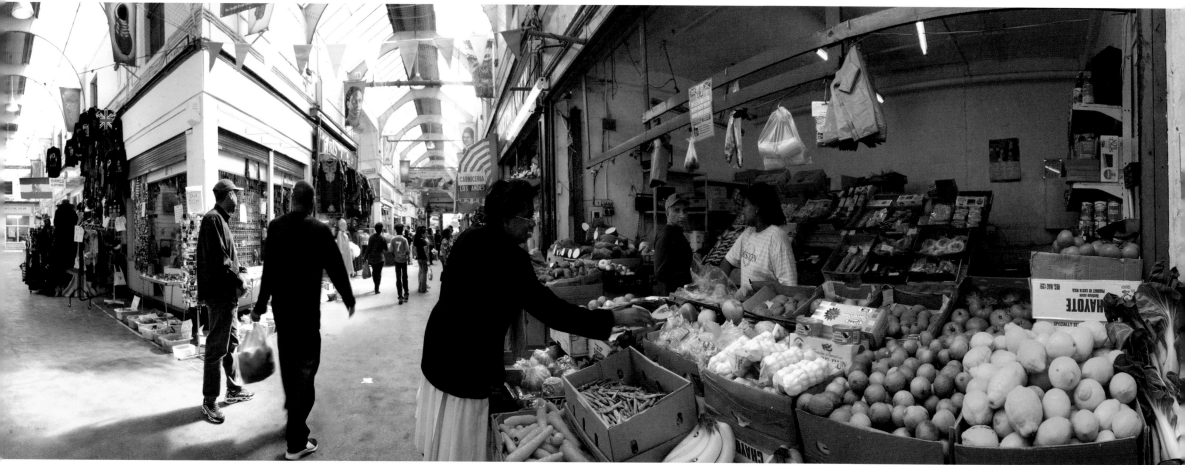

BRIXTON MARKET

BRIXTON

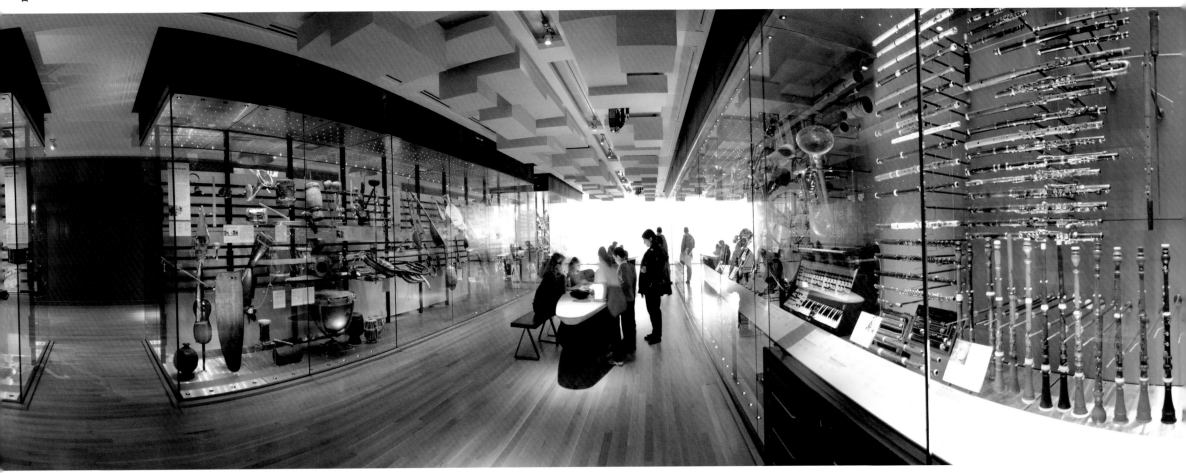

ONE OF LONDON'S LEAST-KNOWN but most enticing museums, the Horniman in Forest Hill, south London, contains a bewildering range of artifacts from a Spanish Inquisition torture chair to the world's largest African mask. Its most remarkable collection is 7,000 musical instruments from around the world, including a pair of human hand-shaped bone clappers that were made in Egypt around 1500 BC.

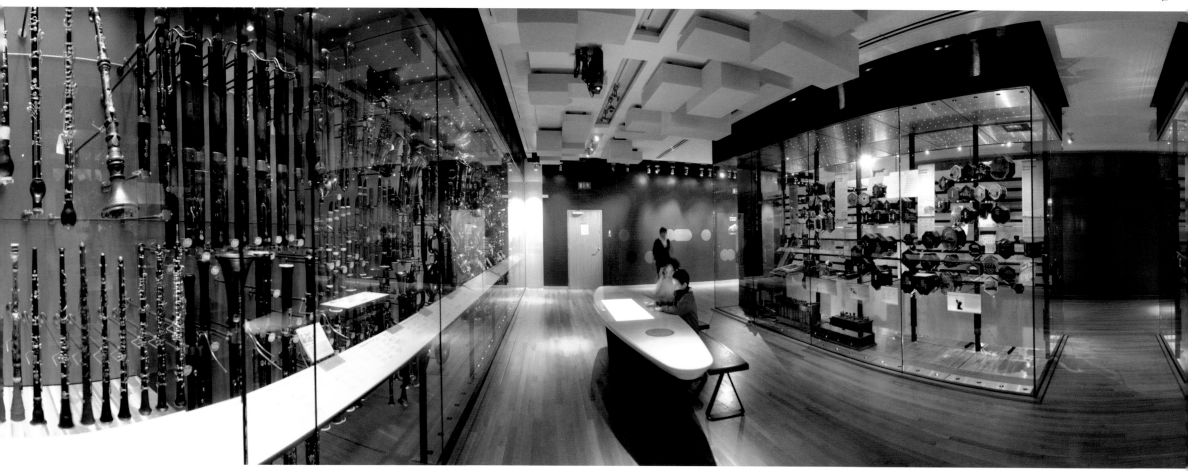

HORNIMAN MUSEUM FOREST HILL

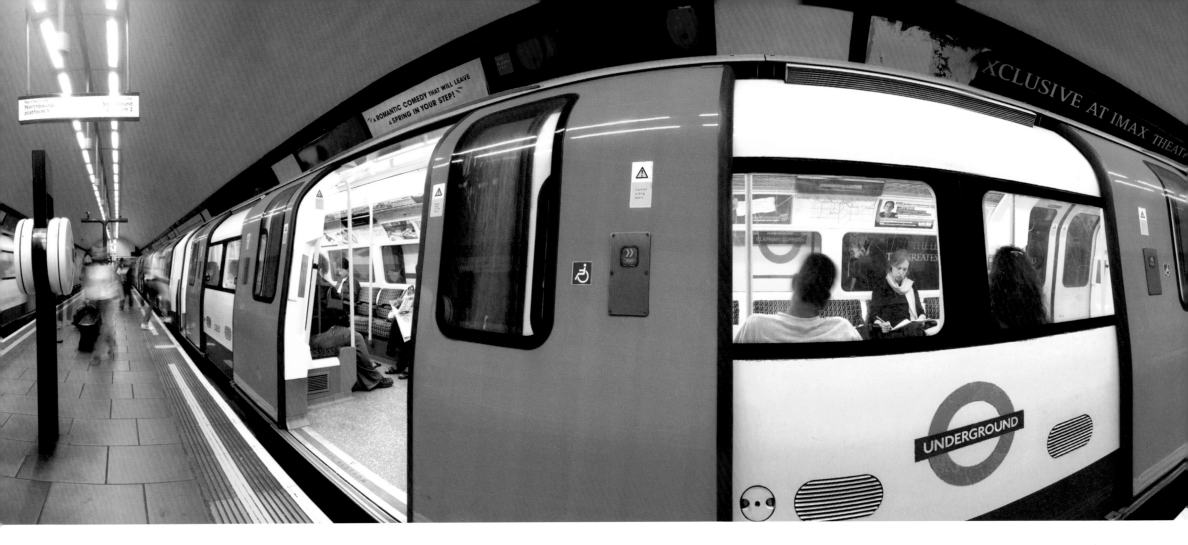

LONDON UNDERGROUND operates 240 miles of railway line, of which less than 50% is actually underground. The network's highest point is at Amersham on the Metropolitan Line, 449 feet above sea level, and the deepest station is Hampstead, 194 feet below ground level. The busiest line is the District Line, which carries 180 million passengers per year.

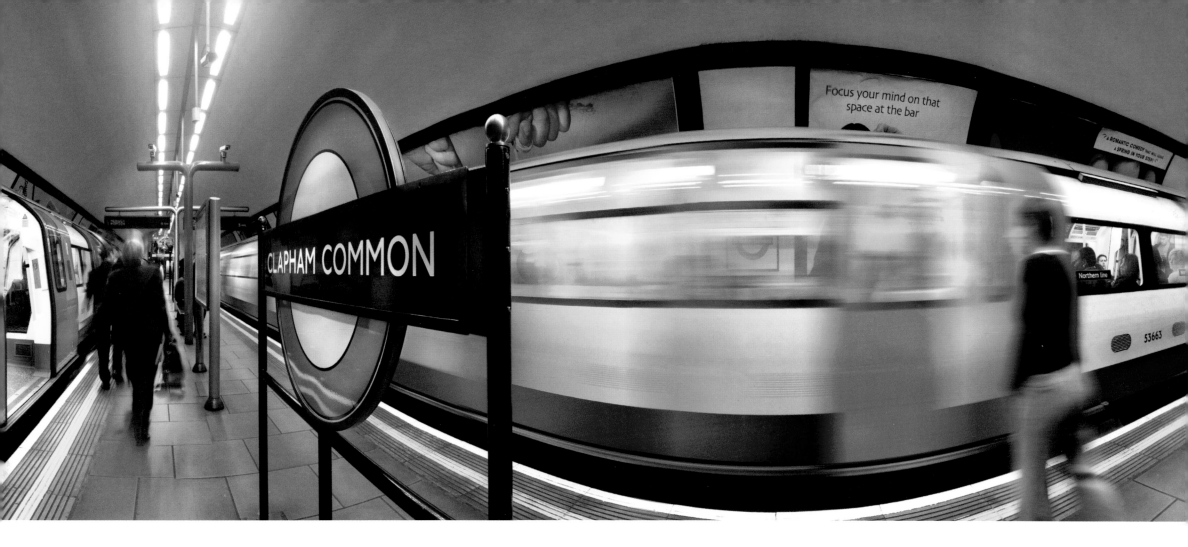

Focus your mind on that space at the bar

A ROMANTIC COMEDY THAT WILL GIVE A SPRING IN YOUR STEP

CLAPHAM COMMON

Northern line

53663

THE TUBE CLAPHAM COMMON

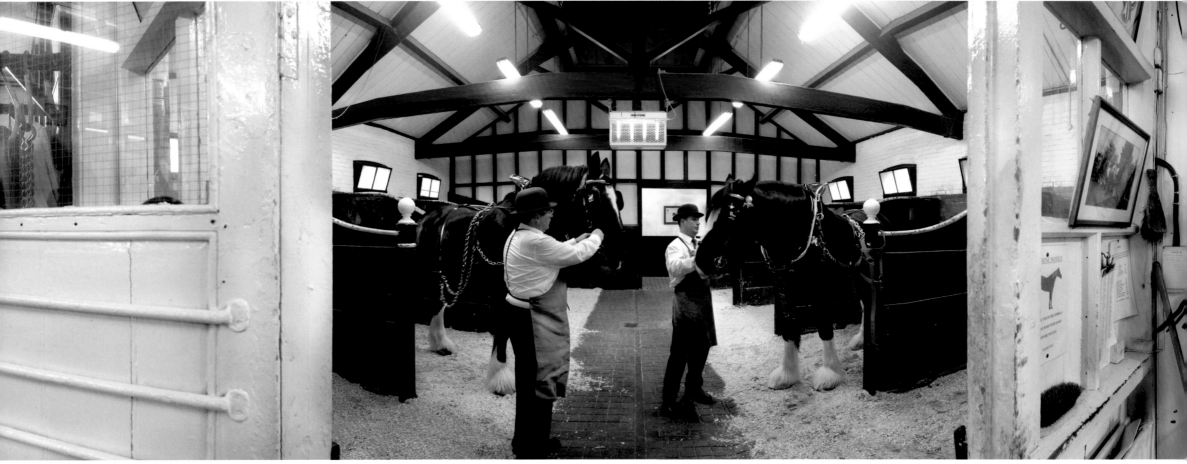

DRAYMEN JOE AND GARY prepare Buster and Mascot for a day's work delivering Young's draught beer to the pubs of south-west London. Young's have been brewing beer in Wandsworth since 1851. The brewery has a farm with 10 dray horses, geese and, of course, their trademark ram. Head brewer Ken has been ensuring the beer is in perfect condition for the last 23 years.

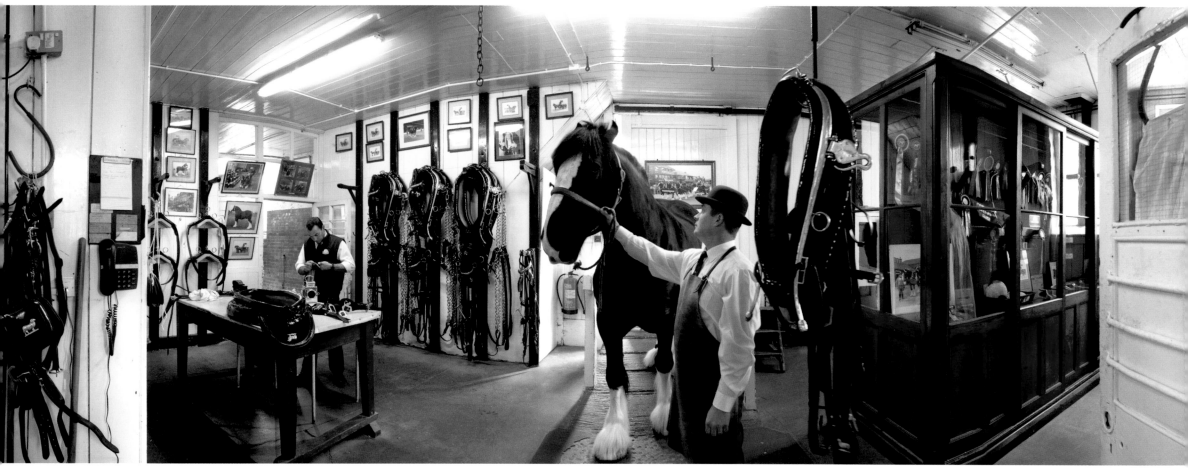

THE RAM BREWERY WANDSWORTH

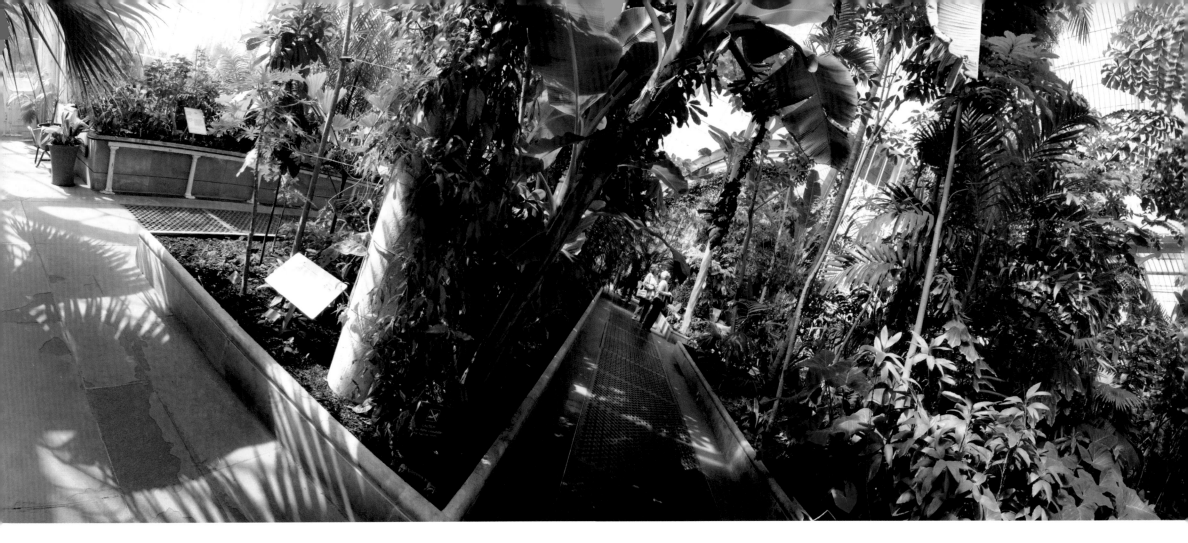

THE ROYAL BOTANIC GARDENS at Kew cover an area of just over 300 acres and house the largest and most comprehensive living plant collection in the world. The Grade I listed Palm House, built between 1844 and 1848, resembles a lush indoor Brazilian rain forest. The conceptual genius of architect Decimus Barton was to make the curved glass panes, of which there are 16,000, mimic the shape of giant tropical leaves and foliage.

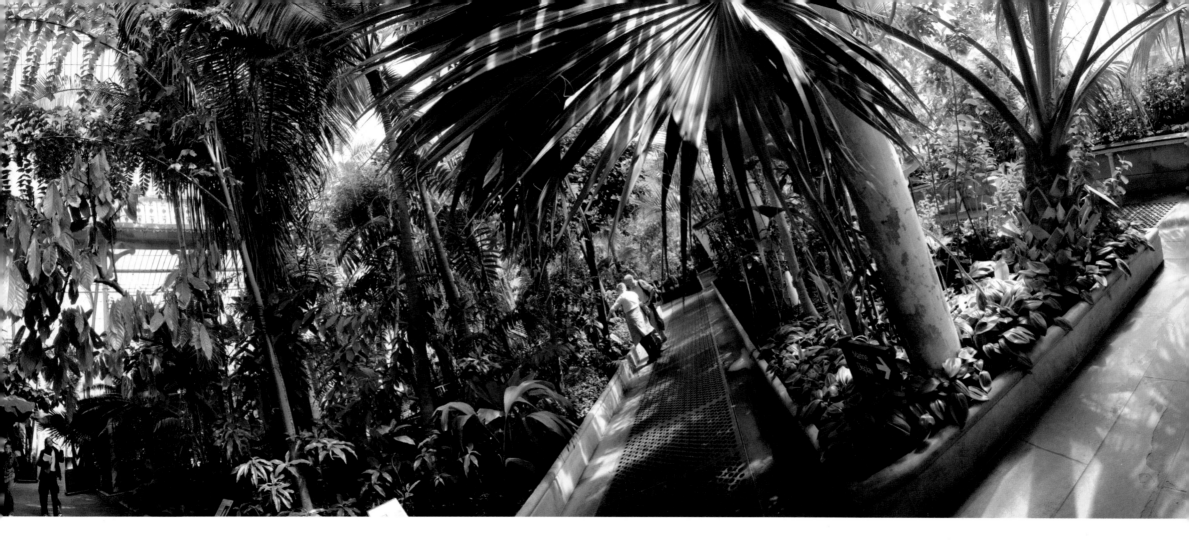

KEW GARDENS RICHMOND

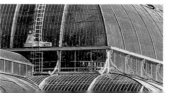

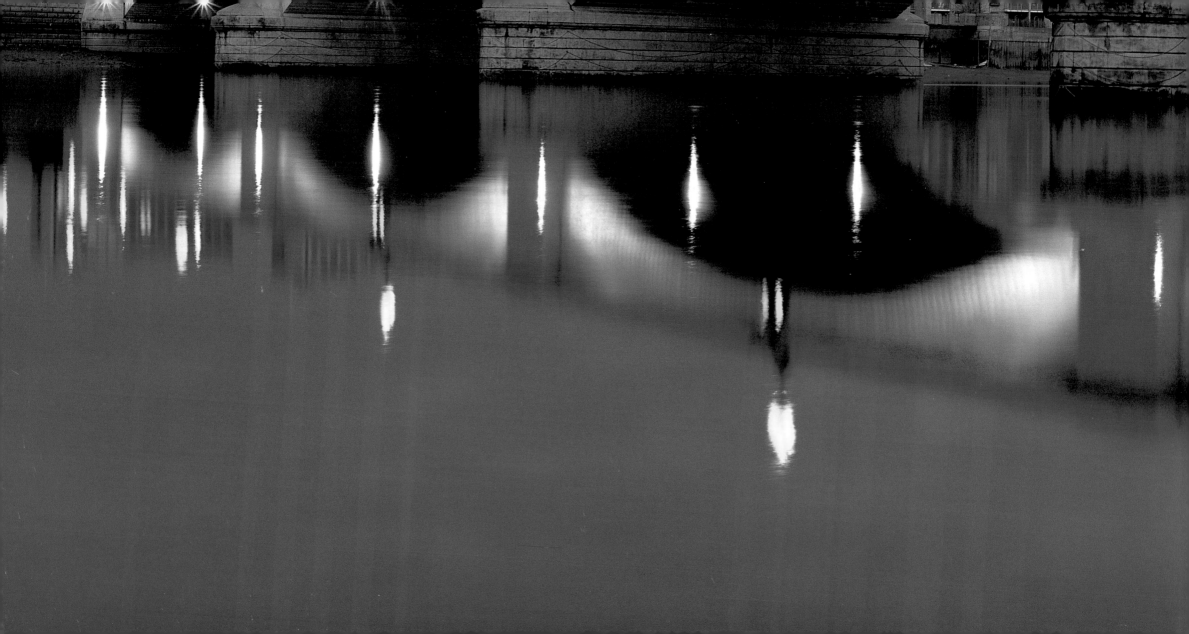